Flaunt

Second Edition

© 2015 Copyright by Underconsideration LLC

First published in the United States of America by
UnderConsideration LLC
5618 Shoalwood Avenue
Austin, Texas 78756
Telephone: (917) 755-0750
Fax: (718) 228-6720
www.underconsideration.com

ISBN-13: 978-0-9826253-9-2

Flaunt

DESIGN, LAYOUT, PHOTOGRAPHY, AND PRODUCTION
UnderConsideraton LLC: Bryony Gomez-Palacio, Armin Vit

TYPOGRAPHY
Mercury Text by Hoefler & Co.
Auto by Underware.

PRINTED IN THE U.S.
By FSC CoC certified Capital Printing Co. in Austin, TX.
Cover: Neenah Paper, Astrobrights®, Solar Yellow 100C.
Body: Crystal Silk Book, 80T.

Flaunt: Designing effective, compelling and memorable portfolios of creative work.

A BOOK BY **Bryony Gomez-Palacio** AND **Armin Vit**

A PUBLICATION OF
UNDERCONSIDERATION

You should never consider your portfolio finished, and you should always be dissatisfied with it. The day you sit back and say, "My portfolio is great," is the day you are dead in the water. Your portfolio requires endless work, and few things are more important than it. This never changes no matter how successful you have become. That's really the only thing I've learned about portfolios.

Adrian Shaughnessy

Portfolio case studies

Self-promo examples

Photographing your own work

Census of portfolio etiquette

Interviews with the interviewers

Introduction

In 2009 we set out to compile a book that covered the basics, mechanics, passions, and disappointments concerning the building and presentation of a designer's portfolio—despite a then-nascent adoption of digital portfolios that made binders, boxes, cases, and other physical objects used as a delivery method to present work, obsolete.

Speaking from experience

One of the strongest reasons we had for doing this book was that we have been in your position before. We know what it's like to be stumped by the question of where to begin a portfolio. Still, one way or another, we managed to create a handful of portfolios that served their intended purpose. Below are some highlights (and some not so high).

BRYONY'S GRADUATION PORTFOLIO

When I graduated from Portfolio Center in December of 2000, I left armed with the Big Box portfolio the school is famous for: a custom-made wood box covered in a dark blue textured fabric, with stacked trays that held a single item in each compartment, and an oversized screw-post book.

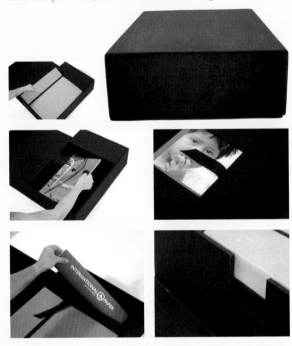

I also produced ten small versions of the main book to use as leave-behinds.

This portfolio helped me secure my first job in Chicago, IL, at Bagby & Co. in 2001.

Not knowing what to expect, we printed 2,000 copies and hoped to break even on our hard costs one year later. To our surprise, we reached that goal before we even had the book in stock, selling over 400 copies in pre-orders soon after announcing it in 2010. Five years later, we've sold 4,000 copies in book form and over 3,300 downloadable PDFs. Any doubt that physical portfolios were still relevant has been eased by the enthused reception of the first edition of *Flaunt*.

Although digital portfolios—not online websites but presentations loaded on tablets or laptops shown by an individual during an interview—have become more common, the physical portfolio is still expected and preferred by a large constituency of graphic designers in hiring positions. Graduating students and young designers benefit the most from a physical portfolio, allowing them an opportunity to package disparate, arguably unripe work in a cohesive way that has the potential to showcase other skills like editing, pacing, and hand-crafting skills. After debating whether the second edition should focus more on digital presentations we decided to keep the focus on what made this book successful in the first place: broaching a subject seldom covered by other mediums and the continued acknowledgment of the breadth of quality, style, and approaches possible in portfolio presentations. *Flaunt* is an effort to showcase a variety of alternatives within this very intimidating range of options, through detailed case studies, various points of view, and nonscientific surveys, each of which will hopefully ease the anxiety and burden of creating a portfolio—perhaps, even help demystify the process of putting it together, and the expectations of presenting it.

The challenge and objective of a portfolio has remained the same all these years: to act as a delivery mechanism that not only showcases our work and accrued experience in the most accessible, effective, and attractive manner, but also manages to communicate the subjective subtleties of who we are as both designers and individuals. The portfolio irrevocably becomes an object brimming with potential, yet burdened with hope; it acts as intermediary between our work, personality, and the possible, always uncertain, future.

"It's all about the work" is a common response to the portfolio conundrum, implying that if you have good work, you never need to worry about how it is presented—a Survival of the Fittest design theory. For a few extra-talented designers, this might hold true; but for the rest of us, we still need to find a way to cohesively, succinctly, and creatively display our work. This work is so typically disparate in medium and scope that it challenges us to develop a visual and editorial strategy that can accommodate any given combination of logos, identity systems, music and video packaging, book covers, magazine covers and spreads, environmental design and signage, websites, and more. Presenting

When I graduated in 1999 from Anahuac University in Mexico City, no one told me what a portfolio was supposed to be. I wrapped a badly constructed cardboard box and poorly glued envelopes (which held items by categories, like identity and packaging) with alarmingly weird three-dimensional renderings.

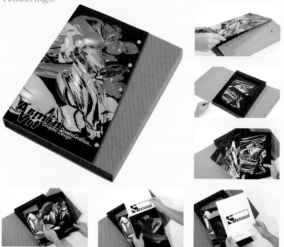

Strange as it was, it did help me get a job in Atlanta, GA, at USWebCKS in 1999.

PLUS HIS SECOND PORTFOLIO

It was clear I needed a new, more mature portfolio in order to search for my second job. I decided on a book that Bryony helped me bind with a complicated Japanese 4-hole binding method that I would carry in a Pina Zangaro metallic case.

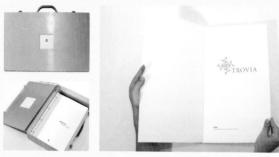

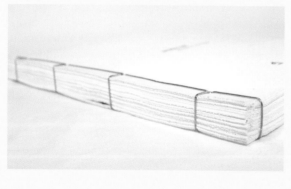

this medley of work can take on a number of forms, from groovy bags to sophisticated cases with loose samples of the work; perfect-bound books of flawlessly photographed work; custom-made boxes with work mounted on neatly-trimmed boards; off-the-shelf ring binders with the work stuffed in them; and more. To make matters more complicated, there is no right or wrong, nor better or worse, solution. The only way to discover what works for each of us is to assess the work we want to show, define the logistics of how we want to show it, and acknowledge the abilities and resources we have to make it happen.

At the core of *Flaunt* is a collection of 41 case studies of diverse portfolios. Through concise interviews they reveal the need, motivation, process, and eventual solution that each of their owners discovered. The detailed breakdowns of price, materials, and resources provide numerous ideas that can be adapted to any kind of portfolio. Generously illustrated with photographs of the portfolios, the case studies bring to life the lessons learned, and demonstrate a bevy of possible visual strategies that best showcase and explain the work. The selected portfolios aim to represent both the most common approaches as well as some offbeat executions that may strike sparks of inspiration for you. While the total number of case studies is exactly the same as the first edition, there are 23 new portfolios showcased that, combined with the previous inclusions, provide a wider spectrum of approaches. We contacted all the returning designers to ask them what has happened to their portfolios and them (professionally) in the six years since we first did.

Complementing the case studies are interviews we conducted by email with 25 professional designers and educators—eight of them new additions from the first edition. All of them have been in the industry for a decade or more, and have had plenty of experience reviewing portfolios and conducting interviews. We posited various useful questions, about their expectations of students' and young designers' portfolios; common mistakes made; the most memorable portfolios they've seen; and even thoughts about their own first portfolios. The results of these interviews have been grouped by question, so that you may see what different designers, in different industries and parts of the world, think of the same issue—they are grouped towards the end of the book under the title of "INTERVIEWS WITH THE INTERVIEWERS."

Additionally, over the course of two weeks, we conducted two parallel surveys online: one targeted at designers showing their portfolios in interviews, and the other at designers who are reviewing the portfolios of prospective employees. We asked the same questions of each group, slightly modified to fit each of their roles, so that we could compare what an *interviewee* thinks are the best practices against what an *interviewer* does. For example, a modest amount of interviewees think

I liked the idea of Bryony's leave-behind and created ten small versions of the book to be sent in trendy metallic bags.

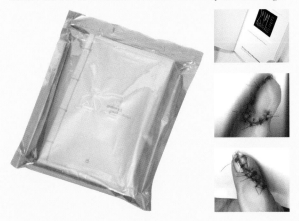

The hard work took its toll on Bryony's finger but it helped me get a job in Chicago, IL, at Norman Design in 2001.

A JOINT EFFORT

In 2004, when we set out to move to New York, NY, we decided to make the structure of our next portfolio identical—a perfect-bound, cloth-covered book with heavy, cream-colored paper, vellum and inkjet prints—each with its own visual language.

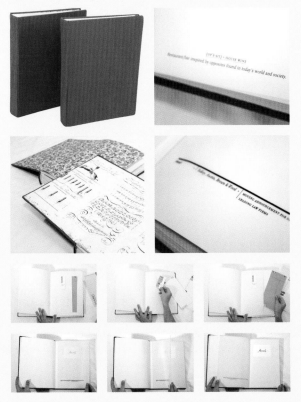

Both portfolios performed as desired, getting us jobs at Addison (for Bryony) and Decker Design, followed by Pentagram (for Armin).

No further portfolios have been created since.

it's appropriate to make first contact with a potential interviewer in person, but responses from interviewers demonstrate that only a *very* small amount of them think this is appropriate. The surveys are far from what would be considered rigorous research but, with 550 interviewee and 270 interviewer responses, we feel this is moderately representative of the larger constituency of the design profession. The results of the interviews are charted under the title of "CENSUS OF PORTFOLIO ETIQUETTE."

A new section in this edition focuses on a sampling of 18 self-promos—mailers, leave-behinds, handouts, etc.—that designers use to get potential employers' or clients' attention. A wide range of self-promos are included to show the multiple approaches possible, from a highly targeted mini-portfolio teaser to a mock hamburger box.

Lastly, another new section, "PHOTOGRAPHING YOUR OWN WORK," goes in sometimes painstaking detail about how designers do the best job they can to photograph their work consistently, handsomely, or at the very least convincingly. We share our own tips and have recruited four other designers to reveal how they capture their work and the post-production process they go through.

We hope that the book's components provide a useful resource, and will serve as a springboard to as many designers as possible, from students on the brink of graduation, to young designers questing toward their first or second jobs, to more experienced designers on their way up the title ranks, to freelance and independent designers in their search for clients, and to any other creative individuals—photographers, illustrators, product designers, architects, and more—as they strive for the best possible way to present their work.

Best of luck,

Bryony Gomez-Palacio + Armin Vit
PRINCIPALS, UNDERCONSIDERATION

Portfolio case studies

In-depth analysis behind the process and motivation of 41 different portfolios.

Nikolaus Schmidt

I CREATED THIS PORTFOLIO WITHIN A PERIOD OF TWO WEEKS IN APRIL 2008, AS A RESPONSE TO A CHALLENGE POSED BY A FRIEND OF THE FAMILY WHO WAS LOOKING THROUGH MY WORK.

STATUS

It is still in use in its natural condition, however people first have a look at the website.

APPROACH

I had a meeting with a well-connected person within the creative industry, and showed him original samples of my works, consisting of cards, flyers, annual reports etc. He replied: "Nice work, but it would have been much better if you'd presented it in a more compact way to highlight your very own approach to graphic design. Come back in two weeks and show me something extraordinary which I'm able to hand over to decision makers." So I produced the book and had one meeting with the head of a publishing house, but unfortunately no job arose. Nonetheless I was very satisfied with the final result of my portfolio book.

I considered a lot of different formats and production techniques. Trying to keep the production costs low on the one hand and to produce something really nice on the other hand seemed to be a difficult task. In the end it was far too expensive, however the result was satisfying.

Trying to stay true to yourself and focus on the content rather than to produce some trendy piece of work was a tricky part. I stuck to my principles, and took this chance to experiment and create something that reflected my personality, as well as my approach to graphic design. The core concept was to design a portfolio with the ability to grow over a period of time, while incorporating as many different production techniques while staying within budget. The book was carefully crafted, keen on details, made good use of typography, and, of course, maintained tactility. Thinking more about a rough and tactile sketchbook, as opposed to a glossy sales brochure, I used grey cardboard for the cover, and a mixture of coated and uncoated paper for the inside pages. The title on the cover was set by hand using good old Letraset.

FLEXIBILITY

As designers, we are all in a constant process of change and personal development. I chose to use screw-post binding which allows for maximum flexibility.

DISPLAY

Always in person.

MEMORIES

I have to admit that most commercial clients prefer a glossy brochure to a hand-bound book. From time to time I thought about producing an updated version but the Internet made it somehow obsolete.

LOOKING BACK (5 YEARS LATER)

Although I am still convinced it was a good thing to produce the portfolio book back then, I have to admit that I didn't get a single job because of the book itself—it merely acted as an amplifier. However, despite all this, a printed piece of design will always be more valuable to me than a fancy looking website or a PDF portfolio. I can hardly think of anything comparable to the smell of ink and paper, and the joy of flipping through the pages of a nicely produced book.

ABOUT

Nikolaus Schmidt is a graphic designer based in Vienna, Austria. Schmidt graduated from London College of Printing with honours and set up his studio in 2007. Schmidt is working in a wide range of media, from brand identity and editorial design, to web and screen design as well as environmental design.

> Working on self-initiated projects is more demanding than working on commissioned projects, especially when you have to put together your very own reference works.

PRODUCTION DETAILS

STRUCTURE	DIMENSIONS (IN.)	PRINTER	PRODUCTION TIME	PRODUCTION COST
Screw-post book	8.2 × 11.6	HP Indigo	2 Weeks	$1,500

MATERIALS	SPECIAL TECHNIQUES	VENDORS	RETAIL STORES	TYPEFACES
Alterna	Laminating	—	—	Avant Garde Gothic
Grey board	Letraset			Monospace 821
FIZZ				

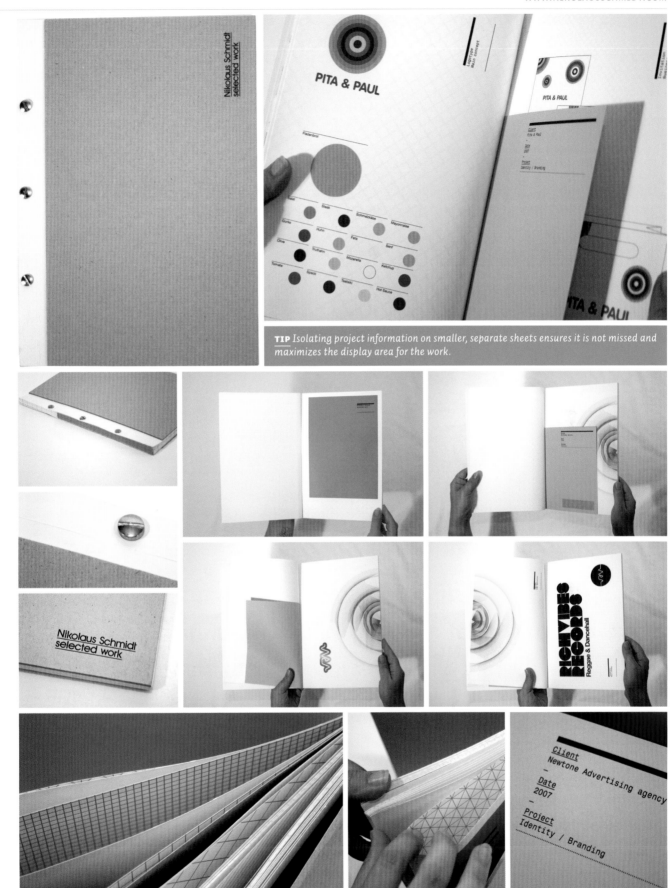

TIP Isolating project information on smaller, separate sheets ensures it is not missed and maximizes the display area for the work.

Josh Berta

I CREATED THIS PORTFOLIO IN THE SPRING OF 2005, IN MY FINAL QUARTER AT PORTFOLIO CENTER. IT WAS ORIGINALLY CREATED TO ATTRACT ATTENTION IN THE JOB MARKET, BUT I WON A FULL-TIME POSITION AT PENTAGRAM THAT BLOSSOMED FROM AN INTERNSHIP WITHOUT EVEN SHOWING IT.

STATUS

I did not use the portfolio immediately after school, but in the fall of 2007, when I began job hunting. I updated it with some professional work and used it in interviews. It is now inactive. Frankly, now that I show work on an iPad, I don't have much need for the portfolio in its current form. However, it would be very easy to update the case by removing the book and including more physical samples, if a potential employer wanted to see them.

APPROACH

Portfolio Center has a seemingly rigid formula on how to make a portfolio: a custom-made box, with a custom book, and trays that retain handhelds. Many students follow this prescription blindly, but I sensed the shortcomings and rethought my approach based on my economic limitations.

So, instead of a custom-made, expensive portfolio box, I purchased a camera case and modified it to fit my purpose. I made the book myself, devising a front and back cover with book board and cloth, using post-screws to sandwich the Epson-printed pages. I also made pocket pages to hold letterhead suites and other printed samples, and simple accordion folded pages to show larger poster series. Instead of special trays, I used sheets of foamcore with elastic loops to secure my various-sized handhelds.

ONLINE

I do have a web portfolio. The layout is very simple. The primary commonality, other than the work, is the use of Trade Gothic Condensed, and the black and white palette.

LASTLY

One of the most crucial bits of guidance I got was to make my book as diverse as possible. That means I show a variety of pieces in my book, geared toward a wide audience, without limiting myself to one apparent area. Since then, I try to share this advice with anyone whose book I'm reviewing.

I also strongly feel that student work should look like professional work. That is to say, the work should suggest knowledge of how to make things in a professional, real world setting. I have no interest in seeing Type 101 exercises in a student portfolio.

LOOKING BACK (5 YEARS LATER)

Using an iPad has been a much easier choice for me. It does require me to photograph my work though, and that can be hard to keep up with. For young designers, I would still recommend bringing actual comps and samples, unless their work is entirely digital.

ABOUT

Josh Berta is a graphic designer in New York, NY, currently working at VSA Partners. Berta has a BFA from the School of the Art Institute of Chicago and attended Portfolio Center in Atlanta, GA. Berta has worked full-time and as freelancer for many NY firms including Pentagram, Piscatello Design Centre, Open, Landor, Sullivan, and DBOX. Berta is a father of two girls. Berta also instagrams and blogs occasionally.

In the end, showing fully-realized comps and/or actual printed pieces makes for a more complete overview of the work, and I think interviewers appreciate that.

PRODUCTION DETAILS

STRUCTURE	DIMENSIONS (IN.)	PRINTER	PRODUCTION TIME	PRODUCTION COST
Case with screw-post book and trays	Case: 13 × 18 × 6.75 Book and trays: 16.5 × 11.5	Epson 1280	4 Months Updates require 8-12 hours	$450
MATERIALS		**PAPER**	**RETAIL STORES**	**TYPEFACES**
Vanguard camera case Foamcore Book board	Book cloth Elastic cord Thread	Epson, matte, heavyweight	Michaels Sam Flax	Trade Gothic Condensed

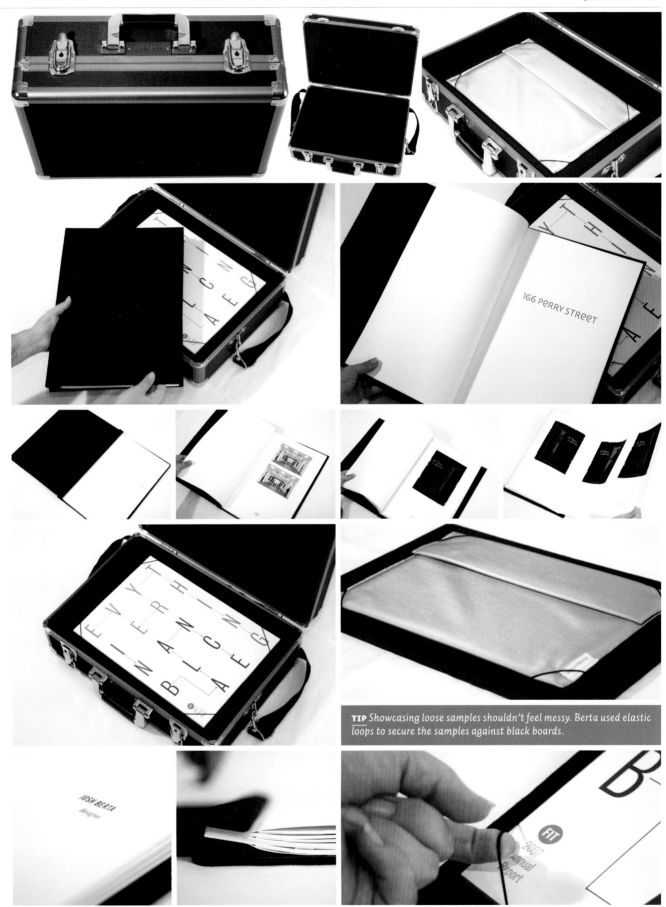

TIP *Showcasing loose samples shouldn't feel messy. Berta used elastic loops to secure the samples against black boards.*

Brian Neumann

I WAS GRADUATING ART SCHOOL IN LATE 2009 AND WANTED TO IMPRESS ANY POTENTIAL CLIENT OR EMPLOYER WITH A HIGH PRODUCTION PIECE. THIS WAS A PERSONAL PROJECT DRIVEN BY MY OWN OBSESSION AND DESIRE TO BE A GREAT DESIGNER, AND MY SEARCH FOR A JOB—AND I DIDN'T WANT TO START AS A JUNIOR. I WAS ABLE TO ACHIEVE BOTH GOALS BEFORE GRADUATING DUE IN LARGE PART TO THIS PIECE.

STATUS

I've updated the résumé, poster, and flash drive contents but I still use this five years later! It still delivers on its original intent to showcase a layered and elaborate but cohesive presentation of my work and design intentions.

APPROACH

I was married to the concept of something outrageous, decadent, and different to what everyone else was doing. I experimented with raw grey board but it ultimately wasn't as versatile as the chipboard which acts as the portfolio container. I also used chipboard for my business cards and note cards. It took quite a while and probably a half-dozen prototypes before getting all of the measurements dialed in and components fitting together. I used Neenah Classic Crest for the letterhead, envelopes, and poster. There is a decent amount of hand work including map folding, notecard rubber band placement, hand embossing, and then putting in the flash drives, business cards, résumés, and posters into the case, then finishing with a large rubber band and notecard.

FLEXIBILTY

Because the container only contains high level information, and the fact that all of the components are removable, this portfolio remains completely updateable.

DISPLAY

I have mailed out dozens of them and also handed them out in person. I wanted something that was a leave-behind to keep me top of mind.

MEMORIES

The perforated bookmark (which has my URL for a playful take on that) was done with a hand-cranked vintage machine that had the round punches—that is a nice detail.

ONLINE

My URL is clear on many of the portfolio pieces and is designed to be the fullest representation of my portfolio of work. My portfolio, as I have approached it, is a representation of capabilities and is a designed piece that reflects my work as opposed to just showing all of my work. The hope is that by being an intriguing well-crafted piece of design the recipient would then visit my website to view my completed projects. Kind of a tease, if you will.

LASTLY

So often I see other designers' work only in the digital space. Everyone has a website. I think that a website is an important and critical component to your overall "portfolio" but I'm still a fan of the tactile and still find it relevant. Taking a moment to pause and think about how to stand out while representing your work has proven really valuable to me; I highly recommend it.

ABOUT

With a deep love of an organized desk, good coffee, and a very specific pencil, Brian Neumann is motivated by excellence and deliciousness. This is carried over in to his work, which Neumann crafts with great intention, understanding, and a high aesthetic standard that yields results. Neumann is known for his work ethic, approachability, and efficiency within the realms of design and branding. Neumann has a thorough understanding of all media, from mobile to web design, to complicated and highly technical printing techniques.

When you're making work for yourself it's such a great time to explore territory that helps you learn and grow.

PRODUCTION DETAILS

STRUCTURE	DIMENSIONS (IN.)	PRINTER	PRODUCTION TIME	PRODUCTION COST
Pocket folder	Folder: 9 × 12.5	Letterpress	2 Months	$1,700
	Poster: 17 × 32			

PAPER	VENDORS	RETAIL STORES	SPECIAL TECHNIQUES	TYPEFACES
Chipboard	Foils + Dies	Pantone	Foil stamping	Gotham
Neenah Classic Crest	Vintage Pressworks	Uline	Etching	Gotham Narrow
			Hand embossing	

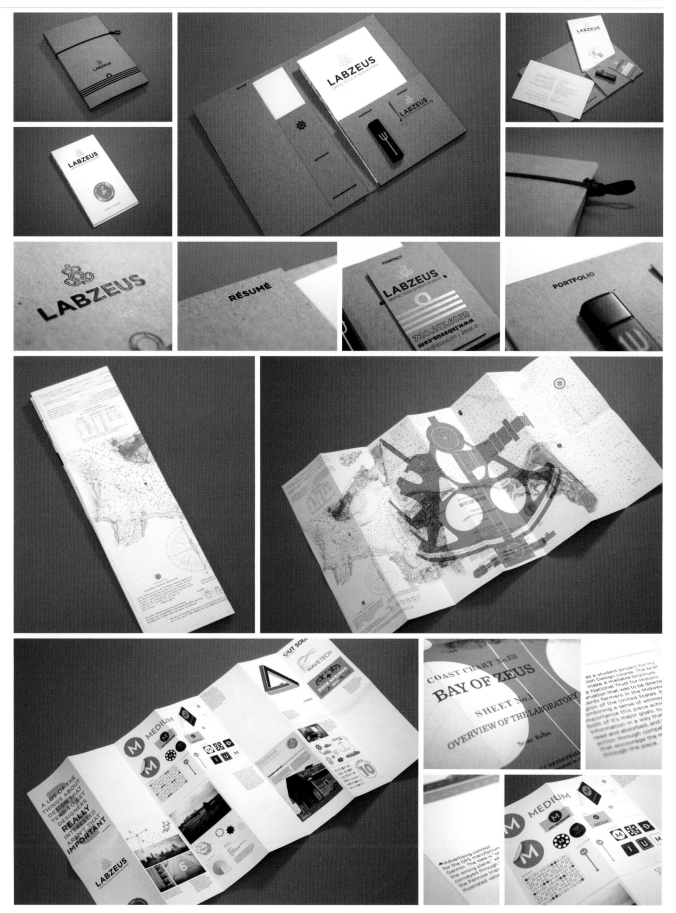

Peter Synak

THIS PORTFOLIO WAS CREATED DURING A UNIVERSITY PORTFOLIO CLASS IN 2008. IT CONTAINS A SELECTION OF MY BEST SCHOOL PROJECTS, AIDING ME IN MY JOB SEARCH AFTER MY UPCOMING GRADUATION. IT WAS MEANT TO REMAIN AS A PERSONAL BOOK COMMEMORATING MY TIME AT SCHOOL, AS WELL AS CATALOGING MY FAVORITE PROJECTS.

STATUS

I used this portfolio for several months after my graduation in 2008— it helped me launch my career during a challenging time with an economical decline as I was able to find a position as a junior designer that I was very excited about. It is now archived.

APPROACH

The book format in itself was part of a graduation class assignment. My particular theme came about as a means for cohesiveness and out of a personal interest in a simple approach to design. Thematically it supported my personal point-of-view for designers to convey information with the most clarity of intent. I've supported this thought with introductory pages printed on see-through vellum combining written words to the visible photographed project underneath.

Selecting all the materials was an exercise executing on the established theme. The vellum sheets layer information offering enough space for large photographs that are meant to speak for themselves. The paper I choose was a white and textured paper of a collection inspired by Charles and Ray Eames to add an interesting texture that I personally enjoy when flipping through books.

FLEXIBILITY

It wasn't intended to be updated at that time or in the upcoming years, as it was a stepping stone to launch my career in design, and partially to commemorate a particular time in my career leaving school, and transitioning into a new stage for myself. I intended to add future accumulated projects in a new portfolio, at a different stage of thought and philosophy towards what design means to me.

DISPLAY

First I sent postcard teasers showcasing different project to spark interest and gain invitations to present myself and the rest of my work. During interviews, I passed out two copies of the book while voicing over all projects either as a presentation or based on questions if I had sent it out pre-interview.

ONLINE

I did not add an online version at that time. Today I don't think this would be possible, as online portfolios are a standard and make it much easier for an employer or possible client to discover a designer.

OTHERS

Over the years I have collected and presented more recent projects when I had interest in new ventures. Most of my current body of work is a collection of digital projects which required a digital representation.

ABOUT

Currently Peter Synak is a Senior Designer at a San Francisco, CA-based startup working on new technology-related ventures focusing on bringing technology closer to people in developing countries. In the past, Synak worked as a freelance designer with various startups and as a staff designer at Ammunition and Method in San Francisco. In past years Synak has mostly worked with technology-related brands such as Adobe, Google, Microsoft, Samsung, Sonos, Autodesk, Barnes & Noble, Beats by Dre, and a few other interesting folks helping them to engage with their audiences.

PRODUCTION DETAILS

STRUCTURE	DIMENSIONS (IN.)	PRINTER	PRODUCTION TIME	PRODUCTION COST
Perfect-bound book	9.5 × 12.5	Epson Stylus Photo R1800	2 Weeks	$500 Multiple copies
MATERIALS	**PAPER**	**VENDORS**	**SPECIAL TECHNIQUES**	**TYPEFACES**
Cardboard Book cloth	Neenah Eames Solar White, 24lb text Canson Vidalon Vellum, 55lb text	The Key Printing & Binding	French fold	Helvetica Neue 45 Light, 55 Roman, and 75 Bold

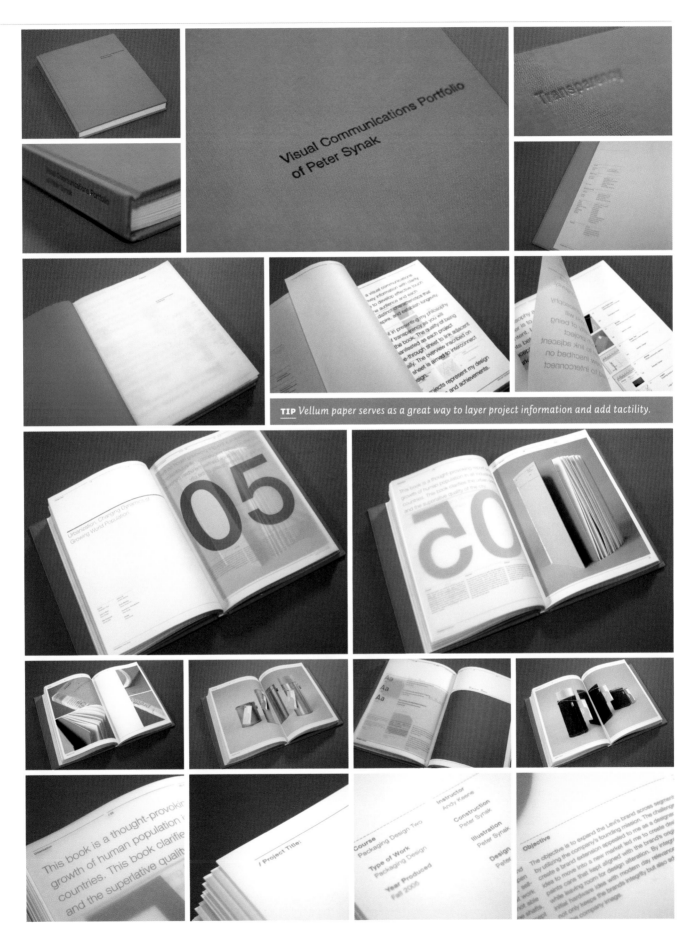

TIP *Vellum paper serves as a great way to layer project information and add tactility.*

Rachel Tranello Majka

I CREATED MY PORTFOLIO IN APRIL OF 2009, JUST WHEN I WAS GRADUATING FROM PORTFOLIO CENTER, IN ATLANTA, GA. I WANTED TO HAVE A VESSEL FOR MY WORK, BUT I ALSO WANTED IT TO TELL A STORY AND BE A REPRESENTATION OF MYSELF IN SOME WAY.

STATUS

Active.

APPROACH

I wanted something that was easy to carry, versatile, and functional. I looked for a shoulder bag but the options I came across were falling flat. It was then I realized I had my own vision that I wanted to execute. In my search I stumbled upon items made out of sails, a material close to my heart and my roots. My grandfather bought a boat the year I was born. Twelve years later—complaining that no one wanted to go out on the boat anymore—he rigged the 25-foot boat to sail solo. I saw that kind of stubborn determination in myself, so I grabbed at this inspirational history and went to work.

I used the jib sail from my grandfather's sailboat—he'd replaced it with a motorized one—and marine-grade vinyl with brass hardware, including the original jib hanks from the sail. I was able to get technical drawings made from my design. After talking with a range of people—from seamstresses and tailors, to industrial luggage manufacturers—I found a woman who was able to make it for me.

FLEXIBILITY

I designed it with removable dividers, so I could use it as a regular messenger bag if I wanted to. I have since removed the dividers, and I'm using the two main compartments.

DISPLAY

I only show it in person. It's unique and irreplaceable.

MEMORIES

I love people's reactions after they've seen it and I tell the story behind it. The best reaction was from my grandfather—he was thrilled with the result. I asked if it was what he'd expected, and he replied that he didn't know what to expect.

ONLINE

I have a website that shows my work but makes no mention of my portfolio. I like the idea of saving something unique for the interview.

LOOKING BACK (5 YEARS LATER)

Over the years, I've added many more digital pieces to my portfolio, so I've had to evolve how I present my work. I still use this portfolio, as it is a great way to bring printed pieces to life in the book—I was once commended on an interview for bringing large format prints along with digital media. Looking back, I remember all the difficulties and complications that were overcome to create this portfolio, and it serves as a personal reminder that there is no task too great to conquer.

ABOUT

Rachel Tranello Majka is currently working as an Art Supervisor at FCB in New York, NY. Tranello Majka has an Associate degree in applied science in business marketing from Alfred State College, and a Bachelors degree of science in communications from College at Brockport, SUNY, in addition to a degree in copywriting, art direction, and photography from Portfolio Center, in Atlanta, GA. Clients include GMC, Buick, Raymour & Flanigan, Merck Vaccines, Pfizer, Leo, and Auxillium.

> I love people's reactions after they've seen it and I tell the story behind it.

PRODUCTION DETAILS

STRUCTURE	DIMENSIONS (IN.)	PRINTER	PRODUCTION TIME	PRODUCTION COST
One-of-a-kind bag with loose samples and a perfect-bound book	19 × 14 × 7	Epson Stylus Photo 2880	3 Months	$260

MATERIALS	PAPER	VENDORS		TYPEFACES
Jib sail Marine-grade vinyl	Red River, Polar matte, 60lb	Technical Drawings: Jason Drew	Production/seamstress: Sylvia Cadle	—

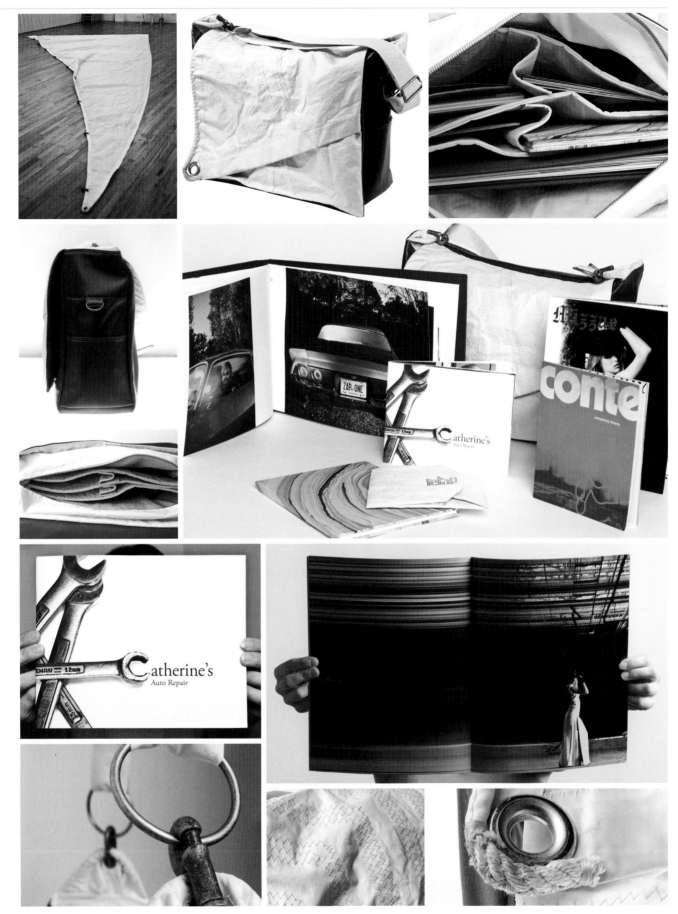

Jonathan Selikoff

I CREATED THIS PORTFOLIO IN MID-2002, WHEN I DECIDED TO LEAVE MY JOB AT LANDOR. IT WAS MEANT TO BE SHOWN TO POTENTIAL FREELANCE CLIENTS, AS I WASN'T LOOKING FOR A FULL-TIME JOB.

STATUS

I used it for at least two or three years. Occasionally, I'll still show it, but I haven't updated it since it was first made.

APPROACH

I had very few real print samples, so a box with scattered samples wasn't really an option. I've always appreciated the small leave-behind books that design graduates tend to put together, and wanted something that felt a little personal. Also, I didn't want to lug something big around. I developed two books—one for logos, and one for packaging and print-based projects.

It was made as cheaply as possible. I got some free Esse paper samples from Gilbert to use for the covers, and the interior pages were all done on a Canon laser copier with tabloid-sized paper. To avoid the difficulty of printing on both sides of the page, the entire book was french-folded, and bound with a silver Wire-O. For the covers, I printed up little name tags, hand-debossed the covers, then glued them in place. The final touch involved block-printing a large red capital "S" from my wood type collection.

FLEXIBILITY

Not really flexible. In order to re-do it, I would have had to cut off the binding. That is the negative aspect; there's just a limited lifespan to it. However, I could print new pages, cut the binding off, and reuse the covers.

DISPLAY

Since it is mostly used towards winning potential clients, I always present it in person.

ONLINE

I had a PDF mini-book that I could email as needed, where the red "S" from the cover was carried through. I've since developed a website for my business, and the letterpress "S" is at the heart of my identity.

PREVIOUSLY

My student portfolio, which I kept very simple, was made out of 11-by-14-inch boards with photographic prints. I eschewed transparencies, which were popular at the time. Logos were presented as white rub-down transfers on the boards. These got a pretty good reaction from interviewers, although I nearly had a heart attack when one interviewer, intrigued by the process, rubbed her fingernail over the transfer. Thankfully, no damage was done.

LASTLY

My ideal portfolio is practical. My student portfolio was a reaction to the overproduced books I had seen done at the time; books with precious shelves and drawers for each sample, and big boxes requiring custom backpacks or luggage strollers. Too much! One student even had a small light table built into the case to view transparencies. I appreciate attention to detail and the desire to create something special to showcase one's work, but there's a point where it becomes more about the case than the work. Besides, you sweat enough when looking for a job. Why work up extra perspiration carrying around something gigantic?

LOOKING BACK (5 YEARS LATER)

It worked for its intended purpose, which was to share with potential clients and agencies after I had left my job. I made a mini version of it to take to a trade show to show prospects and we netted a few clients from it, so it achieved its objectives. I haven't used anything beyond an online portfolio in years.

BIO

Jonathan Selikoff is a creative director, designer, and printer in West Orange, NJ, where he founded Selikoff+Company in 2002 and Vote for Letterpress, a letterpress print studio, in 2010. Selikoff holds an undergraduate degree from Emory University and did his design training at Portfolio Center in Atlanta, GA. Prior to founding his studios, Selikoff worked for Landor Associates in New York, NY, and Hamburg, Germany; Cornerstone Branding, Spring Design Associates; and Wages Design.

I nearly had a heart attack when one interviewer, intrigued by the process, rubbed her fingernail over the transfer. Thankfully, no damage was done.

PRODUCTION DETAILS

STRUCTURE	DIMENSIONS (IN.)	PRINTER	PRODUCTION TIME	PRODUCTION COST
Wire-O-bound book	Logo book: 6 × 6 Print book: 8.5 × 11	Canon color Laser printer	A few days	$30

MATERIALS	PAPER	RETAIL STORES	SPECIAL TECHNIQUES	TYPEFACES
Ink	Cover: Gilbert Esse Interior pages: Strathmore, Writing, white	Paper store Sam Flax	Hand block-printed cover	Scala Sans

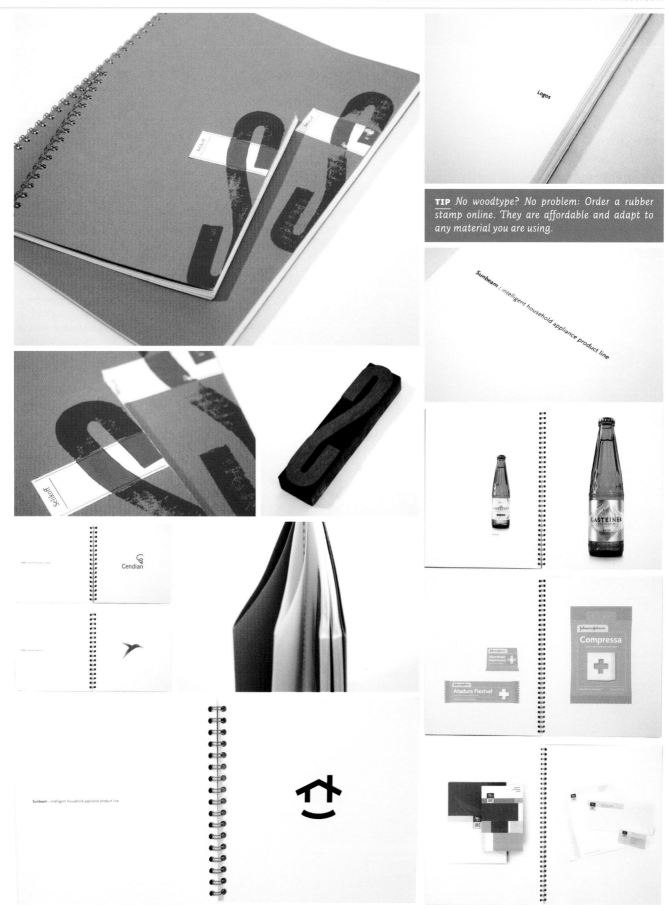

Logos

TIP No woodtype? No problem: Order a rubber stamp online. They are affordable and adapt to any material you are using.

Sunbeam : intelligent household appliance product line

Cendian

Sunbeam : intelligent household appliance product line

GASTEINER

Compressa

Atadura Flexível

John McHugh

IN 2010 THE SMALL AGENCY AT WHICH I HAD BEEN WORKING NOTIFIED ME IT WOULD BE CLOSING THE DOORS IN SEVERAL MONTHS FOLLOWING A ROUGH PATCH DURING THE ECONOMIC RECESSION. I HAD THE LUXURY OF KNOWING BY WHEN I NEEDED TO FIND A NEW GIG AND DECIDED TO USE THE TIME I HAD TO DEVELOP A REALLY COMPREHENSIVE SHOW PIECE TO HELP ME LAND A NEW JOB.

STATUS

I used this particular book as a promotional piece during my job search that lasted about two months in the late summer of 2010.

APPROACH

I've had the opportunity to work on a range of different types of projects spanning advertising, interactive, and print, but my passion really lies with branding and corporate identity work. I wanted to develop a piece that illustrated that type of work I've done—and wanted to do—in a compelling way while at the same time allowing me another vehicle to extend my own personal brand. I settled on a nicely printed and packaged book that I believed would stand out in a job market that is increasingly dominated by email and social media. It's very easy to ignore a link, but it's very difficult to look past a nicely produced piece of work you can hold in your hands. You have to, at the very least, acknowledge its presence before throwing it away.

The piece was mailed along with my résumé and a personal letter in see-through foil envelopes sealed with custom printed Avery labels.

FLEXIBILITY

This was a one-and-done type deal. I had only ordered enough stock to do a limited run of 40 books (though I did run a second edition on different stock for a few interested parties).

DISPLAY

The books were all sent by mail and (I assume) delivered to the correct recipients, though I had a few anecdotal responses from people who admitted to snagging them out of an overflowing mail slot or coworker's desk if they sat too long unopened or unattended to.

MEMORIES

None specifically, though I found the overall reception favorable and received some nice words. And eventually a job.

ONLINE

This portfolio served as a deeper look into a smaller selection of some of my work than I typically had showcased on my portfolio site—which was quite broad at the time, yet relatively shallow when it came to giving background on each project. I would follow-up the book in person with a PDF featuring several case studies that introduced more context from a business case and design solution aspect.

OTHERS

Absolutely, in some shape or form be it my website, or a promotional PDF that can be emailed around. This however was my only printed portfolio to date (not including any printed sample pieces of my projects that I've shared in the past).

LASTLY

I had reached out to Armin Vit early on during my job search mainly because I knew that he had worked in the same field (branding and design) in the same city where I had been mostly targeting my search (New York, NY). I was really just looking for some feedback and advice. He graciously responded and requested me to submit the piece to FPO to be featured. The extra publicity I received from him sharing my work on his site was (and continues to be) invaluable.

ABOUT

John McHugh is a designer specializing in strategic design and branding initiatives. McHugh currently heads the design group at Arnold Worldwide in Boston, MA, where he serves as Design Director helping brands discover and communicate their direction and purpose is his passion. With over 13 years of design and corporate identity experience, before joining Arnold Worldwide McHugh led design engagements at Avenue, a strategic marketing and communications firm focusing on B2B brands, based in Chicago, IL. Prior to that, McHugh worked as a designer with Interbrand in New York, NY, and has had experience working in UX, interactive, print, advertising, and branding. McHugh has worked with a range of leading companies such as AT&T, Boeing, Cars.com, Jack Daniel's, Kyocera, New Balance, Progressive, and Santander. A Baltimore native, McHugh currently lives in Salem, MA, with his fiancée Jessica and their labrador, Lincoln. McHugh studied graphic and industrial design at Lehigh University.

PRODUCTION DETAILS

STRUCTURE	DIMENSIONS (IN.)	PRINTER	PRODUCTION TIME	PRODUCTION COST
Saddle-stitch book	8.5 × 11	HP Indigo 5500	6 Days	$386.69
MATERIALS	PAPER	VENDORS	RETAIL STORES	TYPEFACES
—	Cover: French Paper, Dur-o-tone, Butcher Blue, 100lb cover Interior: Finch Paper Fine iD, 100lb text	Indigo Ink	Jampaper.com	CP Company

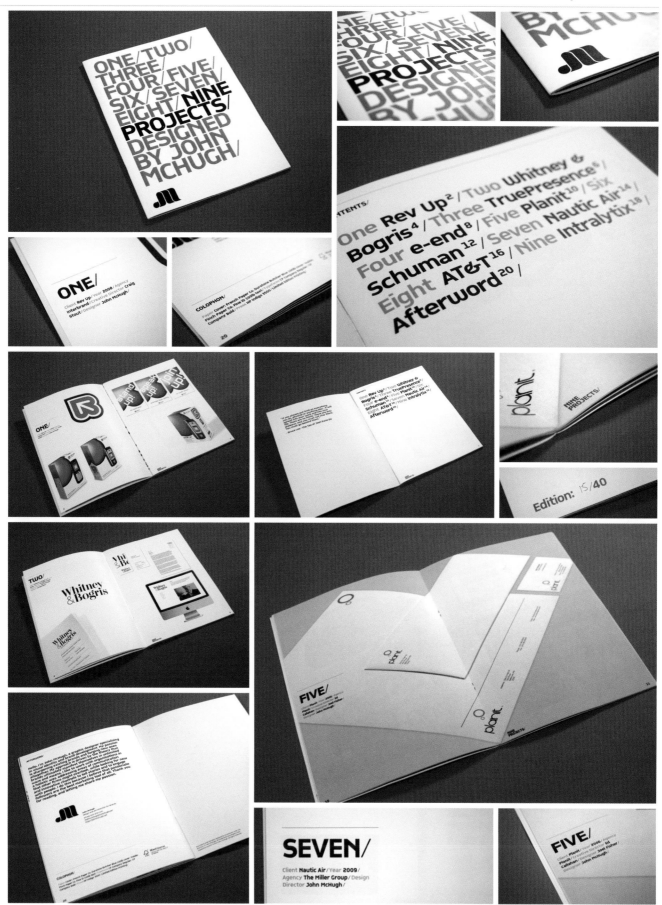

Tomas De Carcer

I CREATED THIS PORTFOLIO IN 2013 FOR A CLASS WITH SCOTT STOWELL TITLED "EXPLAINING YOURSELF," DURING MY MFA IN DESIGN ENTREPRENEURSHIP AT SCHOOL OF VISUAL ARTS.

STATUS

I still have the *Exposé* coat but I only presented it once for class. I intended to use it for my portfolio review at the Art Directors Club.

APPROACH

Scott Stowell challenged us to show our work in a very personal way. This was actually the first time I collected and "exposed" my work to others. Playing with the idea of exhibitionism, I titled this portfolio *Exposé*, in the sense that it is the act of finally revealing myself to the public. With the treatment of a walking gallery show, my projects were printed on fabric and sewn into the lining of a trench coat. I had to design the portfolio in a way that would showcase the full range of my work. There are pockets for actual printed books and a mini iPad to show my digital projects.

I bought the coat from a Goodwill thrift shop, took the measurements, and created a digital template of the lining. I printed tests on paper first, and then directly on fabric for the final piece.

FLEXIBILITY

My initial idea was to be able to add more projects on the coat by printing and sewing on patches, which would make it look even more like a real utility coat. The iPad also allows me to update my digital work whenever I want.

DISPLAY

This has to be shown in person.

MEMORIES

It was funny when I was in the classroom wearing only my underwear and the coat. No one knew what I was going to show.

ONLINE

They don't complement each other because I designed this coat to be something separate from my website. Now that I think about it, I will definitely try to do something to link both of them.

OTHERS

I also created a printed book with a selection of my works.

ABOUT

De Carcer is a designer from Santiago, Chile, with a compulsive habit of sketching and making now living in Brooklyn, NY. Prior to moving to New York, De Carcer worked in communications design and branding in Chile and Argentina for studios Kid Gaucho and Iv Estudio. De Carcer studied design in both Barcelona, Spain, and Santiago, Chile, before completing his MFA in Design at School of Visual Arts. His strengths lay in visualizing data, illustration, and branding, with award-winning projects featured both online and in print. De Carcer is happiest prototyping and finding new ways of provoking his audience through thoughtful design. His everyday passions often become UX design projects, such as his love for bicycling led to creating Chain Gang—an adventure-based mobile app that rewards cyclists for exploring New York City. Currently, De Carcer is a freelance designer.

> You always think that it would take less time but it's always more work than you expect. But don't worry, you can always improve and build on it; your portfolio will never be finished.

PRODUCTION DETAILS

STRUCTURE	DIMENSIONS (IN.)	PRINTER	PRODUCTION TIME	PRODUCTION COST
Rain coat	58 × 50	Fabric/textile printer	2 Weeks	$250
MATERIALS	PAPER	VENDORS	RETAIL STORES	TYPEFACES
Cotton fabric	—	first2print	—	Vitesse
iPad		Nelson		Tungsten

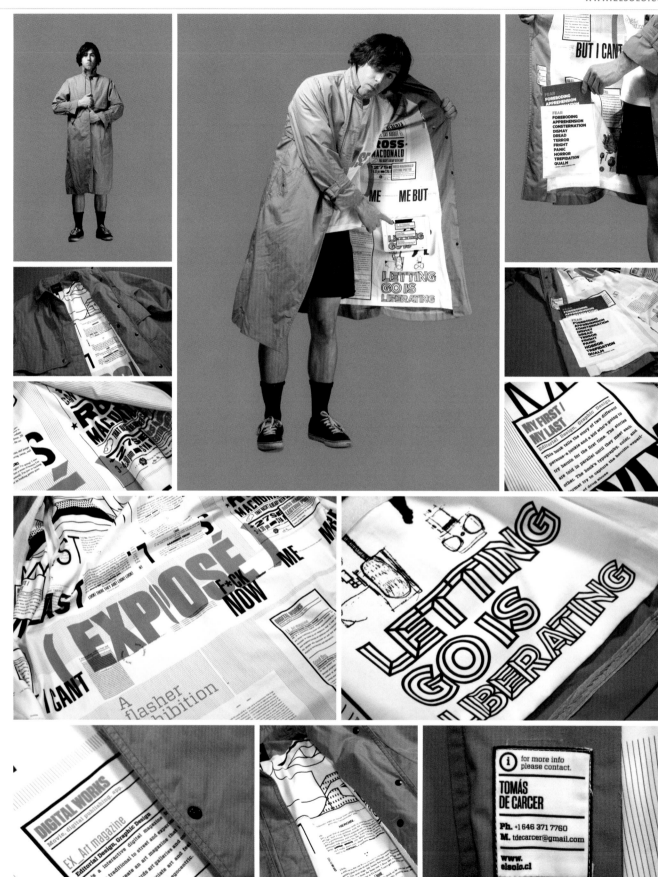

I CREATED THIS PORTFOLIO IN THE SPRING OF 2008, WHILE WORKING AT CBX IN NEW YORK, NY. IT WAS THE FIRST VERSION TO REPLACE MY GRADUATING PORTFOLIO FROM SYRACUSE UNIVERSITY. I CREATED THIS BOOK IN ORDER TO FIND MY NEXT JOB, AND TO CREATE A PERMANENT SNAPSHOT OF MY WORK UP UNTIL THEN.

STATUS

I used it for four months before landing a job at Brand Union.

APPROACH

Since I can remember, I have used this system of logos: the "A" in my name is a different design tool for each touchpoint. My favorite one has always been the X-Acto knife, which was my inspiration for the metal book covers that are composed of laser-cut, bead-blasted, anodized aluminum. The previous portfolio covers were brushed stainless steel, which turned out to be very heavy and picked up too many fingerprints.

Because of the rather unconventional dimensions (9.5 × 13-inches), a completely arbitrary size seeking uniqueness, I could not find any stock binding solution. I found an oversize artist's paper book, from which I stripped the coil off every time I modified the portfolio—a $19.99 binding fee, plus the burden of using one hundred loose sheets of bright white drawing paper.

FLEXIBILITY

In theory it is updateable. The covers are permanent, and the pages can be punched at very specific office stores and copy centers. Unfortunately, I use page numbers in my design, so any new work requires complete repagination. It is impractical, but I love it. I won't have it any other way.

DISPLAY

Mostly in person. My website should suffice when a personal interview is not possible.

MEMORIES

After I graduated from college, I flooded New York City with little employee care packages. I spent over an hour on each, and most firms received several. I went to an interview at Interbrand and they asked me to wait in their cafeteria. While I was sitting there, I overheard two people talking about this cool mailer that someone received with a "Sam" logo. One said to the other, "Oh, neat. We should really bring this person in for an interview one day."

ONLINE

The physical portfolio is a labor of love. The website, on the other hand, is a functional necessity. Most places I applied to required a website in order to be considered for an interview. My portfolio and website share the SAM brand look and feel. The similarities, however, end there. I approached each medium differently, but with a similar goal: to provide an effortless way for someone to see the breadth of my work and the seriousness of my application.

LOOKING BACK (5 YEARS LATER)

My next portfolio was an iPad app. It used more of a traditional slide format embedded in an application I developed. While it was more conventional than my previous portfolio in its design, it still served as a custom expression of my design experience and embodied my general way of thinking.

ABOUT

Sam Becker is a Creative Director at Brand Union in New York, NY. Becker studied communications design at Syracuse University. After school Becker got his start in Crate & Barrel's graphics department, and later worked for design agencies CBX and Interbrand. Becker Tweets at @sambecker, and Instagrams at @smam.

PRODUCTION DETAILS

STRUCTURE	DIMENSIONS (IN.)	PRINTER	PRODUCTION TIME	PRODUCTION COST
Wire-O-bound book	9.5 × 13	Epson Stylus Photo 1400	—	$750
MATERIALS	PAPER	VENDOR	RETAIL STORES	TYPEFACES
Aluminum covers	Moab Entrada, double-sided matte inkjet, 300g/m2	Unique Copy Center Advanced Laser and Waterjet Cutting	—	Apex Sans Dolly

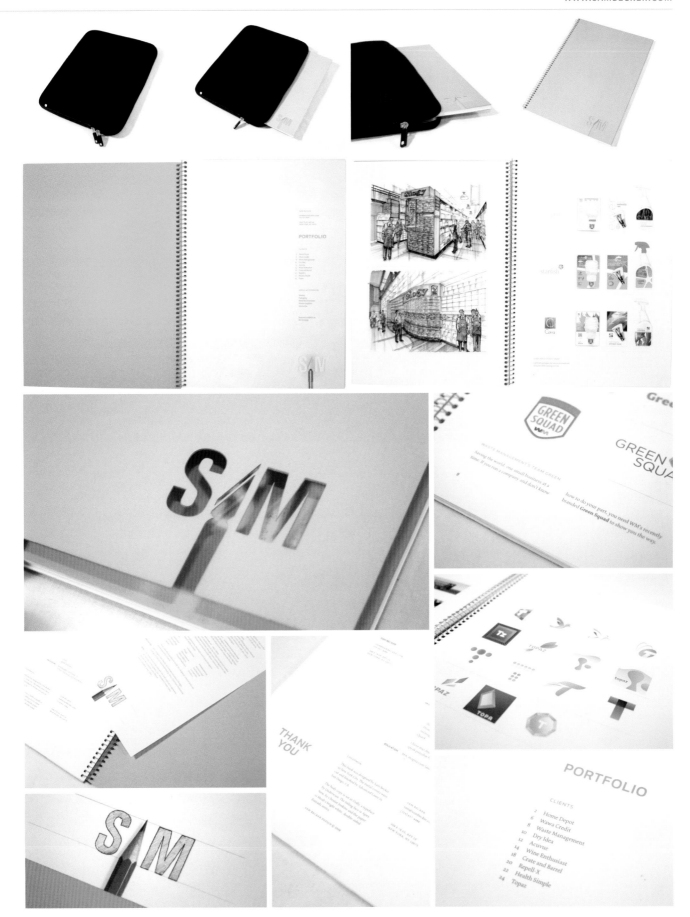

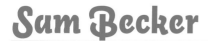
Sam Becker

I CREATED THIS APP IN THE SUMMER OF 2013 WHILE WORKING AT BRAND UNION IN NEW YORK, NY. I HAD ORIGINALLY WANTED TO CREATE ANOTHER BOOK BUT THE PROCESS SEEMED TOO SLOW AND CUMBERSOME THIS TIME AROUND.

STATUS

I interviewed with it for four months before landing a job at Interbrand.

APPROACH

To create my portfolio I leaned heavily on the skills I had cultivated as a developer for Apple's app store. It was fun and rewarding to combine my interests in branding and design with my passion for programming. The iPad was a joy to present from and, I believe, helped showcase my technical capabilities.

FLEXIBILITY

Adding projects or client-specific language is as easy as adding some PNGs to my app target and creating a new build. What took an afternoon with my previous portfolio could now be done in minutes.

DISPLAY

Entirely in person.

MEMORIES

While not as substantial a record as my previous portfolios, building this app was a different kind of labor of love. The upshot is that I always have it with me in case of emergency!

ONLINE

For reasons of confidentiality, none of this work was published online! Only presented in person.

ABOUT

Sam Becker is a Creative Director at Brand Union in New York, NY. Becker studied communications design at Syracuse University. After school Becker got his start in Crate & Barrel's graphics department, and later worked for design agencies CBX and Interbrand. Becker Tweets at @sambecker, and Instagrams at @smam.

> The best portfolios can be consumed quickly; they allow the work to speak for itself. In my opinion, it is the best way to gauge a designer's type and layout skills, because, presumably, they created their portfolio without the benefit of a design director.

PRODUCTION DETAILS

STRUCTURE	DIMENSIONS (IN.)	PRINTER	PRODUCTION TIME	PRODUCTION COST
iPad App	—	—	Minimal	Only my time!
MATERIALS	PAPER	VENDORS	RETAIL STORES	TYPEFACES
iPad Air 2 (silver) Navy leather case	—	—	Apple	National

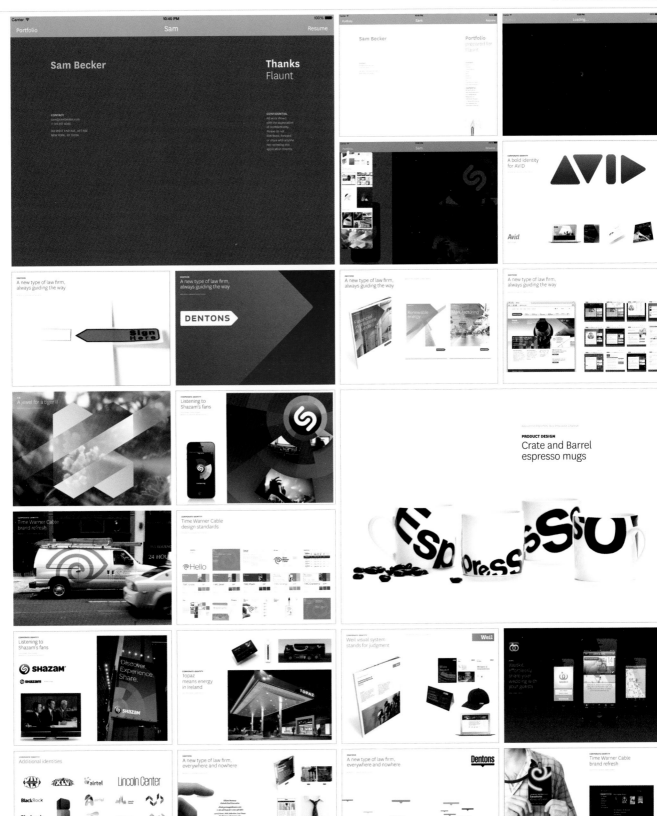

Jessica Hische

THIS PARTICULAR VERSION OF MY PORTFOLIO WAS CREATED IN LATE 2008, FOR PRINT MAGAZINE'S NEW VISUAL ARTISTS COMPETITION. I NOW USE IT TO PURSUE FREELANCE WORK, AS WELL AS POTENTIAL CLIENTS.

STATUS

Still in active duty.

APPROACH

I wanted a portfolio that I could easily edit and change depending upon who it was going to. A friend recommended Lost Luggage, a company that made really beautiful book portfolios for photographers and other businesses. The general look and feel that they provided complements my design and illustration work—they feel hand-crafted, yet are still very polished and sophisticated.

The actual book is made of wenge wood, aluminum, and leather, with a screw-post bind, wherein the screws are flush with the cover. I purchased pre-drilled Mohawk paper that prints excellently through Epson printers, which I alternated with black paper. They offer customizable features, like silkscreening and engraving—the one I ordered has a metal tab engraved with my name in a typeface that I designed.

FLEXIBILITY

Very flexible. The way it is bound makes it easy to swap out projects, which I often do, depending on who the portfolio is sent to.

DISPLAY

I use this portfolio for send-outs more than anything else. I actually have two identical books, so I'll always have one on hand for an in person review.

ONLINE

My printed portfolio is definitely more succinct than my online portfolio. Because I do design, illustration, and typography, it would be impossible to show a wide range of work in a book portfolio. For that reason, the printed portfolio tends to be tailored to specific clients. For example, if I'm submitting a portfolio for a holiday ad campaign, I have to be selective about the work that I send. The online portfolio is far more extensive, but I tried to give both the same general feel.

PREVIOUSLY

After graduation, I had a large box portfolio that was really impractical. Even though it demonstrated my range of work beautifully, to ship it would have cost me hundreds of dollars. Lugging it around town was such a pain that I'd end up trying to schedule geographically-convenient interviews. I also created a few small hand-bound portfolios after that, which elicited "ooohs" and "aaahs." Yet, they were impractical, because I couldn't tailor the content.

LASTLY

I'm a huge believer in a portfolio that's easy to change and edit. Like a website, if it's not easy to update, in the long run, you never will. You'd wind up starting over again in six months, when you have newer, and better, work. I always try to include a few actual pieces, along with the portfolio—seeing and holding books or packaging in person is different from seeing it printed out on paper.

I've seen some amazing and intricate portfolios with crazy die-cut covers or hand-bound edges, but in the end you should try to create a portfolio that makes your work look best. It's not always the flashiest one that is best suited for the job.

LOOKING BACK (5 YEARS LATER)

My printed portfolio hasn't been updated for some time. Most of my clients are working under tight deadlines, which means there's often no time to put together a printed custom portfolio. There are still jobs that request it, and I do think it makes a big difference to send a printed portfolio if you can, but they are few and far in between with the kind of clients I work with. I show this portfolio often to students and young professionals, as I think that a printed portfolio is still the best way to apply for a full-time position (it's just been a while since I've done so!). It's a wonderful time capsule of my favorite work from that time in my career, and I look forward to curating a new version soon.

ABOUT

Jessica Hische is a letterer, illustrator, and type designer working in San Francisco, CA, and Brooklyn, NY. Hische graduated from Tyler School of Art with a degree in Graphic Design. Previously, Hische worked at Headcase Design in Philadelphia, PA, and as senior designer at Louise Fili Ltd., in New York, NY. Hische has been selected to Forbes' 30 Under 30, Print magazine's New Visual Artists, and the Art Directors Club's Young Guns.

PRODUCTION DETAILS

STRUCTURE	DIMENSIONS (IN.)	PRINTER	PRODUCTION TIME	PRODUCTION COST
Screw-post book	11 × 14	Epson 1280	24 Hours	$500
MATERIALS	**PAPER**	**RETAIL STORES**	**SPECIAL TECHNIQUES**	**TYPEFACES**
—	Moab Entrada, double-sided matte inkjet, 300g/m2	Lost Luggage	Tipped-on artwork on black paper	Archer

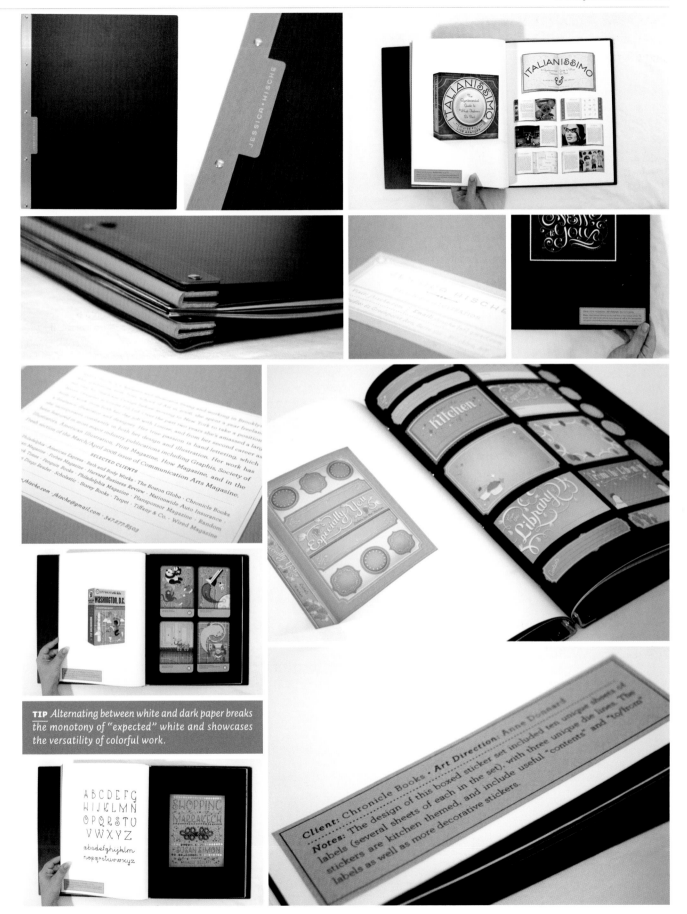

TIP Alternating between white and dark paper breaks the monotony of "expected" white and showcases the versatility of colorful work.

Dirk Wachowiak

I CREATED MY PORTFOLIO IN 2003 WHEN I APPLIED FOR AN MFA AT THE YALE UNIVERSITY SCHOOL OF ART GRADUATE PROGRAM. AS A FREELANCE DESIGNER, THE PORTFOLIO IS MAINLY DEDICATED TO OTHER DESIGN STUDIOS.

APPROACH

When I show my work, it is collected in a simple box that I can carry with me and set up on a table. It is a mélange of professional work I have done for several design studios and experimental/personal output—I decided to mix both areas, as I realized I could never predict what the reviewer expects.

I wanted to offer the reviewer a non-linear structure. People can walk around the body of work and become an active participant. It's similar to an analog appropriation of a website: you click on the link that appeals to you most. If I see that people need direction concerning what is visually important, I am there to provide some guidance.

FLEXIBILITY

The whole idea of not having my work in a fixed, bounded, and printed media expresses my idea of modularity. This flexibility allows for all sorts of updating—the only limitation being that the reviewer needs a large table or surface. The arrangement on the table is also flexible, although I usually place posters as the first layer, followed by books and invitations, then other pieces on top. This collage gives the reviewer a quick impression of the whole work, and it is especially easy to note the typographic qualities that are so important to me.

DISPLAY

I show the portfolio in person. When this is not possible, I refer people to my website. The structure gives you a sense of my design approach, and the content communicates the area of my graphic design work.

ONLINE

The non-linear structure of my website proves to be a search-and-discover process. As I am not a web designer—and working within my limitations—I devised a system that functions with grid-based pop-up windows. The user will discover new windows as he or she navigates through the site, and the option to have many windows open simultaneously allows for project comparison. The website is not necessarily user-friendly, but it communicates my unique approach to design.

PREVIOUSLY

In 1998, I created a portfolio for an internship during my studies at Pforzheim University, School of Design. I prepared a multimedia portfolio that allowed one to navigate through my work, and a printed piece, which I used as backup. The first design studio was not impressed by the printed matter and advised me to show only the multimedia portfolio in the future. The second design studio I visited, MetaDesign, was more interested in the printed matter than the multimedia CD. Still, despite initial bumps, I got the internship at MetaDesign.

BIO

Dirk Wachowiak is a graphic designer and type designer based in Stuttgart, Germany. He studied graphic design at Pforzheim University, School of Design, and earned his MFA from the Yale School of Art. While there, Wachowiak was employed as a teaching assistant to Tobias Frere-Jones. Wachowiak teaches typography at Pforzheim University, School of Design.

> *I wanted to offer the reviewer a non-linear structure. People can walk around the body of work and become an active participant.*

PRODUCTION DETAILS

STRUCTURE	DIMENSIONS (IN.)	PRINTER	PRODUCTION TIME	PRODUCTION COST
Box with loose samples	13.75 × 9.825 × 10.25	—	—	$3.00
MATERIALS	PAPER	VENDORS	RETAIL STORES	TYPEFACES
Cardboard box	—	—	IKEA	—

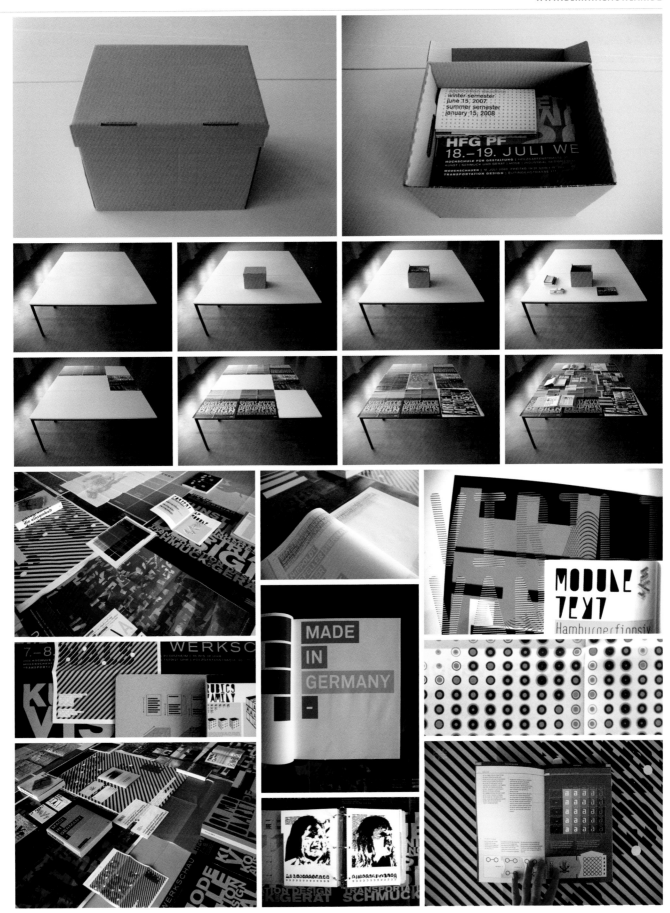

Christian Helms

THE MAIN PURPOSE OF THE PORTFOLIO WAS TO SECURE MY EXIT FROM PORTFOLIO CENTER IN 2002, AND CONVINCE AN UNWITTING DESIGN STUDIO TO PAY ME MONEY TO DO SOMETHING I WOULD HAVE DONE FOR FREE.

STATUS

I used it until I got a job. Shortly after, I caught wind of a great secret: once employed, your big box of student work is essentially useless.

APPROACH

My choice was handed down to me via divine proclamation. At the Portfolio Center, no box equaled no graduation. Although I hated this orthodoxy, I have to admit that it is a clean and professional form of presentation. I chose the simplest, least flashy box I could order. I saw other people binding theirs in pink cowhide and realized that so much flash on the outside might overshadow the work inside. I didn't want the package to oversell the contents.

I had the box built, but all of the contents were meticulously hand-made by me. In school, we all spent countless hours perfecting the craft of the hand-held parts, and they were beautiful. I remember the terror I experienced during interviews, watching as an art director strolled into the room with a sloppy sandwich, and thinking of my poor, defenseless portfolio, sitting there helplessly.

The box was just a starting point. Even more important than the work itself was the opportunity to tell my story, to talk about what I loved and what I hoped to do as a designer.

FLEXIBILITY

Had I needed to update it, I'd be in trouble.

DISPLAY

Always shown in person. It's a one-off, so the thought of shipping that thing to a studio was unbearable. Plus, you lose the chance to talk about the work and connect with your audience.

MEMORIES

In true Portfolio Center fashion, it weighed at least 30 pounds. I am not a large man, and dragging it through New York, NY, in 3 inches of snow wasn't much fun. I'd show up at interviews looking as if I'd just finished a triathlon.

ONLINE

My class may have been the last year of design grads not to have websites. Hard to imagine now.

LASTLY

Despite all of my complaints, this book got the ball rolling for me professionally, and Portfolio Center played a huge part in helping to make it happen. These days, it's rare to see strong craft and good production in student books. When I do, I'm immediately impressed, and more predisposed to taking the time to talk through the work.

LOOKING BACK (5 YEARS LATER)

Wow. I think this thing actually holds up pretty well. Some of the work itself makes me cringe, but in terms of format and presentation I think it would have a strong impact today. It seems like no one spends time on crafting a physical portfolio anymore. If a kid showed up at Helms Workshop with something like this, I'd be impressed—and I'd spend more time with him/her because of the work they put into the piece.

But, it would definitely need a corresponding website.

ABOUT

Christian Helms is the founder of Helms Workshop, a strategic design and brand development studio. Helms is also the co-owner of Frank restaurant, a mecca for craft beer, cocktails, and artisan sausage. Helms clients range from national brands like Pabst Brewing, Southern Comfort, and Jack Daniel's, to Texas standouts Alamo Drafthouse Cinema and Austin Beerworks, as well as a host of bands including Spoon, Modest Mouse, The Hold Steady, and Wilco.

Helms' work has received international recognition, publication, and awards, and he lectures across the country. Helms was awarded a gold record from the Recording Industry Association of America, despite being unable to carry a tune. Helms lives in Austin, TX, with his wife Jenn, son Hatley, and Boston-Pug mutt ScatterBug.

PRODUCTION DETAILS

STRUCTURE	DIMENSIONS (IN.)	PRINTER	PRODUCTION TIME	PRODUCTION COST
Box with screw-post book and trays	12 × 19 × 7	Epson	5-9 Weeks	$1,200

MATERIALS	PAPER	VENDORS	SPECIAL TECHNIQUES	TYPEFACES
Wood Fabric	Various samples finagled from paper reps	Portfolio Box	—	The Sans

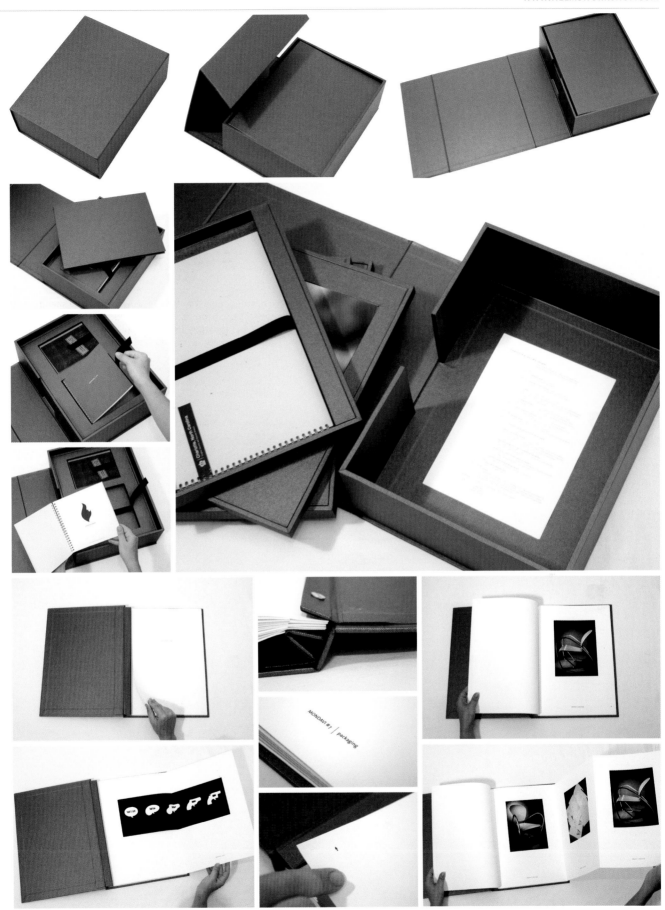

The Decoder Ring Design Concern

WHEN FLAUNT WAS ORIGINALLY CONCEIVED I WAS RUNNING A SMALL DESIGN STUDIO CALLED THE DECODER RING, WITH GEOFF PEVETO AND PAUL FUCIK. BOTH HAVE A SCREEN PRINTING BACKGROUND, WHICH SHOWS IN THE PRODUCTION OF THE PROMO PIECE. UNTIL 2006, ALL OF MY CLIENTELE HAD COME THROUGH WORD OF MOUTH. RATHER THAN WAITING FOR CLIENTS TO COME TO ME, I DECIDED TO TARGET CLIENTS IN SPECIFIC INDUSTRIES VIA THE PROMO.

STATUS

Instead of printing a zillion of these things and blanketing the country, we printed a limited, numbered run of 200. We wanted the pieces to have special value, and for clients to understand that the piece was just for them.

APPROACH

Economy was the principal driving force. We wanted the flexibility to burn customized digital portfolios on demand, knowing that the minute we created a singular portfolio it would be out of date—we'd inevitably have some new project we wanted to add. And so we set out to assemble a letterpress Digipak with an attached highlight book, screen printed shipper and portfolio CD—all put together with intern power.

FLEXIBILITY

Absolutely. It's updatable and customizable.

DISPLAY

We would send out an email a few days before the portfolio showed up via FedEx, often accompanied by posters, studio tees, and other swag.

MEMORIES

The mailer sleeves were tighter than expected, and we lost two interns to paper cuts stuffing these things.

ONLINE

The promo was meant mostly as a teaser, to drive traffic to the website, which functioned as a primary portfolio.

LASTLY

We got a lot of great responses, and they directly or indirectly lead to a lot of fun, high-visibility projects for clients like *The New York Times* and *Men's Health*. However, at the end of the day, our best clients still came from word-of-mouth referrals.

LOOKING BACK (5 YEARS LATER)

Five years later, these look like really pricey paper coasters, door stops, or shims to level your desk. Asking someone to take the time to insert a CD and cue up a portfolio is ridiculous. They looked great though—maybe that drove a few folks to the website.

ABOUT

The Decoder Ring is a screenprint-focused studio for hire, specializing in posters, products and fine art prints. Decoder partners on many projects with design and brand development studio Helms Workshop, and operates out of space in the Workshop Compound in South Austin, TX. The company began in 2004 as a design collaborative with a focus on design and screen-printing for the music industry. In short time the studio won acclaim for its bold, unique approach and has been featured in publications, festivals, and gallery shows across the world.

In 2010 Decoder shifted the studio's focus toward screenprinted projects and the acclaimed Decoder Fine Art Print Series. The project hosts famed artists and designers for studio residencies, creating multi-layered fine art serigraphs. Past collaborators include Gary Baseman, Tara McPherson, Jeremy Fish and Dalek.

PRODUCTION DETAILS

STRUCTURE	DIMENSIONS (IN.)	PRINTER	PRODUCTION TIME	PRODUCTION COST
Box with booklet and CD	5.5 × 5 × .25	Stumptown Press	2 Weeks	$3.50 Each × 200 $700 Total

MATERIALS	PAPER	VENDORS	SPECIAL TECHNIQUES	TYPEFACES
Chipboard CD	French Paper, Construction	Stumptown Press	Letterpress Silkscreen	Century Gothic Military Serif Southern Brus

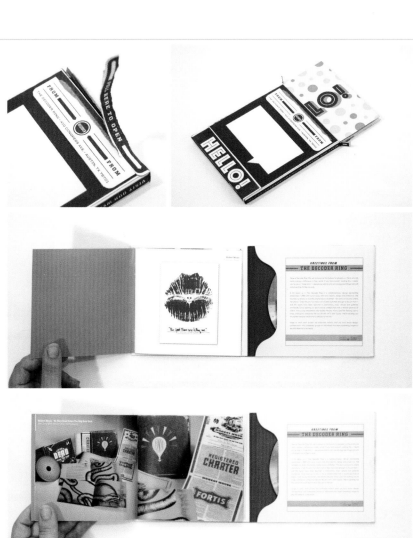

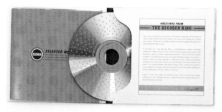

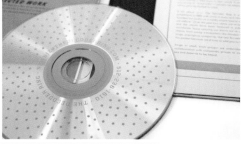

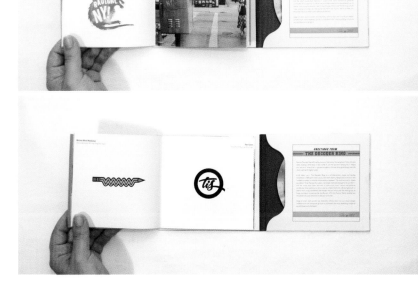

Chris Toombs

I CREATED THIS PORTFOLIO WHILE AT SAN DIEGO STATE UNIVERSITY, FOR MY PORTFOLIO CLASS IN THE FALL OF 2013. THE MAIN PURPOSE OF THE PORTFOLIO WAS TO GET A JOB AFTER GRADUATION.

STATUS

I was lucky enough to land a job after school so it was shown for about a month at six different interviews. I continue to use it when I need to for freelance gigs.

APPROACH

I love the craftsmanship of design so having a printed book that is an experience and smells like ink is important to me. I chose a small size so the book travels well and won't take up a lot of desk space when I present. I worked my way through school as a production designer so it was important to me that I show my thinking and ideation process so I didn't end up with another production job.

Because my portfolio was so small, showcasing process would have added a bunch of pages so I made separate process books for each of the projects in my portfolio—I don't think every interviewer cares about process so having the option to share, or not to share, was important to me. The surrounding box is designed to function both as protection, and presentation.

The book is Wire-O-bound with a three-ply chipboard cover skinned with Neenah Desert Storm paper and white bookbinder's cloth for the spine. The book block has single-ply chipboard for the first and last page that slides into a pocket on the inside cover so the block can be removed. The book block is printed on Staples Photo Supreme Matte paper. The process books are printed on the same paper and saddle-stapled. The custom box is made of corrugated cardboard and skinned with the same Neenah Desert Storm paper.

FLEXIBILITY

The Wire-O-binding and removable cover gives me the ability to add or subtract projects as needed.

DISPLAY

I always show my portfolio in person.

MEMORIES

I printed my book at home and I don't recommend this to anyone. My printer started banding halfway through my book and I had to borrow a friend's printer to finish printing. Make friends who are in portfolio class and who have been though portfolio class! I had three of my friends rally after my printer broke and I owe them beer for life because without them I would have turned in an unfinished portfolio. They will also give you honest feedback thoughout the process because they know what it takes.

All of the projects in my book start with the letter "C," are color coded, and organized by environmental photography, brand elements, then product photography. I have a thing for systems.

ONLINE

My website uses the same icons I used throughout my stationery, but not all of the projects in my book are online—I want to have something new to show during an interview.

LASTLY

First and foremost I would say make sure your portfolio represents what you want to do and who you are as a person. There are multiple student projects in my portfolio that I will probably never take out because they are built on ideas I'm passionate about. I think employers want to hire people as much as talent, so if you can show your interest through your work, interviewers will get a better understanding of who you are as a person. Second, care about your craft. Third, build a network of friends who can help give you honest feedback on your portfolio. I had fellow students, professors, and working professionals in the design industry give me feedback throughout my portfolio process. Lastly, create a stationery set that matches your portfolio—if your website matches your portfolio that is printed on the same paper as your résumé and business cards, you are going to make an impression.

ABOUT

San Diego, CA, native Chris Toombs is a jack of all trades. Graphic designer by day and craftsman by night, Toombs spends evenings and weekends exploring the tactile side of design, trying out new techniques in his search to marry message to medium. Toombs spent his formative years surfing and swimming, and both remain passions today. Toombs regularly commutes to work by bicycle and enjoys spending time with his wife Monica and his new baby daughter Betsy.

PRODUCTION DETAILS

STRUCTURE	DIMENSIONS (IN.)	PRINTER	PRODUCTION TIME	PRODUCTION COST
Custom box with a Wire-O-bound book and saddle-stitched books	Box: 12.75 × 9 × 2.75 Book: 11 × 8.5 Booklets: 8.5 × 11	Canon Pixma Pro 9000 Mark II	3 Days	$800

SPECIAL TECHNIQUES				
Rotary engraver Wood carving	Airbrush Laser engraving	Letterpress CNC machine	Laser-cut acrylic	Silkscreen

MATERIALS	PAPER	VENDORS	RETAIL STORES	TYPEFACES
Three-ply chipboard Bookbinder's cloth Bookbinding glue	Neenah Desert Storm paper Staples Photo Supreme Matte paper	Inscriptu Inc.	Staples Office Depot Artist & Craftsman Supply	Univers Arvil

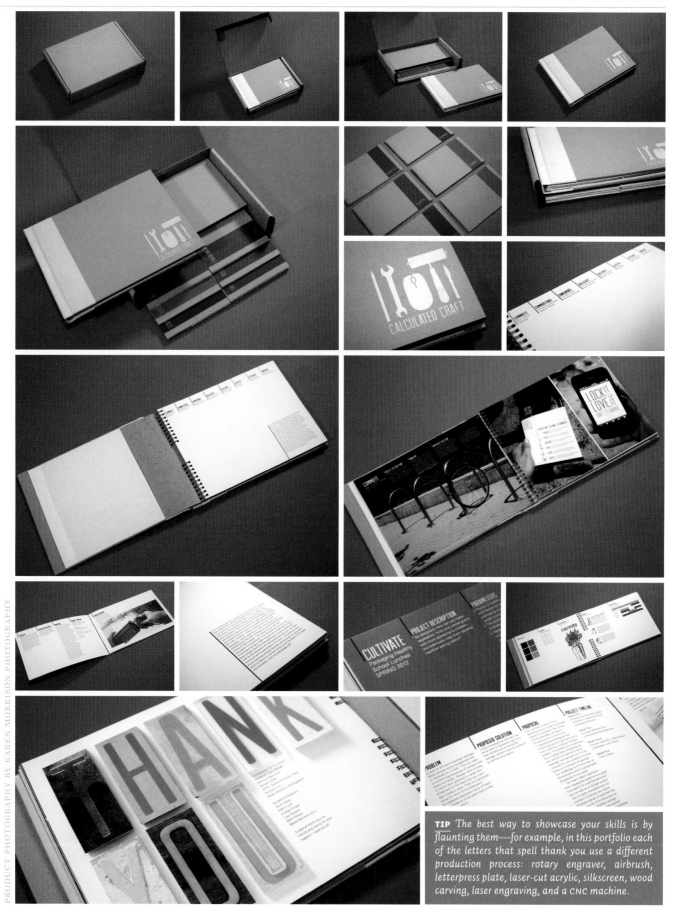

TIP The best way to showcase your skills is by flaunting them—for example, in this portfolio each of the letters that spell thank you use a different production process: rotary engraver, airbrush, letterpress plate, laser-cut acrylic, silkscreen, wood carving, laser engraving, and a CNC machine.

Timothy Cohan

THIS PORTFOLIO WAS ONE OF THE LAST PROJECTS I CREATED IN MY FIRST YEAR OF GRADUATE SCHOOL AT SCHOOL OF VISUAL ARTS IN MAY 2013. SCOTT STOWELL, CREATOR OF THE COURSE ENTITLED "EXPLAINING YOURSELF", PROVIDED THE FOLLOWING BRIEF: PRESENT YOUR WORK—AND EXPLAIN WHO YOU ARE AS A DESIGNER—TO OTHERS. AT THE TIME I WAS ONLY CONCERNED WITH MAKING THE PIECE, NOT ITS POST-GRADUATE USE.

STATUS

I have not yet used this portfolio in the conventional sense, i.e., to get a job. But, it is still in active duty as a piece of my oeuvre—a portfolio within my portfolio.

APPROACH

There are three attributes that I wanted to express: sketching, a fascination with tactility and authenticity, and improvisation. Finding the right container was the first step and would dictate the form of the interior design. After several days of fruitless searching, a classmate of mine sent me a photo of a case outside her apartment. It was rusty, caked in filth, and locked shut. It was perfect.

I used a generous amount of industrial strength cleaner and elbow grease to refurbish the aluminum case. I replaced the rusted out hardware with functional latches from another vintage case. I mocked up the compartment dividers with foam core and cut the final masonite pieces with a band saw. After securing the dividers with wood glue, I began tearing up and gluing down the sketches. The sketches literally surround and contain an artifact from the project within each compartment. Closing the cover aligns a photo of the final piece with the process of its making. To finish I filled the compartments.

FLEXIBILITY

It is not updatable. It is a record of a small and specific body of work and the time spent making it.

DISPLAY

The size and weight of this piece makes it a challenge to transport. I have only shown it in person a few times. However, I love the idea of someone opening it in my absence. Maybe some day I'll bury it for someone to find 100 years in the future. Could you imagine digging this thing up in your back yard?

MEMORIES

Originally, I incorporated hinged acrylic doors for each compartment, each with a laser-etched logo. This sounded great, but it just didn't work out as I hoped and there was no time left to change it. For its first great unveiling I had to present it this way, which was a bit of let down. But, I've since revised it and I am much happier with the results.

ONLINE

The tactility and the weight of this piece is integral to the viewing experience. Translating it into a digital one would dilute the concept.

OTHERS

I have developed other portfolios but never one this complex. Sometimes for practical reasons, I opt for more neutral options that allow the work to take precedence. These aren't nearly as dramatic but they clearly showcase the work.

LASTLY

The format of a portfolio should be determined by its purpose. On some interviews I simply filled the clear sleeves of an off-the-shelf black portfolio. Recently, some of my colleagues have begun using iPads, a sleek and neutral, albeit high-glare portfolio display. This portfolio is probably not appropriate for every job interview, but when the right opportunity comes along I'll be ready. I love to look through an exquisitely made custom portfolio and I think it's worth the effort to make at least one. I look forward to making my next one.

ABOUT

Timothy Cohan is an artist, designer, and entrepreneur, born in Beverly, MA. He received his BFA in Visual Communication Design from The Hartford Art School in 2005 and his MFA in Design and Entrepreneurship from School of Visual Arts in 2014. Cohan has worked as a graphic designer in Boston, MA, Los Angeles, CA, and New York, NY, exploring many areas of design, with a particular focus on environmental graphics. Notable projects include the retail signage and wayfinding system for City Creek Center in Salt Lake City (EG magazine, 2012) and the street signage and addressing system for the Emirate of Abu Dhabi (EG magazine, 2014). In 2014, inspired by his love of sketching people and cityscapes, Cohan founded Pincil, an online sketch gallery and marketplace. Cohan's sketches, paintings, and sculptures have been shown in New York and Hartford, CT. Cohan has contributed to Print magazine's blog and his work has been published in several books on design including Graphic Style Lab and Infographics Designers' Sketchbooks. Cohan works at Pentagram Design in New York and currently lives in Brooklyn, NY.

PRODUCTION DETAILS

STRUCTURE	DIMENSIONS (IN.)	PRINTER	PRODUCTION TIME	PRODUCTION COST
Metal case with custom divisions for samples	26 × 18 × 9.5	Epson Stylus Pro 7900 Canon Color Laser 1180	40 Hours	$100
MATERIALS	PAPER	VENDORS	RETAIL STORES	TYPEFACES
Aluminum case Masonite Plywood Paper Glue	Book covers: French Paper, Speckletone Book pages: HP Color Laser paper Sketch lining: Strathmore	—	Da Vinci Art Supplies FedEx Office	Din Next LT Pro

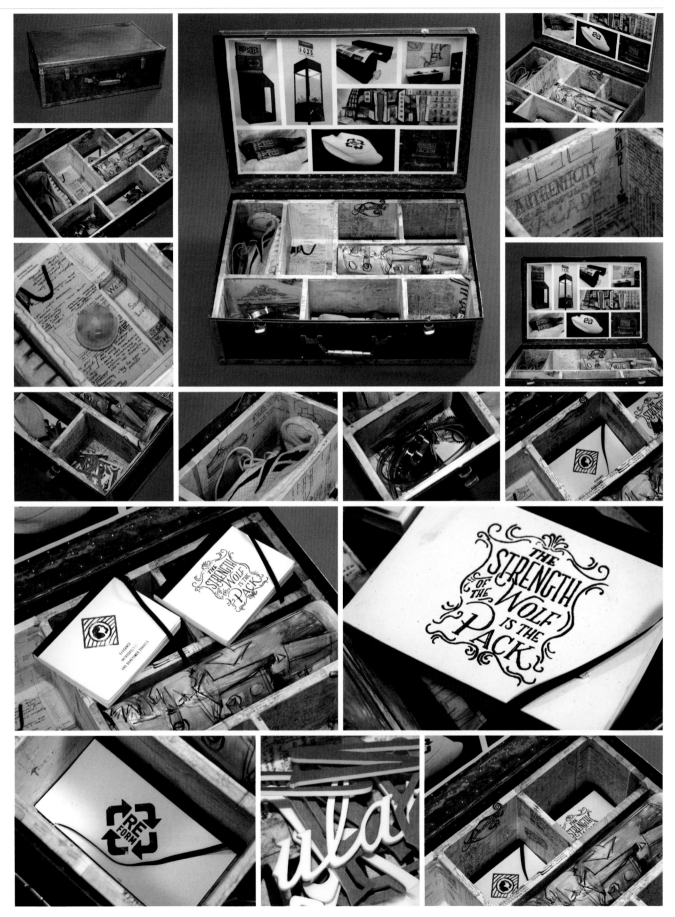

Hyun Auh

I DEVELOPED THIS PORTFOLIO IN 2005, DURING MY SENIOR YEAR AT THE FASHION INSTITUTE OF TECHNOLOGY IN NEW YORK, NY. I NEEDED A KICK-ASS PORTFOLIO FOR THE PORTFOLIO DAY AT THE ART DIRECTORS CLUB AND, MOST IMPORTANTLY, TO SNARE ME A JOB UPON GRADUATION.

STATUS

Now retired, I used it for about four months after graduating.

APPROACH

I wanted to create a book that reflects my personality and design sensibilities. More importantly, my passion and level of craftsmanship. I chose the accordion style because it allowed me to create a unique presentation using a very simple technique by pushing the limits of the format. I loved the fact that the whole book could be a single sheet that unfolded, eliminating the need for elaborate binding techniques and allowing the work to be viewed in unique configurations. The aesthetics of the bind-less format also reflected the simple and minimalist approach that I took with the projects that went into the book. I also discovered a neat little factoid that the accordion fold book originated in eastern Asia, which made it even more appropriate because of my South Korean heritage.

I created the accordion fold using a heavyweight, inkjet paper roll. The biggest challenge was figuring out how to print the entire book on one continuous sheet. It took countless nights of experimenting to finally figure out how to trick my Epson printer into printing my spreads continuously without cutting the roll of paper or leaving gaps in between spreads. I used binding boards for the cover and case, then wrapped them in Touche paper. The book was inserted into a personalized vellum sleeve, then a case I built with binding boards and glue.

I also created several copies of a miniature version that I carried with me, which I handed out as a takeaway for employers who I really wanted to work with.

FLEXIBILITY

It was not built with the intention of getting updated, but if it was absolutely necessary, extra pages can be slip-sheeted into the book. Unfortunately, this would decrease the value, since the inherent quality of the book is that it is composed on one continuous piece of paper. The one aspect of the portfolio that can be updated is the translucent sleeve, which I personalized, depending upon whom I was going to send it to.

DISPLAY

I dropped it off in many cases, and hands-on only when I was called in.

MEMORIES

This portfolio is actually the second version. The first one was sort of a test run that I rushed because I needed it for an interview. I wasn't satisfied with the result and decided to improve upon it. That test run really helped fine-tune many things that I missed the first time around.

ONLINE

It was a different time back then and didn't feel it was necessary.

LASTLY

Making this book amidst my final semester and senior projects really took a toll on me. Probably shortened my life by a few years. But I would do it all over again if I had to, and it was definitely worth all the sweat and tears.

LOOKING BACK (5 YEARS LATER)

I think the portfolio design holds up pretty well. Unfortunately I can't say the same about its contents, which were full of class projects. This book is actually almost 10 years old and looking at it through the eyes of a much more seasoned and mature designer, I can see a lot of little details that could have been done better, especially to make it more audience friendly. There should have been a better balance between form and function.

ABOUT

Hyun Auh is a graphic designer based in New York, NY. Auh's work has been recognized in numerous awards and publications including the Type Directors Club, the Brand New Awards, Creative Review, I.D. Magazine, and Behance. Auh lives with his wife and two daughters, Autumn and Sky.

PRODUCTION DETAILS

STRUCTURE	DIMENSIONS (IN.)	PRINTER	PRODUCTION TIME	PRODUCTION COST
Accordion-fold book with slipcase	5.875 × 11.375 × 2.25	Epson 2200	3 Months	$150

MATERIALS	PAPER	RETAIL STORES	SPECIAL TECHNIQUES	TYPEFACES
Binding board Spray paint	Inkpress, 2-sided matte, heavyweight Touche paper Translucent vellum Yupo synthetic paper	B&H Photo Talas	Black laser print on black paper	The Sans

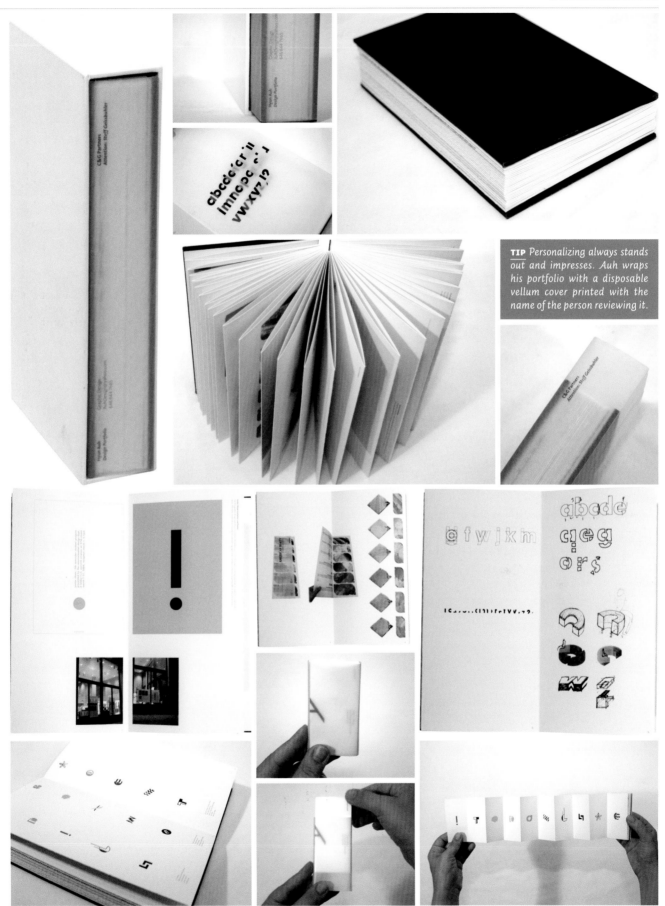

TIP Personalizing always stands out and impresses. Auh wraps his portfolio with a disposable vellum cover printed with the name of the person reviewing it.

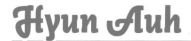
Hyun Auh

I SPENT ABOUT THREE MONTHS (APRIL – JUNE 2013) CREATING THIS BOOK AFTER LEAVING MY JOB. IT WAS CREATED BOTH FOR JOB HUNTING AND POTENTIAL FREELANCE GIGS—I WANTED TO CREATE AN OBJECT THAT WOULD LEAVE AN IMPRESSION.

STATUS

I used it to land a job and still use it for on-the-side freelance gigs.

APPROACH

I really enjoy designing books and experimenting with paper and binding techniques. I wanted to create something sculptural and tactile, an object that goes against the conventional formats of today's digital age.

It took an absurd amount of planning. Every page was folded in a different angle and the contents had to be rotated to the exact angle of each folded page. The cover was laser-printed black on Touche black, and the monogram was laser-cut. Red paper was inserted in between, which showed thru the laser-cut portion. The interior pages were printed on Finch Fine iD on an HP indigo press. The whole thing was hand-bound with strips of red paper and Cello Mount. The case was built from laser-cut acrylic glass pieces which I sanded and assembled myself.

FLEXIBILITY

It's possible, but not ideal. I can simply slip-sheet extra pages or paste on additional content but I probably wouldn't. I learned a lot from this process and there are so many things I would do differently. Mainly making it simpler and less labor intensive.

DISPLAY

I mostly show it in person but made a few mini versions that I can send to prospective clients.

MEMORIES

It really tested my patience.

ONLINE

I kept my existing website and the only thing that ties the two formats together is the monogram.

ABOUT

Hyun Auh is a graphic designer based in New York, NY. Auh's work has been recognized in numerous awards and publications including the Type Directors Club, the Brand New Awards, Creative Review, I.D. Magazine, and Behance. Auh lives with his wife and two daughters, Autumn and Sky.

It's not about how polished your portfolio is, it's about how polished you are as a person.

PRODUCTION DETAILS

STRUCTURE	DIMENSIONS (IN.)	PRINTER	PRODUCTION TIME	PRODUCTION COST
Case with perfect-bound book	9.5 × 11.5	BSquared, HP Indigo	3 Months	$500
MATERIALS	**PAPER**	**VENDORS**	**SPECIAL TECHNIQUES**	**TYPEFACES**
Cello Mount	Finch Fine iD	Mohawk	Laser-cut	The Sans
Acrylic Glass	Touche	Fibermark		
		Paper Presentation		
		Canal Plastics		

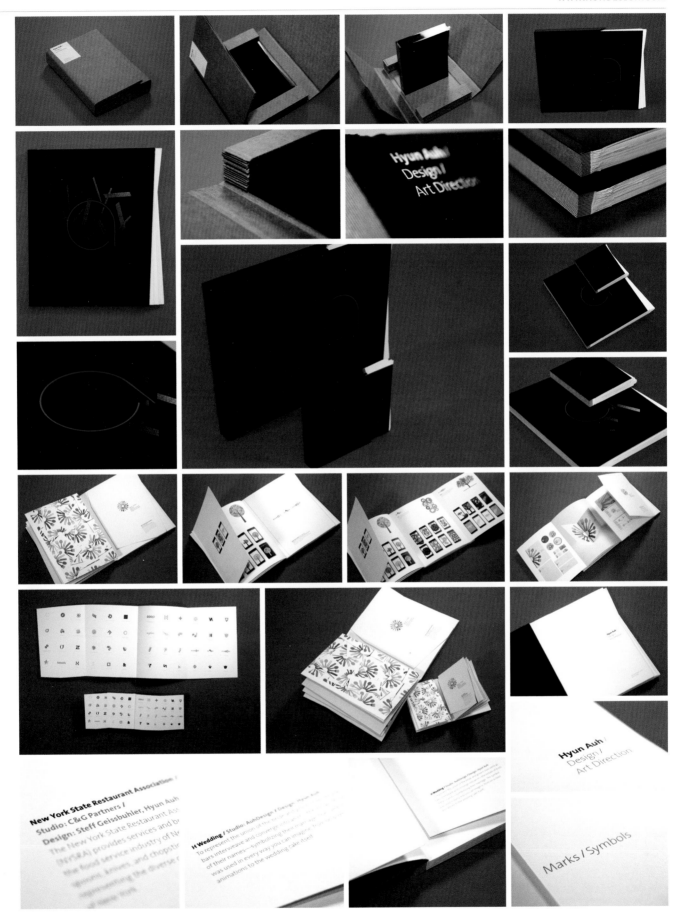

Ariel Rudolph Harwick

I MADE THE PORTFOLIO AT THE END OF 2013, AND I COMPLETED THE CASE LATER IN 2014. I'D RECENTLY MOVED TO WASHINGTON DC FROM NORTH CAROLINA, AND THOUGH I HAD A RESPECTABLE NUMBER OF FREELANCE CLIENTS, I WAS LOOKING FOR MY SECOND FULL-TIME JOB. I DESIGNED IT FOR INTERVIEWS AT DESIGN STUDIOS AND FOR MEETINGS WITH POTENTIAL FREELANCE CLIENTS. WITH ALL THE BLOOD, SWEAT, TEARS, AND DOLLARS THAT WENT INTO IT, I DIDN'T WANT IT TO BE USELESS AFTER GETTING A JOB!

STATUS

I'm happy to report that the portfolio fulfilled its first purpose—it got me a permanent position. As for the second—thanks to the internet—most of my freelance clients are too far away for in-person meetings, so I frequently use the website to gauge clients' interests and needs.

APPROACH

I gravitated toward a generously-sized book format; it seemed like the best way to cohesively present such a wide array of projects. I considered screw-posts for their flexibility but eschewed plastic slipcovers—I wanted the portfolio to feel as polished, unique, and substantial as any piece I would create for a client. As a graphic designer, artist, and writer, I take as much pride in my craft as my content, and I want the viewer to tangibly feel that pride as they interact with the book.

From a practical standpoint, the gray divider pages make each project totally discrete. No project is on the back of any other, so I can easily swap them around without reprinting pages. The dividers also improve pacing by creating rhythm and hierarchy, and they give the eye a rest between photo-heavy spreads.

The interior pages alternate uncoated paper for the divider pages with coated paper for the rest to create textural contrast. The pages are scored multiple times for flexibility, since the book block is pretty thick. Having the printer drill and score the pages would've doubled production costs, so I did both myself. I used a scoring board (it has lots of little parallel grooves) and a bonefolder to score. I actually drilled it with a power drill, which created a burr that I had to beat down with a hammer. It wasn't ideal, but it was cheap. Next time, I'll invest in a fancy Japanese screw punch.

Where the book was a labor of love, the case was a labor of hate. As a print designer, I needed to be able to carry samples along with my book. I decided to modify an existing laptop bag pattern, a questionable idea considering that this was only my fourth sewing project ever and that the pattern was listed as "advanced." Ignoring these portents, I changed the size, increased the padding, added interior pockets for my samples, and gave it a flap to make it even more waterproof (the exterior is made of sport jacket fabric extracted from the chaotic Jo-Ann Fabric and Craft Stores clearance pile). The result is reasonable as long as you're not a seamstress, but my sewing machine and I are no longer on good terms.

FLEXIBILITY

Yes, though at a cost. The loose covers and screw-posts make it possible to rearrange and add pages at will. However, the size I've chosen requires me to get my pages printed at a shop—which costs decent money—rather than doing it myself, so I'll only update when I have a substantial chunk of projects to switch out all at once.

DISPLAY

Always in person, though the project descriptions make it so that someone could just as easily enjoy the book on their own.

ONLINE

My physical portfolio and my website share the same visual cues from my personal identity—logo, color, pattern—and the same spare elegance. But because the physical portfolio allows for more typographic and compositional variety, it better showcases my expertise as a print designer.

ABOUT

Rudolph Harwick studied studio art and creative writing at the University of North Carolina at Chapel Hill. Based near Washington, DC, Rudolph Harwick is a graphic designer who freelances and works at a design studio while enjoying book arts, printmaking, and writing short fiction. When she's not creating identities, campaigns, and publications, Rudolph Harwick can probably be found in the woods, the art studio, or huddled with a good book.

PRODUCTION DETAILS

STRUCTURE	DIMENSIONS (IN.)	PRINTER	PRODUCTION TIME	PRODUCTION COST
Custom srew-post book in a custom bag	Book: 12.37 × 14.37 × .62 Case: 16 × 14 × 3.5	HP Indigo	Several weeks	$265

MATERIALS				
Lokta paper Aluminum screw-posts Webbing	Cialux book cloth Water-resistant nylon Zipper	PVA Blue linen Velcro	Davey binders board Interfacing Hardware	Starched mesh Craft foam

PAPER	VENDORS	RETAIL STORES	SPECIAL TECHNIQUES	TYPEFACES
Chorus Art, gloss 80lb cover Finch Fine ID, uncoated, 80lb cover	Petree Press Swoon Patterns	Bookmakers Inc Mulberry Paper And More Jo-Ann Fabric and Craft Stores Goodwill Fairfax Sewing Center	Hand-scoring Drilling	Whitney Sentinel

TIP Bold and brief lead-in text clearly establishes the purpose of each project and focuses attention on key accomplishments.

Andrea Friedli and Frédérique Schimmelpenninck

OUR PORTFOLIO WAS CREATED IN 2011. IT WAS THE FIRST PORTFOLIO WE CREATED TOGETHER, MIXING OUR INDIVIDUAL WORK INTO A SINGLE COHESIVE PROJECT—WE WANTED TO SHOW FUTURE CLIENTS A BROAD VARIETY OF OUR BEST WORK FOR MAGAZINES BY CREATING A NEW MAGAZINE.

STATUS

We still use it today.

APPROACH

We thought it would be best to show work for magazines by making one, remixing our own work into a new dynamic magazine. We took our time selecting the work and developing edgy compositions by sketching with our cameras. Eventually the final pile of magazines was photographed in a professional studio. It was then printed in an archetypal magazine format.

FLEXIBILITY

It could only be updated approximately every 10 years or if there was enough material to make interesting combinations.

DISPLAY

We show it in person and send it in the mail equally.

MEMORIES

Studio photographer Emilio Brizzi needed lots of tiny pieces of wood to put underneath the pages to make sure they wouldn't bend.

ONLINE

This concept works best offline—as a magazine it is best shown in its true, and tangible, form.

ABOUT

Andrea Friedli studied textile design at the Zürcher Hochschule der Künste (ZHDK, Switzerland) and worked as a textile designer and illustrator before moving to Amsterdam, Netherlands, where she studied graphic design at the Gerrit Rietveld Academie. Since 1998 Friedli works as an independent designer for cultural, commercial, and social clients.

Frédérique Schimmelpenninck was educated in graphic design at the Hogeschool voor de Kunsten Utrecht (HKU Utrecht). Since 1999 Schimmelpenninck designs for a variety of newspapers and magazines both as picture editor and art director.

Friedli and Schimmelpenninck met each other working for Elle Decoration. They discovered their shared love for magazines and made a portfolio combining their most favorite spreads. From the Amsterdam-based studio they design books, magazines, websites, corporate identities, and posters. In 2014 they won a European Design Award with corporate illustrations for men's fashion label F.G. van den Heuvel.

> We are really pleased to have made something in an edition of 500. It is easy and liberating to have something you can easily leave behind, give away, or send out.

PRODUCTION DETAILS

STRUCTURE	DIMENSIONS (IN.)	PRINTER	PRODUCTION TIME	PRODUCTION COST
Magazine	11 × 8.3	Offset printing	2 Weeks	$620
MATERIALS	PAPER	VENDORS	RETAIL STORES	TYPEFACES
—	Glossy magazine paper	KvK	—	Avenir

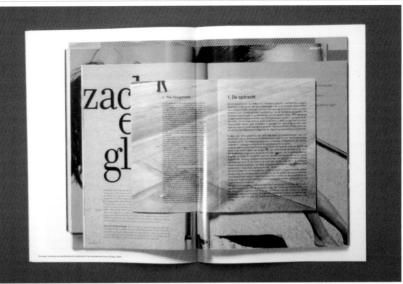

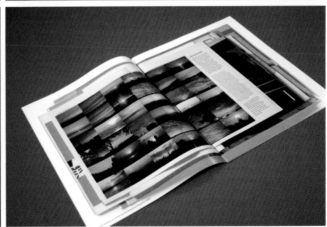

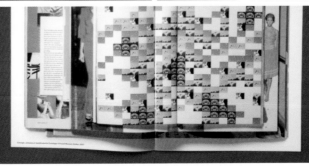

Patrick Allison

I CREATED THIS PORTFOLIO TO MEET GRADUATION REQUIREMENTS FOR THE PORTFOLIO CENTER IN THE SUMMER OF 2009, AND TO HELP ME FIND MY FIRST REAL GRAPHIC DESIGN JOB AFTER GRADUATION.

STATUS

I'm still using the portfolio, though I've been adding and subtracting from it as I go along.

APPROACH

When I started the process, I was against spending a lot of money on a case with loads of bells and whistles. I scheduled a lunch with my mentor to discuss what was actually important when showing student work, and it was one of the most enlightening portfolio conversations I'd ever had. I learned that the portfolio was about the work, and only about the work.

I vowed that I would spend no more than $20 on the whole book, and that I'd work extra hard to make it as interesting and as beautiful as the custom cases. After experimenting with tons of materials, I settled on constructing it out of raw, corrugated cardboard. I found a beautiful, black screw-post book by Pina Zangaro online that I purchased for $10. A production instructor at Portfolio Center helped me with the dieline, which took about thirty minutes to complete. If a prospective employer happens to drop it, or leaves a coffee ring on it—as they have been known to do—I don't have to stress. There are three extras in my closet, with résumés and business cards to match, ready to go at a moment's notice.

FLEXIBILITY

I designed the portfolio to be an organic book. It can grow or shrink, depending on the circumstance, and any advancements or new projects that I complete.

DISPLAY

I prefer to show it in person.

LOOKING BACK (5 YEARS LATER)

Thinking back to five years ago, I realize my portfolio strategy has undergone a tremendous shift. A student portfolio is like the pilot light on an oven. It is a crucial spark in igniting a creative career but once the flame is lit it is an entirely different matter to keep it burning. The sad fact is, the second the ink dried on my student book it immediately began to go stale. It is a look back on the designer who I used to be but not an accurate portrayal of who I have become since. To keep my metaphorical cooktop toasty I've had to change my approach. I still have the physical book, but it is my digital portfolio, a myriad of social media outlets, and mostly my reputation that gets me work these days. If I had known that then, I would have done things differently. You hire a student because there are still undeveloped lumps of creative clay with crazy ideas and a lot of hunger. A student book should be raw, it should be about excitement, optimism, and should be blatantly transparent when it comes to process. After all, what is a spark if not a celebration of bright, hot potential?

ABOUT

Patrick Allison is a designer and illustrator based in San Francisco, CA. Allison attended Portfolio Center in Atlanta, GA, and received a BA from Berry College in Rome, GA. Allison has done design work for Coca-Cola and Abercrombie & Fitch, and illustration work on children's books for Jackson Fish Market. Allison currently works at Gap Inc. and is owner and designer at Knotty Co. bow ties.

> *I learned that the portfolio was about the work, and only about the work.*

PRODUCTION DETAILS

STRUCTURE	DIMENSIONS (IN.)	PRINTER	PRODUCTION TIME	PRODUCTION COST
Box with screw-post book	16 × 13 × 3	Laser printer	9 Hours	$0 Box $25 Book

MATERIALS	PAPER	VENDORS	SPECIAL TECHNIQUES	TYPEFACES
C-Flute corrugated cardboard	Moab Entrada, double-sided matte inkjet, 300g/m2	eBay Pina Zangaro	Oil transfers	Chalet

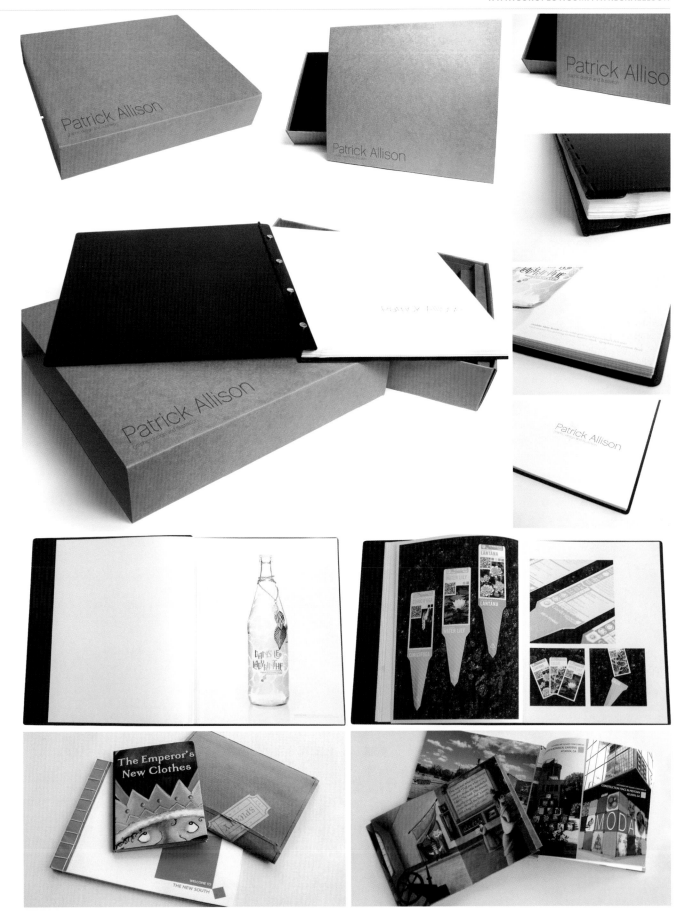

Bradford Prairie

MY PORTFOLIO WAS CREATED IN THE SAN DIEGO CITY COLLEGE GRAPHIC DESIGN PORTFOLIO CLASS, BETWEEN SEPTEMBER 2013 AND JUNE 2014. THE PORTFOLIO SHOWS MY STUDENT WORK FROM 2012 TO 2014. I CREATED THIS PORTFOLIO TO SHOW IN THE 2014 AIGA STUDENT PORTFOLIO REVIEW. CAREER-WISE I DIDN'T REALLY NEED THE PORTFOLIO SINCE I'M CONTINUING MY EDUCATION AND IT WILL BE OUT OF DATE BY THE TIME I START JOB-HUNTING. IT'S JUST SOMETHING I WANTED TO DO.

STATUS

Still in active duty.

APPROACH

At first I wanted to make a fully digital portfolio, but the book format was a better choice for my mostly print-based body of work. It is difficult to properly show print projects on screen—type gets scaled too much and pixel density often becomes an issue. The bound book gave me huge spreads where I could display things full-size. I was also able to design and pace the viewing experience more with a book. Digital portfolios have a culture of being right to the point. I want to tell the story behind each project and emphasize process. Also, I just like books.

The case is made from Lineco Binder's Board, wrapped in Cotlin bookcloth, and quarterbound with Iris bookcloth. The pages were digitally printed and Wire-O-bound. I used a concealed binding to give the portfolio a spine and a more book-like appearance. My friend and colleague Heber Miranda built the case.

FLEXIBILITY

On reflection, I wish I made the portfolio more updatable. If I made any changes, I would have to reprint the book and recreate the photography setups I used. I'll probably remix the book in a few years when I graduate.

DISPLAY

I only show the book in person as I love to dialogue with the viewer. I do have a digital version of the book on Issuu that I occasionally send to people.

MEMORIES

I had the case built based on measurements provided to me by my printer. Turns out the measurements were off. I had to scramble to get the case rebuilt at the last minute. Don't always trust measurements from your vendors, I guess.

ONLINE

No online version at the moment since I'm still in school and not in the market for a job. When I graduate I plan on making a portfolio website to accompany the book.

ABOUT

Bradford Prairie is a graphic designer and photographer from San Diego, CA. After pursuing a career in the culinary field, Prairie turned to graphic design, completing the graphic design program at San Diego City College. Prairie is currently pursuing a degree in Digital Art and Design at the University of California, Irvine and is a designer at Macleod Asare Chan.

> I underestimated how dirty people's hands are. The copy of the book I brought to my portfolio review was covered in oily fingerprints by the end of the event.

PRODUCTION DETAILS

STRUCTURE	DIMENSIONS (IN.)	PRINTER	PRODUCTION TIME	PRODUCTION COST
Wire-O-bound book with custom case	13.5 × 11.5	HP Indigo Press	3 Weeks	$400

MATERIALS	PAPER	VENDORS	SPECIAL TECHNIQUES	TYPEFACES
Lineco Binder's Board Cotlin Iris bookcloth	Silk finish, 80lb cover	Talas Blend International Bindery Golden Rule	Foil stamp	Chronicle

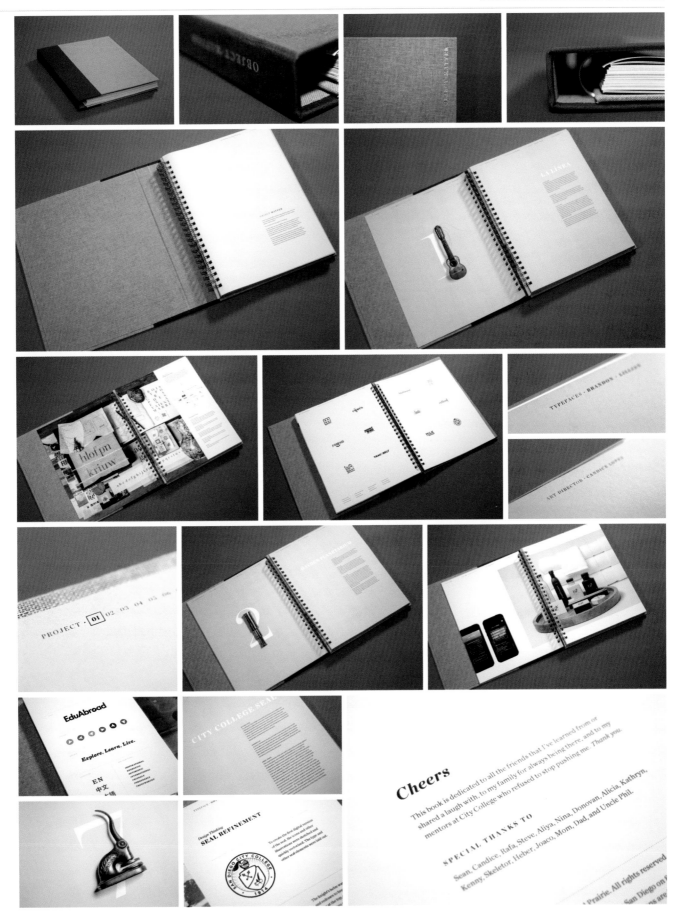

Michael C. Lewandowski

MY PORTFOLIO WAS CREATED IN THE SPRING OF 2012 AS A GRADUATION REQUIREMENT FOR THE CULMINATION OF MY WORK DURING THE COMPLETION OF MY BACHELOR'S OF SCIENCE DEGREE IN INDUSTRIAL DESIGN. THE PRIMARY PURPOSE WAS TO CREATE A PHYSICAL RÉSUMÉ OF PREVIOUS WORK TO BE PRESENTED DURING JOB INTERVIEWS AS WELL AS SOCIAL DISCUSSION.

STATUS

The portfolio is currently being used. It is still relevant and still represents my aesthetic as well as skill sets as a designer.

APPROACH

Our requirements while at school for the creation of the portfolio were pretty straightforward: create a printed portfolio representing yourself as a designer and the work you have thus far created. I, as usual, had a propensity to create something that stood out from the sea of other graduate portfolios my peers were creating. For me to feel like I accomplished a unique project meant creating it in a way that I could hold, analyze, and admire it as if it were a souvenir.

The personal aesthetic that I'd been experimenting with at the time was geometric and crystalline shapes. Since I was a child, my parents had taken me on many vacations hunting for fossils and minerals across the country and the ocular properties of crystals as well as their physical texture intrigued me. For that reason, many of my designs were influenced by those shapes. That same aesthetic inspired me to translate those shapes into different materials and push the boundaries of what I knew in terms of mechanical skill sets to implement those designs. At the time, I was learning to use our school's 3-axis CNC mill which had been all but forgotten. I'd mastered the standard 2D functions but wanted to push the envelope of the software to 3D capabilities. This curiosity pushed me to experiment with the various features and functions of the mill and eventually led me to create the faceted portfolio cover I was hoping to achieve.

Ultimately, with the cover, I wanted to portray the raw beauty of the material. To accomplish this, I chose a hardwood, specifically red oak, selected for its beautiful natural color and grain. As one plank would not suffice to cover the entire portfolio, I chose two. Overall, I created the design as a singular design and then split it into two files and cut them separately. I joined them using traditional furniture techniques with dowels and glue, painstakingly sanding bit by bit—to finish I coated them with a clear coat for preservation.

FLEXIBILITY

The portfolio itself is updatable. It is a simple portfolio bound by posts, easily modified for more or less projects as required.

DISPLAY

I will only show it in person. I find, during interviews, the recipient spends a lot of time running their hands over the texture and it sparks conversation before ever opening the portfolio to review my work. It also gives context to projects within the portfolio itself and allows me to further elaborate on physical examples of my design proficiencies.

MEMORIES

One of my favorite teachers while at school chastised me for not broadening my scope of aesthetic in the closing months of my degree. It was not that I was so enamored by crystalline shapes, but rather a dedication to perfecting a design in which I'd spent so much time experimenting with—I had to push its boundaries from computer generated images to tangible objects. He also warned me that once you create a project with a certain standard of quality, it is only expected that all future projects and creations will be the same if not better than the last. As our teachers and employers would be the first to critique our portfolios, it was only fitting that I create something this particular teacher would see and remember me by. The portfolio cover was, in part, created to stick my tongue out and subtly say "na-na-na-na-boo-boo-look what I created to say f u."

ONLINE

The portfolio is not complemented by an online version. I do use Coroflot to promote my work and show off the portfolio content but reserve the cover for in-person review. The design language is translated into my personal branding and connects the tactile properties of the cover with the graphics of my business card.

LASTLY

I find it very hard to talk about myself or my projects and thus created this piece as a way for me NOT to talk about myself but rather lead the recipient to make logical conclusions about me on their own. This relates to the dreaded elevator speech, which if only given 30 seconds, what would you say or show to convince someone of your experience and skills? My portfolio cover represents specific ideals I uphold as a designer and those I wish to convey: attention to detail, craftsmanship, dedication to quality, and personal manufacturing and design proficiencies.

ABOUT

Michael C. Lewandowski chose to use up his savings for European travel after graduating high school. Upon returning Lewandowski worked as a construction laborer while attending community college where he studied criminal justice and architecture. When his girlfriend suggested industrial design he took a leap of faith and immediately fell in love with the possibilities that industrial design had to offer, from product design to exhibit design and all the disciplines in between. With no creative background or artistic skills Lewandowski took on every opportunity he could to broaden his knowledge and skills through internships. Professionally, Lewandowski works as the lead product designer at a multinational mobile phone manufacturer. Personally, Lewandowski freelances in various disciplines of product design. In the very little free time Lewandowski possesses, he enjoys fossil collecting and relic hunting, a pastime his family has fostered since he was a boy.

PRODUCTION DETAILS

STRUCTURE	DIMENSIONS (IN.)	PRINTER	PRODUCTION TIME	PRODUCTION COST
Screw-post book	15 × 19	—	4 Days	$90
MATERIALS	**SPECIAL TECHNIQUES**		**RETAIL STORES**	**TYPEFACES**
Red oak wood	Solidworks / Milling	Hand sanding / Clear coating	Amazon.com	—

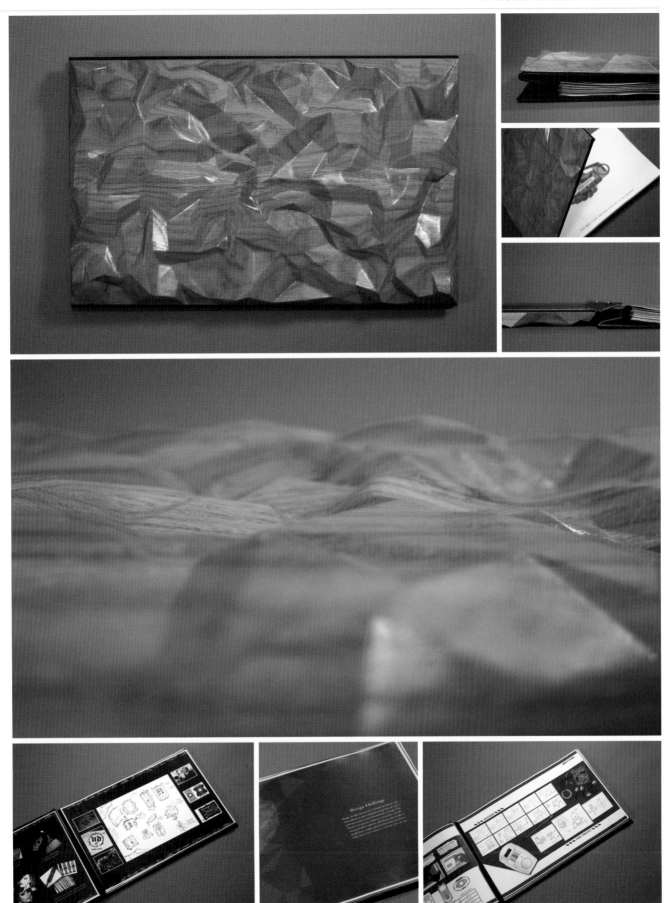

Caryn Audenried

I CREATED THE PORTFOLIO IN FEBRUARY 2009, DURING MY THIRD YEAR AT CARNEGIE MELLON, IN PREPARATION FOR THE DESIGN SCHOOL'S JOB FAIR. I USED IT WHILE SEARCHING FOR A SUMMER INTERNSHIP AND ALSO USED IT TO GET MY FIRST JOB OUT OF COLLEGE.

STATUS

As of now, it is retired. I used this portfolio for over a year but eventually replaced it with a more portable solution.

APPROACH

At the time, I had a lot of print work to show in different forms—a book, a set of cards, a magazine, and custom boards showcasing other non-printed projects. Creating a book cover to bundle all of the different items together touched on a recent interest of mine in book making. The folder is made out of chipboard covered in raw canvas I had also used in a previous student project. I loved this raw canvas for the nice textural quality and soft feel it gave to the book, and to boot it was super cheap. For the typography on the cover I created a stencil by printing out the type and taping all over the back of the paper with masking tape to build it up and give the paper strength. Then I cut out the letters by hand with an X-acto knife and stenciled it with spray paint.

The cards were printed on an Epson inkjet printer in the student printing lab and spray mounted to black illustration board.

FLEXIBILITY

I would say it is purposely updatable. I left all of the interior pieces loose, so I could rearrange them to suit whatever position I was interviewing for or who I was talking to. As a student my latest work was constantly changing so it was nice not to have to make a new portfolio every time I had a new project.

DISPLAY

I only used this portfolio in person—it's quite heavy and I'd rather have people look at my website if I'm not there to show it. Looking back, it was actually quite big and awkward to pull the pieces out that I needed and display them in some of the smaller settings where interviews were conducted.

MEMORIES

I still look back fondly on this portfolio as getting the most bang for my buck, especially for displaying printed work, and I had a lot of fun making it! It's good that I enjoyed the process because it actually didn't help me get my internship at all—I ended up going to a design firm across the country for the summer who only saw my website and interviewed me over the phone.

ONLINE

At the time, I was pretty set on becoming a print graphic designer and didn't have much by way of web design skills, but I did muddle my way through creating a bare-bones portfolio site to display the same projects as the folder. The companion site had a similar design aesthetic to the print portfolio cards in typography and style but had much shorter descriptions and content. At that time I preferred to keep the website as a preview of my work and show the full projects face-to-face during an interview.

LOOKING BACK (5 YEARS LATER)

This was one of those design school projects I look back fondly on creating—spending a whole weekend making a thing with my hands, cutting out those stencil letters with an X-acto—the process was what I loved about it. As an object, it actually turned out to be a bit big and unwieldy. I still remember walking around the job fair holding this thing that looked like a huge Trapper Keeper. Eventually I had to stop using it, in favor of a more robust website and digital portfolio that I could just send to prospective employers over email.

Given that the most recent portfolio I created cost upwards of $500 for printing and materials—due to poor planning on my part—I definitely miss the great printing and supplies resources I had in college to create this first one on the cheap. After all, the portfolio should be about the work, not about how fancy of a container it's in.

ABOUT

Caryn Audenried is a graphic designer and illustrator based in New York, NY, who currently works as a product designer at XO Group. Audenried graduated from Carnegie Mellon's School of Design, and previously worked at R/GA in New York, and as a freelance graphic designer and illustrator.

PRODUCTION DETAILS

STRUCTURE	DIMENSIONS (IN.)	PRINTER	PRODUCTION TIME	PRODUCTION COST
Folder with loose samples and boards	9 × 12 × 2	Canon inkjet	2 Days	$20 Folder $30 Cards $50 Total

MATERIALS		PAPER	VENDORS	TYPEFACES
2-ply chipboard	Spray paint	Cardstock, white	—	DIN 1451
Raw canvas	Embroidery thread	Canson paper		Mrs Eaves

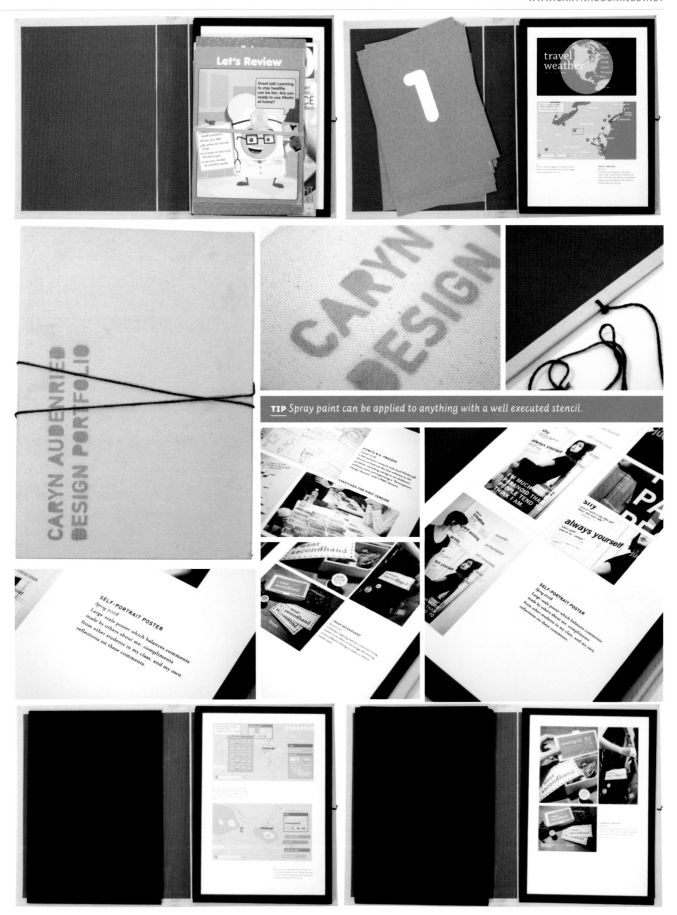

TIP *Spray paint can be applied to anything with a well executed stencil.*

Soup Design Group

WE DESIGNED AND CREATED THIS NEWSPAPER PROMO ON SEPTEMBER 2013 FOR A PRESENTATION AT NIKE. WE HAD A VISIT / PRESENTATION SETUP AND WANTED TO SHOWCASE SOME OF OUR NEW WORK.

STATUS

We still have 25 left and hand them out to potential clients.

APPROACH

We wanted something straightforward and simple, with large images and our best work—a 36-page newspaper print felt like a great choice.

FLEXIBILITY

We can easily update the front cover with the latest studio news and update the inside pages with new work.

DISPLAY

We mostly send it by mail.

MEMORIES

The design and production came down to the last day, last hour to send it to the printer, we just made it in time to get it printed and back to jump on a plane to Nike.

ONLINE

We have an online version that simulates as a flip book.

OTHERS

We have two printed books: one for our action sports designs, and one for our entertainment and licensing designs.

ABOUT

Soup Design Group has been referred to as a "Motley looking crew," ranging from street style hipsters to punk and metal enthusiasts, but what makes the team function on a daily basis, is their individuality. Soup Design Group utilizes their skills to adapt to every style, genre, culture, and lifestyle that their clients demand. Soup Design Group was founded by Dan Janssen and Hilary Paige.

PRODUCTION DETAILS

STRUCTURE	DIMENSIONS (IN.)	PRODUCTION TIME	PRODUCTION COST	
Saddle-stitched Newspaper	11 × 14	2 Weeks	$700 Business cards × 500	$7.66 Each
			$700 Gold coins × 100	$2,300 Total
			$500 Stickers sheets × 500	

ADDITIONAL ITEMS	PAPER	VENDORS	PRINTER	TYPEFACES
Gold coins	Accent Opaque Smooth,	L&L printers	Indigo Digital Press	ITC Lubalin Graph
Cars	White, 50lb text			Bebus Neue
Sticker sheets	Sticker paper			

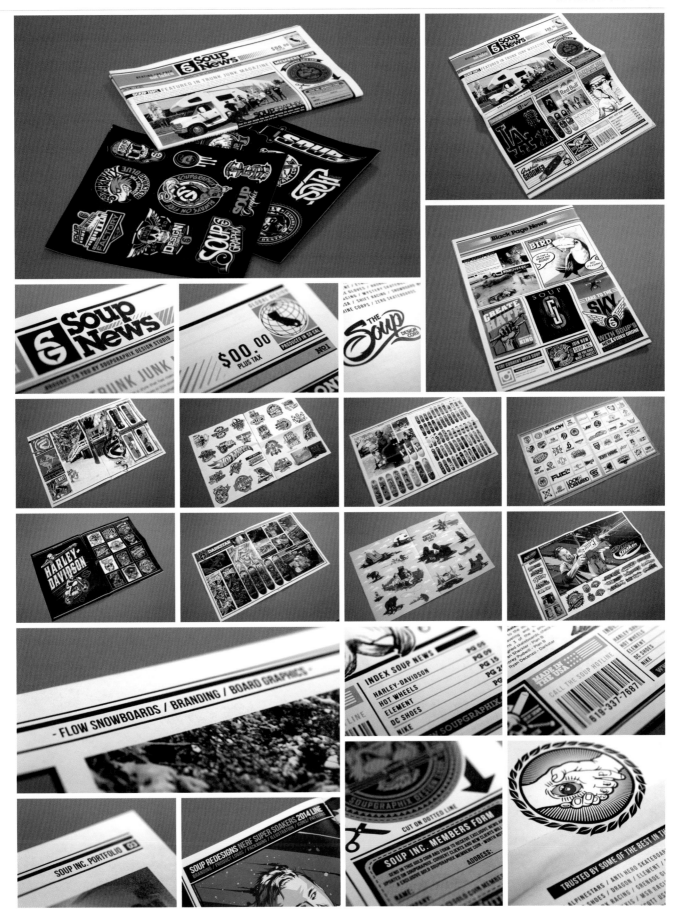

Frank Gargiulo

I CREATED MY PORTFOLIO IN JULY 2007, AFTER YEARS OF HAVING A PORTFOLIO THAT CONSISTED OF 4-BY-5-INCH TRANSPARENCIES. I NEEDED TO FIND AN EASIER WAY TO SHOW MY WORK TO FREELANCE CLIENTS AND POTENTIAL FULL-TIME EMPLOYERS.

STATUS

While the portfolio is still in use, my website is the primary vehicle for showing my work.

APPROACH

I wanted a creative portfolio with the feel of a magazine or book. Once printed, two images were mounted to illustration boards that served as the front and back covers, and then it was all bound together with Wire-O.

FLEXIBILITY

In some ways it's flexible and in other ways it isn't. Taking out the Wire-O binding and adding pages is fairly easy. The main difficulty is the presentation of the music section. Every time a new CD cover is added an entirely new photo shoot with a friend is needed. I was aware of this going into the project, but the idea of taking a portrait of a friend holding a CD package wasn't something I was willing to sacrifice.

DISPLAY

It can be presented with or without my presence. The portfolio and work speak for themselves. I believe it's a clear representation of who I am as an art director and designer.

MEMORIES

The music section was shot three times before it was successful. The first time, the photographer forgot his camera and my friends/models became grumpy waiting for him to come back. So the photos didn't turn out as well as they could have due to the circumstance. The second time, I tried to piggyback the work on to a fashion shoot, and felt so rushed that I didn't get what was needed. The third time was a charm—my friend, Marcelo Krasilcic, did an amazing job. He captured exactly what I was looking for.

ONLINE

Online and offline are somewhat related to each other. It's my goal to update the site in the near future, so that it will be comparable to the printed portfolio. I want to use more common elements, rather than the images of my friends holding the CDs. I'm not web tech savvy enough yet to create it, but I'll get there.

LASTLY

I went to see a leading headhunter in New York, NY, before creating this portfolio. I wanted to get an idea of what they thought was a successful presentation. I was shown dreadful portfolios, both in look and content—mostly heavy, leather-bound traditional portfolio monsters that screamed boring and serious. After explaining my concept to the headhunter, she sought to discourage me. I'm glad I didn't listen. A week after finishing my portfolio, I was offered two positions—one that I accepted.

LOOKING BACK (5 YEARS LATER)

Surprisingly I still use my printed portfolio for appointments. Mostly because I really like it. Some people love to flip through it while we talk. Others suggest the obvious iPad (and I have thought about it) but for the time being I'm happy to keep it lo-fi. To be honest, the way people feel about the work being shown in print versus digitally helps me get a little bit of insight into their personalities.

ABOUT

Frank Gargiulo is the award-winning creative director at Art Dictator, a multidisciplinary design practice. Gargiulo is a graduate of the School of Visual Arts, where he studied both illustration and design. Most of his career has been spent working in the entertainment industry, entertaining people with his designs for CD packaging, book jackets, Broadway posters, and motion graphics for MTV.

> I think the portfolio and work speak for themselves. It's a clear representation of who I am as an art director and designer.

PRODUCTION DETAILS

STRUCTURE	DIMENSIONS (IN.)	PRINTER	PRODUCTION TIME	PRODUCTION COST
Wire-O-bound book	11.5 × 11.5	Xerox DocuColor 7000	1 Day	$100
MATERIALS	**PAPER**	**VENDORS**	**RETAIL STORES**	**TYPEFACES**
Illustration Board	Silk, 110 lb	Soho Reproductions	—	Bell Gothic
				Trade Gothic Condensed

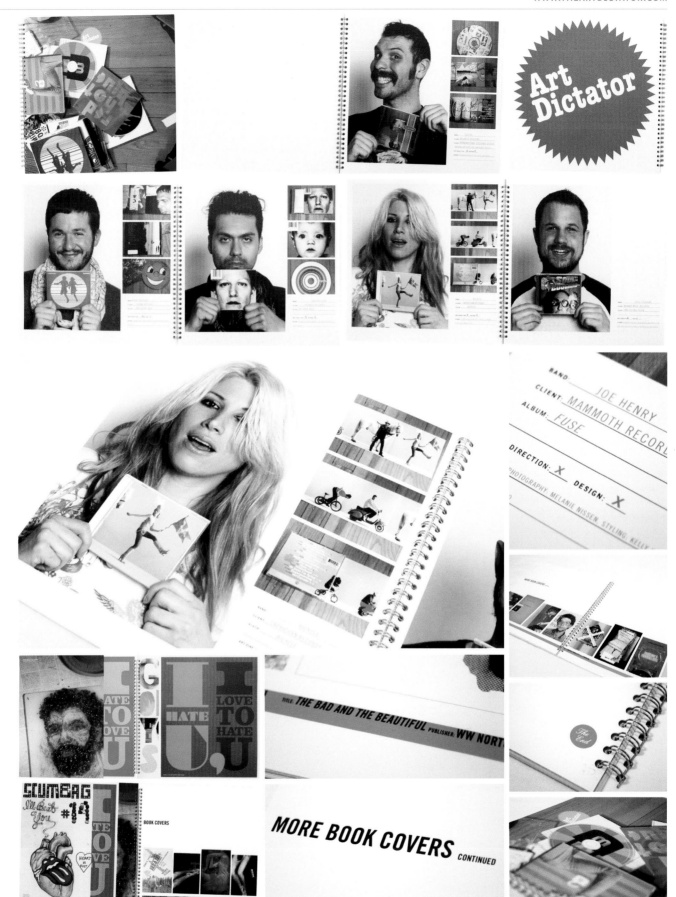

EVERYONE MUST CREATE A PORTFOLIO IN ORDER TO GRADUATE FROM THE UNIVERSITY OF NORTH TEXAS COMMUNICATION DESIGN PROGRAM—I ALSO USED IT TO ACQUIRE MY FIRST FULL-TIME JOB.

STATUS

Retired after three months of use.

APPROACH

I originally wanted to have a larger hand-bound book for interviews, and a smaller book to send out to places where I wanted to work—the large book proved too ambitious, so I only produced the small book. I chose the size based on lulu.com options, a square that fit perfectly within a small pizza box from Uline. I had planned on silkscreening this. Ultimately, my website was enough to earn interviews, and the small book was enough to impress the people I met.

I never sent the book out, so lulu.com was not involved in the first set of copies. I silkscreened the cover using eight inks on French Paper. The inside is printed on semi-gloss paper, and was perfect-bound by a friend who ran the university press.

FLEXIBILITY

Nil. I consciously wanted my portfolio to feel like a finished piece. I like the permanence and absoluteness of something that can't be added to, or subtracted from.

MEMORIES

It was generally well-received, though I did get into a drunken argument with a certain esteemed designer from San Francisco (who shall remain nameless, and with whom I now stand on good terms). This person objected to the overall length of my book, saying that I was wasting people's time. My response was, if they didn't have time to look at my work, then I didn't want to bother working for them. I strongly believe that your portfolio should reflect the kind of work you wish to be involved in, and that it should appeal to the kind of people you want to work with.

ONLINE

The online version had a much broader range, and spanned a longer period of time. In almost all cases, the online version was sent out as a link in an email that then turned into an interview. While there was overlap in the content, storytelling, and the type choices, the two pieces functioned quite differently—to me the website was an opportunity to do things you couldn't do in book form.

LASTLY

I think smaller portfolios are easier to carry, especially when interviewing in a large city, where you are often forced to ride public transit. I also believe that having an online presence these days is a must.

LOOKING BACK (5 YEARS LATER)

Looking back on my college portfolio, I'm still quite happy with it, and I think it was an appropriate solution for 2007. However, if I were graduating and seeking a job today my approach would be different. I did—thankfully—put a lot of effort into my website back in 2007, but that would be my primary focus in 2014—potentially at the expense of any physical book. Having reviewed portfolios and hired designers over the past few years, a digital portfolio is a must-have in my opinion. I still believe there is a role for print, but it's in a much more limited and secondary capacity. Leave-behinds and mailers can still be powerful tools if done well.

ABOUT

Ben Barry is a designer in Brooklyn, NY. Previously, Barry worked at Facebook, where he focused on developing internal culture, voice, and brand. Barry also co-founded the Facebook Analog Research Laboratory, a print studio and art program. Before Facebook, Barry, a graduate of the University of North Texas, worked for The Decoder Ring in Austin, TX. Barry is also an alumnus and advisor of Project M.

I only showed it in person—if people didn't have time to see me, I didn't have time to work for them.

PRODUCTION DETAILS

STRUCTURE	DIMENSIONS (IN.)	PRINTER	PRODUCTION TIME	PRODUCTION COST
Perfect-bound book	8.5 × 8.5	Canon i9900	—	$150 Per book
PAPER	**SPECIAL TECHNIQUES**	**VENDORS**	**RETAIL STORES**	**TYPEFACES**
Cover: French Paper, 140lb Interior: Red River, double-sided semi-gloss, 45lb	Eight spot ink Silkscreen	University of North Texas Press	—	Gotham United

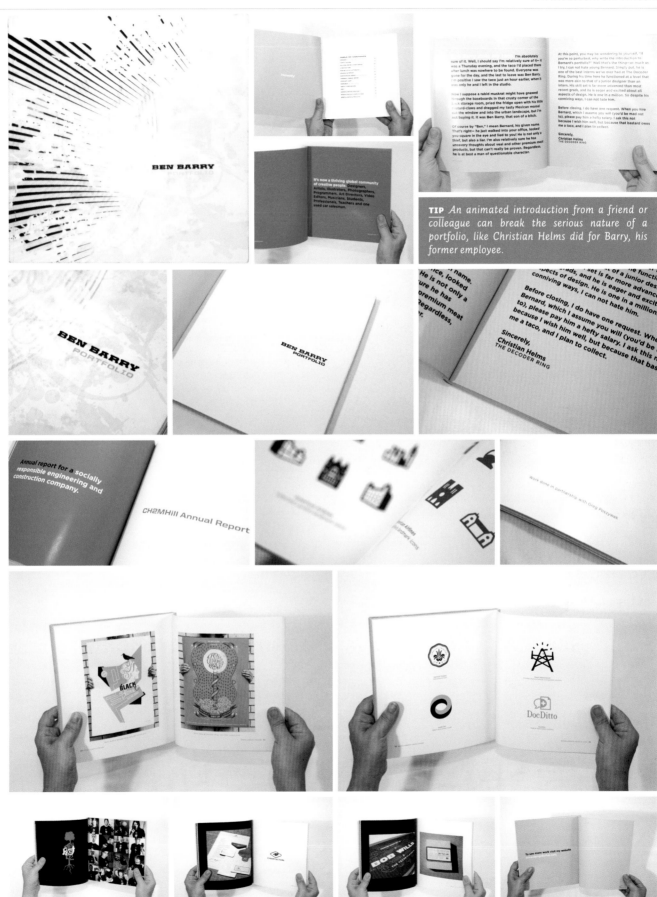

TIP An animated introduction from a friend or colleague can break the serious nature of a portfolio, like Christian Helms did for Barry, his former employee.

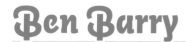

I CREATED THIS PORTFOLIO IN THE FINAL DAYS OF MY TIME WORKING AT FACEBOOK (DECEMBER 2013) WHILE I STILL HAD ACCESS TO THE RESOURCES AT THE ANALOG RESEARCH LABORATORY—I NEEDED IT TO LET PEOPLE KNOW THAT I HAD LEFT FACEBOOK AND WAS AVAILABLE FOR FREELANCE WORK.

STATUS

Still in active duty.

APPROACH

I was driven by budget, time, and the resources I had access to: silkscreening, color laser printer, and saddle-stitch stapler. I also wanted it to be simple, lightweight, and easily mailable while still being nicely designed and produced, so I used simple uncoated paper stock cover with a digitally printed interior. I folded and stapled it with a standard saddle-stitch.

FLEXIBILITY

None. This is true because of the form, but mostly due to the content. It is meant to show work done during a specific period of time for a specific client.

DELIVERY

I don't really "show it". I mail copies to people, and give them to people in person as a takeaway. If I'm meeting with someone in person they're already familiar with my work from my website.

MEMORIES

Several recipients posted photos excitedly on Facebook and/or Instagram. Feedback has been positive, and it's helped get me several projects by reminding people I already knew that I was available.

ONLINE

While not specifically designed to work together, most of the work is also on my personal portfolio website. My website is the primary way that people are exposed to my work.

OTHERS

I have had many online portfolios, but as for physical portfolios just my portfolio upon graduating college.

ABOUT

Ben Barry is a designer in Brooklyn, NY. Previously, Barry worked at Facebook, where he focused on developing internal culture, voice, and brand. Barry also co-founded the Facebook Analog Research Laboratory, a print studio and art program. Before Facebook, Barry, a graduate of the University of North Texas, worked for The Decoder Ring in Austin, TX. Barry is also an alumnus and advisor of Project M.

> I think in general the internet is the best way to get your work out there, but using print in limited applications can feel very special and unique for the recipient.

PRODUCTION DETAILS

STRUCTURE	DIMENSIONS (IN.)	PRINTER	PRODUCTION TIME	PRODUCTION COST
Saddle-stitched book	8.5 × 11	Canon imageRUNNER	3 Days	$2.40 Each x 220 $528 Total
MATERIALS	**PAPER**	**RETAIL STORES**	**SPECIAL TECHNIQUES**	**TYPEFACES**
Staples	Cover: French Paper Construction, Nightshift Blue or Steel Blue Interior: Hammermill Color Copy Paper	Amazon.com French Paper	Silkscreen Hand-stapling	Alright Sans

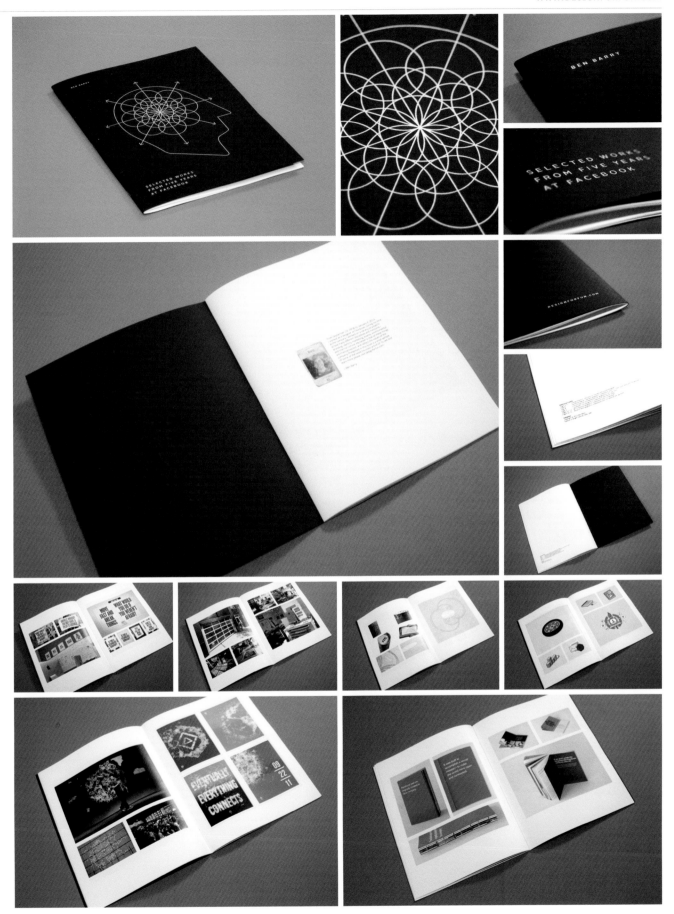

Julia Ondich

THIS PORTFOLIO WAS CREATED IN THE SPRING OF 2008 FOR MY GRADUATION FROM THE SEATTLE CENTRAL COMMUNITY COLLEGE GRAPHIC DESIGN PROGRAM (NOW THE SEATTLE CENTRAL CREATIVE ACADEMY). I WAS PLANNING ON PURSUING MY FIRST FULL-TIME JOB AS A GRAPHIC DESIGNER.

STATUS

I used it for a period of two months, where I presented the portfolio at five interviews and a couple of talent pools.

APPROACH

Circumstances, resources, and my own quirkiness dictated my choice of materials. I wanted the portfolio to act like a storybook—to speak in my voice, and to convey the stories I'd accrued concerning projects, and the circumstances under which I was creating each piece. CaseEnvy, a Seattle-based company, manufactured the screw-post binding. I filled it with pages printed on Moab Entrada double-sided inkjet paper, and printed on the large-format Epson in Seattle Central's production studio. The herringbone jean bag with red zipper was custom-made by a friend of mine to fit the portfolio. I found the red briefcase at a Goodwill store.

FLEXIBILITY

I suppose that it is. I could use the exact same format and add newer work to it, but I feel that I have outgrown this portfolio. My skill set has expanded since leaving school, and I would probably want to do something a little different next time around—though I'd maintain the storybook style.

DISPLAY

I have done both in person and delivery, but my website was enough to generate a first round interview.

MEMORIES

I usually bring a set of drawings and tiny paintings along with me when I present. I use them to tell the story of how I became acquainted with graphic design—people enjoy sifting through my briefcase of strangely-printed treasures.

LOOKING BACK (5 YEARS LATER)

I graduated design school on the cusp of what would become the digital multi-screen explosion and the beginning of a huge economic downturn. I still had a flip phone in my pocket. While it's a little painful to look back on at this point, this portfolio really served me well. It got me in the door and launched a successful (so far!) career despite the economic environment. I've had the privilege of working on everything from packaging in the outdoor industry to retail environments as well as illustration and brand identities for new companies. I've been very lucky.

ABOUT

Julia Ondich is a designer working in Seattle, WA. Ondich attended the Seattle Central Creative Academy and started her career in 2008 at Urban Influence Design Studio. Ondich then worked on packaging design and retail environments at Mint Design with Mike Calkins for many years. Ondich is currently a Senior Designer at FellSwoop, working primarily on apps and digital cross-device experiences for retail clients like Brooks Shoes and publishing industry giants Condé Nast and Time Inc.

> I was so exhausted that I drilled holes on the wrong side of the paper twice in a row, so in a nervous fit I had to print the entire thing three times.

PRODUCTION DETAILS

STRUCTURE	DIMENSIONS (IN.)	PRINTER	PRODUCTION TIME	PRODUCTION COST
Case with screw-post book	11 × 14	Epson 4900	2 Weeks	$2 Case $200 Total

MATERIALS	PAPER	VENDORS	RETAIL STORES	TYPEFACE
Screw-post masonite book Denim fabric Zipper	Moab Entrada, double-sided matte inkjet, 300g/m2	Case Envy	Paper Haus	Archer

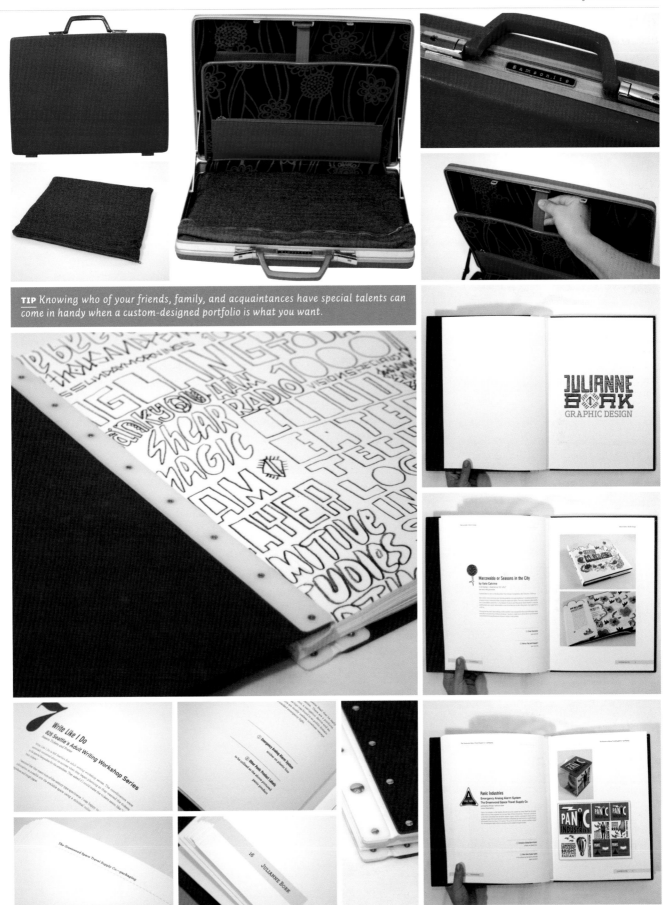

TIP Knowing who of your friends, family, and acquaintances have special talents can come in handy when a custom-designed portfolio is what you want.

David Lanford

THIS PORTFOLIO WAS CREATED IN 2012, WHEN I WANTED TO PRESENT SOME RECENT WORK TO MY CLIENTS AND FRIENDS IN AN INVENTIVE MANNER.

STATUS

I did one mailing in 2012. It is no longer in use.

APPROACH

I think everyone likes to flip through a stack of colorful cards or pictures—I know I do. It was this concept and the price that prompted the choice. The postcards were printed at moo.com. The print quality and finishing are great. A stack of 21 cards is tied together with string and a small blue "tag". It is very low tech.

FLEXIBILITY

It would be very easy to update—just add more cards to the stack.

DISPLAY

These were sent by US snail mail.

MEMORIES

I did not get much in memorable anecdotes—but the increase in web traffic was nice.

ONLINE

All of the work in the portfolio is on my website. This mailing simply shows recent work that many of my clients may not know about.

OTHERS

This was my second review piece. The first review of my recent work was a large tabloid.

ABOUT

David Lanford creates identities, publications, and environmental graphics for clients such as the National Park Service, the Smithsonian Institution, and the Architect of the Capitol. Lanford was formerly an associate at Gallagher & Associates where he collaborated with the Kennedy Center for the Performing Arts and the National Trust for Historic Preservation. Lanford lives with his family in Silver Spring, MD, where he can usually be found walking his golden retriever.

I keep coming back to this:
If you are truly different, you will look different.

PRODUCTION DETAILS

STRUCTURE	DIMENSIONS (IN.)	PRINTER	PRODUCTION TIME	PRODUCTION COST
Individual cards	4 × 6	Digital	—	$ 25.50 Each × 40 $1,020 total

MATERIALS	PAPER	VENDORS	RETAIL STORES	TYPEFACES
String	—	moo.com	Local hardware store	Kievit

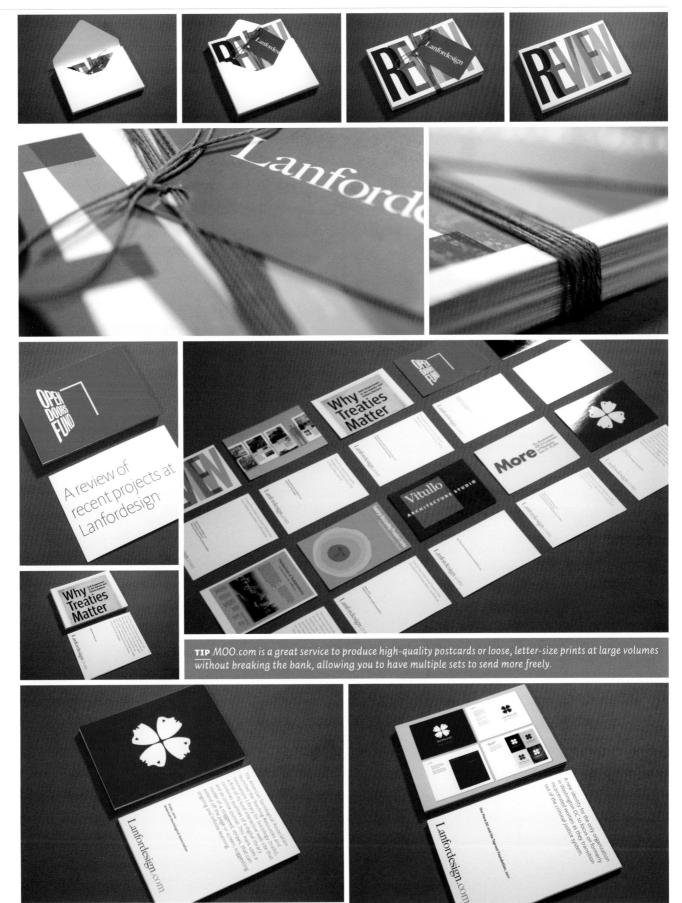

TIP MOO.com is a great service to produce high-quality postcards or loose, letter-size prints at large volumes without breaking the bank, allowing you to have multiple sets to send more freely.

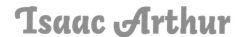

Isaac Arthur

MY PORTFOLIO WAS CREATED TO GAIN FREELANCE OPPORTUNITIES WITH DREAM CLIENTS; PLACES LIKE MICROBREWERIES, HUMANE SOCIETIES, AND FLY-FISHING SHOPS.

STATUS

I presented my portfolio to dozens of people in New York, NY, at the 2009 Art Directors Club National Student Portfolio Review and to twice as many potential freelance clients here in Indianapolis, IN.

APPROACH

I began my Capstone Portfolio Class at Herron School of Art and Design in January 2009. We began the semester by determining what we wanted out of life, how design fit into that plan and how our portfolio and presentation helped to articulate and achieve such goals. I wanted a standard portfolio book to showcase my work, but also wanted to include process sketches, printed pieces, and several other small pieces. I hated the idea of carrying everything loose in a case and wanted an excuse to get in the wood shop. So I started sketching and prototyping a hybrid book/box to meet my specific needs.

Rather impetuously, I decided on a final size and format for my portfolio before knowing whether or not I could acquire the necessary materials. Luckily, I was able to get a screw-post hinge from Shrapnel Design and some beautiful walnut wood from a local lumber store.

FLEXIBILITY

I'm dealing with this now. I hate using plastic sleeves to present my work, so I designed my portfolio to have a raw texture that included uncoated exposed paper. I wanted people to be able to touch the paper when viewing my work. While great in theory, the book is not as modular as it needs to be. For example, last week I showed my portfolio to a local nightclub, and had to reprint several pages because a project I didn't want to show them was on the backside of a project I was including.

DISPLAY

I only show my portfolio in person because I like to drive the discussion. If I want to work with someone in another state, I'll send them an introductory letter via post, with an invitation to check out my website, and take it from there. I actually landed a freelance gig in Florida using this method.

MEMORIES

Before my first interview, I was waiting outside the studio, trying to get up my nerve. A bird flew overhead and shit on the messenger bag I used as a portfolio case—a disgusting smear down the front corner. Incredulous, all I could do was wipe the bag off in the grass and go inside to present.

ONLINE

My website complements my portfolio by showing more images and details about each project. When sharing the portfolio, I discuss project goals and design decisions with the person across the table from me. I try to accomplish this on my website with conversational copy, but it's certainly not the same.

PREVIOUSLY

During college, I used a blog and a bundle of boards to earn freelance work. Looking back, it's amazing that I managed to get any work, let alone the fun projects I was fortunate enough to be involved with.

LASTLY

I use every opportunity and bit of feedback I get to craft a better portfolio presentation. I'm amazed at how many young designers will get negative feedback on their portfolio and take it to their next interview without even considering what they heard.

LOOKING BACK (5 YEARS LATER)

I used my portfolio for a brief period while still in school, but founded CODO Design the day after graduation. So almost as soon as it debuted, it started to collect dust. If we're being honest, I built it because it was a requirement of our senior capstone class. We had been planning CODO for a year leading up to graduation and while I knew I would never use the thing, I treated it as a fun wood shop project.

All that being said, I do still use a print portfolio on a weekly basis for my business. We used to have something similar to the elaborate setup I built in school, but over time, simplified it to what it is now; a series of utilitarian Pina Zangaro screw-post books with plastic sleeves that house work tailored to whatever industry we're talking to that day.

When we first started using the screw-post book, we would feverishly swap out projects and pages leading up to a meeting. Now, we have separate portfolios for different work categories: food and beverage, general small business, and nonprofit clients. All of our responsive web design is showcased on an iPad.

This set up has made our lives easier and it's funny how amazed people are when you pull out a portfolio. I imagine it's something akin to the cool, restored warehouse creative space that design firms are all supposed to have—people love seeing a real life portfolio—even if it's just a simple tool.

ABOUT

Isaac Arthur is partner and designer at CODO Design, an Indianapolis, IN, branding and web design firm founded on the belief that they can create better design by including clients in the creative process. They focus on the food and beverage industry, small businesses, and not-so-small businesses.

PRODUCTION DETAILS

STRUCTURE	DIMENSIONS (IN.)	PRINTER	PRODUCTION TIME	PRODUCTION COST
Box with screw-post book	11.5 × 14 × 2.75	FedEx Office	2 Weeks	$275
MATERIALS	**PAPER**	**VENDORS**	**RETAIL STORES**	**TYPEFACES**
Walnut wood Aluminum screw-post	Cougar, 80lb cover	Shrapnel Design	—	Caecillia Trade Gothic

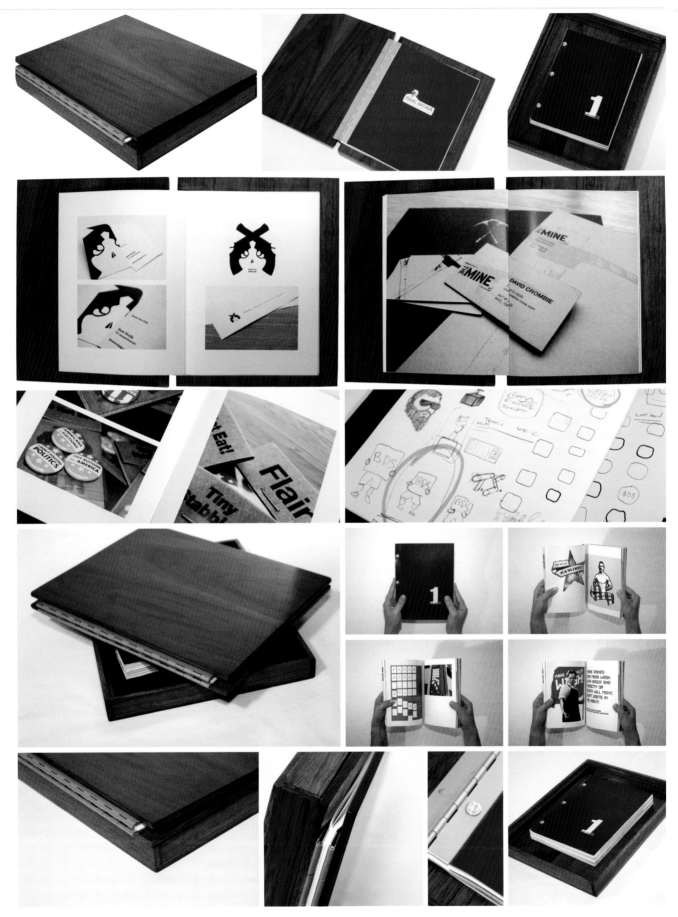

Anna Hatzisavas

MY PORTFOLIO WAS CREATED IN MY FINAL MONTHS OF UNIVERSITY (NOVEMBER 2012), WHERE I COMPLETED A BACHELOR OF DESIGN AT MONASH UNIVERSITY IN MELBOURNE, AUSTRALIA. IT WAS MY FINAL ASSESSMENT TASK, AND WAS ASSESSED BY MY TEACHERS AS WELL AS INDUSTRY CREATIVES. IT WAS ALSO MEANT TO ENSURE THAT I HAD EVERYTHING READY TO FIND A JOB AFTER GRADUATION, BE IT A FULL-TIME JOB AT A FIRM OR FREELANCE WORK.

STATUS

While I have now found employment, using this portfolio to help secure my position, I do sometimes still use it for freelance positions—although the book is becoming slowly outdated.

APPROACH

I had two components to my portfolio: my book, with my project descriptions accompanied by photographs of my projects, and the physical version of each project (when possible). I wanted a box that could keep these components neatly together and I wanted the overall design to be simple and timeless, something that I could get years of use out of.

The box itself is lined with Buckram on the exterior for its durability and linen on the interior for its softness. It has my name embossed on the spine and an internal shelf where the book sits flush with the edge of the box. A ribbon helps lift out the portfolio, where the physical items can be found underneath. A magnet located in the flap/opening of the box ensures it stays closed. The book had to be printed and bound simultaneously with the creation of the box in order to calculate the thickness of the book to, in turn, calculate the height of the internal shelf. This ensured that the book sat absolutely flush with the edge of the box. The book uses white boxboard for the hard covers and is coptic-bound. I chose to use section binding so that the pages would fall flat open when taking people through the portfolio—I left the binding exposed purely as a visual aesthetic. Gold foiling was used on the cover for my logo. The same gold foiled logo was also used for my business cards, and the same font across my business cards and website.

FLEXIBILITY

I did consider this when creating my portfolio but I didn't want a portfolio that had loose pages, Chicago screws, or plastic sleeves. I feel like I found a happy medium with the box—the physical items within are obviously easy to add and remove—and it is only the book that would require an update.

DISPLAY

I always show it in person which is why I have only included a few sentences for each project description—as I like to explain the projects more thoroughly myself. I believe your portfolio gets you an interview, but your personality and ability to explain your work and processes get you the job.

MEMORIES

I was once asked what was the point of having the same project in the book as well as the physical version! I believe that it's nice to be able to hand over the physical version to an interviewer while talking to the images.

ONLINE

My portfolio branding is carried across my business cards and website. A website is also of course much easier to update with current work, and is accessible anywhere in the world—it is just as important as a physical portfolio.

LASTLY

Your portfolio not only showcases your work, but it also says something about you, so it is important to make it the best it can be! Don't rush it, don't cut corners, and be prepared to pay a bit more to ensure quality!

ABOUT

Anna Hatzisavas is a graphic designer born, living, and working in Melbourne, Australia. After graduating with a Bachelor of Design, Hatzisavas has worked for various Melbourne studios, and has exhibited her work in Melbourne and Sydney. Hatzisavas has a particular love for typography and publication design and enjoys designing for both print and digital mediums.

PRODUCTION DETAILS

STRUCTURE	DIMENSIONS (IN.)	SPECIAL TECHNIQUES	PRODUCTION TIME	PRODUCTION COST
Coptic-bound book and samples in a case	8.3 × 11.7	Gold foil Embossing	2.5 Weeks	$410
MATERIALS	**PAPER**	**VENDORS**	**RETAIL STORES**	**TYPEFACES**
Buckram Linen Boxboard Binder's thread	Stephens Smart White, 140g/m2	Whites Law Bindery	Paper Point	Futura Std Book

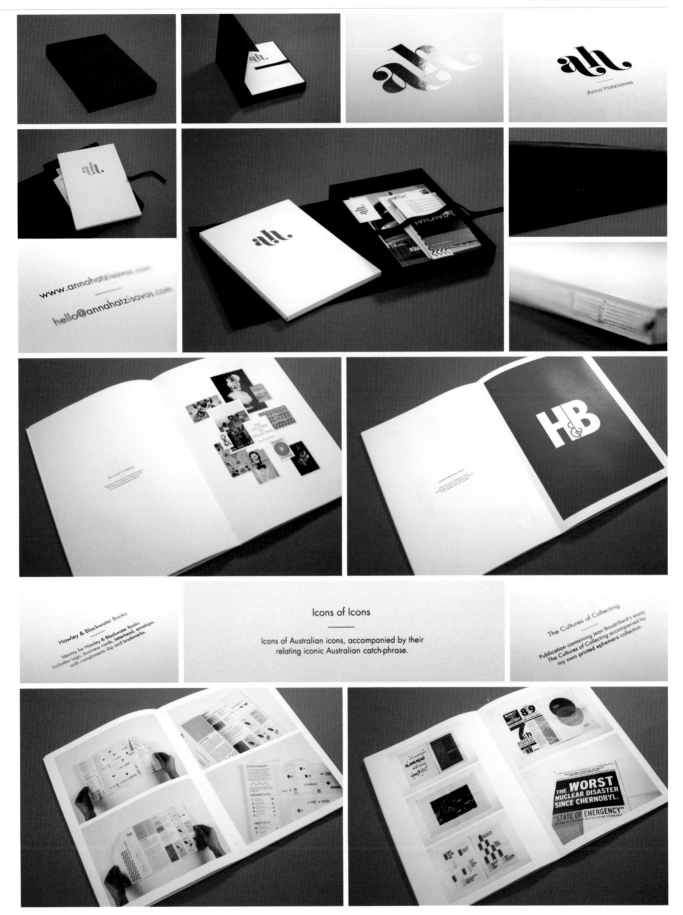

Hawley & Blackwater Books

Identity for Hawley & Blackwater Books. Includes logo, business cards, letterhead, envelope, with compliments slip and bookmarks.

Icons of Icons
———
Icons of Australian icons, accompanied by their relating iconic Australian catch-phrase.

The Cultures of Collecting

Publication containing Jean Baudrillard's essay The Cultures of Collecting accompanied by my own printed ephemera collection.

Leanna Jones

I CREATED MY PORTFOLIO IN THE GRAPHIC DESIGN PROGRAM AT SAN DIEGO CITY COLLEGE IN SPRING OF 2013. IT WAS THE LAST CLASS I TOOK IN ORDER TO REFINE AND CURATE MY WORK FOR FUTURE EMPLOYMENT. THE PROCESS BEGAN IN JANUARY AND ENDED IN MAY—AFTER COMPLETING SCHOOL I USED MY PORTFOLIO TO SECURE A JOB.

STATUS

It's still in use because I show certain projects, but I was lucky enough to find work quickly after graduation with my book. I've stayed busy since finishing it, so I haven't really needed to show it in its entirety recently. I am in the process of adding some of my professional work to the mix.

APPROACH

I was determined to have a print portfolio. I really identify with the narrative book approach that San Diego City College focuses on and wanted to create an individualized reflection of my design sensibility. Craftsmanship and hand elements play a big role in my design process and philosophy.

I printed the pages at home on an inkjet printer, a total of eleven signatures. Having a good amount of creative control is important to me, especially in situations where I am creating something personal. I built the covers using bookbinder's board and imitation suede book cloth. The tactile quality of that book cloth aligns with my design philosophy and overall theme. My book had a multi-cultural vibe so in the end I felt that coptic binding best supported the style of the work. Nine holes were punched into the covers and signatures and I bound the pages together with white binder's thread. I also heat-pressed my personal logo in white vinyl onto the cover.

FLEXIBILITY

While it is technically possible to update the physical book, I built it to act as a representation of what I accomplished in my undergrad education. In the future as I update my work I will make corrections on my website because it changes so frequently. Although it is not always in active use, it was important for me to have an artifact that shows the work I did during that time. I am passionate about book-making, so don't be surprised if I create one in the future. I like the idea of ending up with a library of portfolios.

DISPLAY

In person. I also have an online flipbook that reflects the interior contents that I send to people when I can't show it live.

MEMORIES

When I first ordered the book cloth I had this idea in my head that it would be a little more on the orange side and a little earthier than the bright coral pink that greeted me when I opened the package. I was under a stressful deadline to complete the project and I am NOT a pink-girl type. When I saw it I cried—I showed it to my instructor, who tried to convince me that it was okay and that it would work perfectly. In the end, I didn't have a choice. I don't know if I just needed to spend time with it, but once I built my covers I fell in love with that coral pink and really made it my own. Now, a year and a half later nearly everything I buy is in that color.

LASTLY

I chose to attend a portfolio program outside of where I got my undergraduate degree because I knew that it would be a more intense and difficult process. I knew that I would find fulfillment knowing that I worked harder and was being pushed to reach my fullest potential. San Diego City College has a reputation for creating very authentic, personal, narrative-driven portfolios and I felt that this approach resonated with me the most. My advice to people would be to always push yourself further than you think you should and create something that is your own. I think creating something that really showcases your authentic voice is key, and SDCC was where I think I really found mine in the early phases of my design education.

ABOUT

Leanna Jones is a graphic designer, creative enthusiast, and visual junkie born and based in San Diego, CA. After graduating from San Diego State University with a degree in design and a newfound love of book/print-making and letterpress, Jones completed the design program at San Diego City College. After completing her portfolio Jones won Best of Cross Cultural Design in the 2013 AIGA San Diego Student Portfolio Review. Jones went on to work at Digitaria with clients such as Qualcomm, Islands Burgers, Discover America, and CBRE. Currently Jones freelances with Digitaria and other companies on a variety of app and web-related projects. Jones also enjoys taking on fun, interesting projects solo, including branding and packaging for Churn and Kaneh Co. When Jones is not designing, you can usually find her at a good festival, the beach, practicing (and teaching) yoga, singing, dancing, cooking, or hanging out with her best friend, a chocolate labra-hound puppy named Penny.

I like the idea of ending up with a library of portfolios.

PRODUCTION DETAILS

STRUCTURE	DIMENSIONS (IN.)	PRINTER	PRODUCTION TIME	PRODUCTION COST
Coptic-bound book	9 × 12	Canon Pixma Pro 9000	3 Days	$400

MATERIALS	PAPER	VENDORS	RETAIL STORES	TYPEFACES
Waxed thread	Red River double-sided	Red River	Artists & Craftsman Supply	Bodoni Egyptian
Bookbinder's board	Polar, matte, 60lb	Hollanders	Office Supply Store	Bodoni Poster
Book cloth		Enormously		Metro

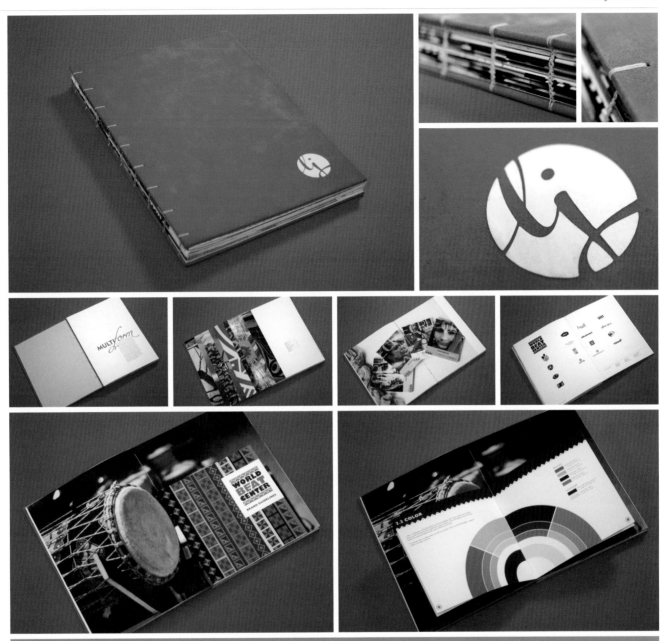

TIP Small booklets within a larger portfolio are a great way to add information that is clearly encapsulated to the one project. These smaller booklets can be sewn, glued, inserted, or even stapled. Use them to add process, research, guidelines, or additional project scope.

Hamish Childs

I CREATED THIS PORTFOLIO BETWEEN MAY AND JUNE OF 2011, AS A RETROSPECTIVE OF MY FIRST THREE YEARS OF PROFESSIONAL WORK BEFORE I RELOCATED FROM CHRISTCHURCH, NEW ZEALAND, TO MELBOURNE, AUSTRALIA. I WAS LOOKING FOR FULL-TIME WORK. THERE IS SUCH HIGH LEVEL OF TALENT AND GREAT STUDIOS IN MELBOURNE, I FIGURED I NEEDED TO DO MORE WITH MY PORTFOLIO THAN EMAIL A PDF OF MY WORK TO STAND OUT.

STATUS

A few months initially, although now I have completed a lot more projects since, it still is good to have on hand and I do still hand them out now and then.

APPROACH

I felt it was a good/different format to showcase my body of work to date and also create something tangible that I could give to people.

FLEXIBILITY

Yes. I think the format is good and I would like to continue to update and catalog my work within this format. Possibly every three years?

DISPLAY

I always try to hand-deliver my portfolio for review. If asked back for an interview, it was a good way to present and talk through the work.

ONLINE

My website—although in need of a major update—does complement my printed folio in style, fonts, colors, etc. They are not identical, but there are consistencies between the two.

ABOUT

Hamish Childs is a passionate multidisciplinary designer from New Zealand. Childs takes a conceptual attitude to every project whether it's branding, signage, exhibition design, packaging, print, publication, or digital design, creating visually interesting solutions to communicate ideas—Childs' work is often inspired by his keen interest in illustration and graffiti art. Childs work has been recognised by the New Zealand Best Awards and Australian Design Biennale Awards.

PRODUCTION DETAILS

STRUCTURE	DIMENSIONS (IN.)	PRINTER	PRODUCTION TIME	PRODUCTION COST
Folded poster into booklet form	Flat: 30.7 × 22.5 Folded: 7.5 × 5	—	2 Weeks	—

MATERIALS	PAPER	VENDORS	RETAIL STORES	TYPEFACES
—	Via Smooth, Bright white, 148g/m2	Blueprint Ltd	—	Graphik

TIP *Folds within a larger sheet are a great method to add pacing, hierarchy, and intrigue.*

Matthew Takach

DURING MY SENIOR YEAR AT THE KANSAS CITY ART INSTITUTE, I TOOK AN INDEPENDENT STUDY COURSE CALLED PROFESSIONAL PRACTICE. ONE OF MY ASSIGNMENTS WAS TO DESIGN A PORTFOLIO. THIS INCLUDED DESIGNING THE BOOK ITSELF AND ALSO CRAFTING A WAY TO PRESENT MY BODY OF WORK AND MYSELF ALONG WITH IT. ADDITIONALLY ALL OF THE STUDENTS WERE REQUIRED TO ENGAGE IN AT LEAST THREE INTERVIEWS OR PORTFOLIO REVIEWS WITH WORKING PROFESSIONALS.

STATUS

This book started as a school project to present my student work. I updated it a few times on my first year or two after graduation but it has since been replaced with a new portfolio that reflects having more years of experience as a designer.

APPROACH

After I created an all-encompassing identity, I settled on a horizontal Wire-O-bound format that would allow for a large and luxurious presentation. I felt that my body of work should be presented as a single holistic product with an intentional progression, with built-in flexibility that allowed me to edit the content if necessary. For every project in this book, there are two spreads: the first shows the final piece, and the second is for the process work. I included examples of my initial stages, ideation, half-baked concepts, prototypes, and semi-final designs. I believe this helped others understand how I worked through a project, and to determine whether or not my process was similar, or compatible, to theirs. I made the covers with black matte board and Fabriano paper. I used a laser-cutter to carve the logo out of the board I adhered to the front. The interior pages were printed, french-folded, trimmed and collated, and the book was Wire-O-bound with a wrapping technique that hid the spine.

FLEXIBILITY

Because my book was bound with a Wire-O, it was possible to cut the wire and replace pages whenever necessary.

DISPLAY

In my experience, when designers are interviewing potential employees they want candidates to actively present their work—so this is what I always do. I've heard stories about interviewers who just flipped through portfolios in five minutes and made snap judgments, but I haven't had that experience. Those whom I have met cared about the body of work and how it was presented, both visually and verbally.

MEMORIES

Interviewers seemed intrigued, and they appreciated the visceral quality of the material—they touched the die-cut materials and asked technical questions about my production solutions. I wasn't always sure if they liked it or not, but at least it wasn't something they just wrote off. Although I intended to have a large book, I went overboard—when the book was open on a table, it spanned well over 3 feet. One time, I had an interview at a small firm, where they didn't have a large surface in which to present. I spent the whole time trying to balance this huge portfolio on a small plastic chair while holding my laptop on my knees, in order to show examples of my screen-based work.

ONLINE

I currently have an online portfolio, which complements my printed book. However, my website is very systematic and consistent, in contrast to the more dynamic printed portfolio. I also do not show any process work, because that imagery really needs to be explained in person in order to be properly understood.

LASTLY

In some interviews, people were surprised by two things in particular: a) that I was presenting this large, old-school book; and b) that I included process work. I always thought it odd to not do these things.

LOOKING BACK (5 YEARS LATER)

After seeing my portfolio published in the first edition of *Flaunt* it was obvious to me that my book looked like it had been done by an inexperienced designer. Compared to the more established entries mine looked very green. A few years later I redesigned my portfolio, incorporating the lessons I learned from reading *Flaunt*. Back then I was using my new portfolio (page 84) in earnest and I was much happier with how it worked during interviews, and I think it was obvious that the presentation belonged to a more seasoned designer than my original book.

ABOUT

Matthew Takach is a graphic designer in New York, NY. Takach received a BFA from Kansas City Art Institute, and is the design director of a small design firm called One Tomato.

PRODUCTION DETAILS

STRUCTURE	DIMENSIONS (IN.)	PRINTER	PRODUCTION TIME	PRODUCTION COST
Wire-O-bound book	12.5 × 20	Epson R1800	25 Hours	$125

MATERIALS	PAPER	VENDORS	RETAIL STORES	TYPEFACES
Matte board	Mohawk, Superfine, 100lb	Limited Papers	Office Depot	FF DIN
PVA glue			Pearl Art Supply	FF DIN Text Pro

TIP *A portfolio's design should not overshadow the work shown inside—Takach's bold numbering system anchors all of his projects without overshadowing.*

Matthew Takach

I DESIGNED AND BUILT MY PORTFOLIO IN THE SPRING OF 2013. I HAD LEFT MY FULL-TIME JOB A FEW MONTHS PRIOR AND WAS WORKING AS A FREELANCE DESIGNER, BUT I WAS ALREADY BEGINNING TO THINK ABOUT POSSIBLY SETTING UP INTERVIEWS FOR A FULL-TIME JOB IN THE FUTURE. WHILE I HAD PREVIOUSLY UPDATED MY ONLINE PORTFOLIO MY BOOK WAS IN DIRE NEED OF A REFRESH IF I WAS GOING TO MEET WITH POTENTIAL EMPLOYERS.

STATUS

I ended up using my portfolio for probably about five months. Today I'd consider my book semi-retired. I plan to stick with it but if I were to go on another interview I'd definitley need to update my projects and ideally I would build a more durable wrap-around cover. After being schlepped all over New York, NY, my current book is starting to show some wear and tear.

APPROACH

I believe if a designer's work is more print-focused they should show their work in print, which is why I've always presented my portfolio as a book. My previous portfolio was big. Really really big (page 82). For my current portfolio I wanted to keep it large enough to show the work to a room full of people but small enough that it was easy to handle and would still feel like an intimate experience.

For the interior pages I used Red River paper on an Epson Inkjet printer, which is made specifically for inkjet. The rest of the book was made with black matte board, Canson paper, and book-making glue—the only thing I didn't do by hand is the type on the cover which was laser-cut.

FLEXIBILITY

My previous portfolio was bound with a Wire-O, which made it difficult to update. This time around I decided early on I was going to use screw-posts so I could update it even though that meant the book wouldn't lay flat. This ended up being the right decision since I later decided to update a few projects and even add a new one while I was still using my book for interviews. It's still a little annoying trying to get all the pages as square as possible when I bind it back up but overall I'm happy with how it works.

DISPLAY

I've only shown my book in person.

ONLINE

I have an online portfolio which complements the book without looking like a carbon copy. My website came before the book and it may be one of the last Flash sites on the Internet in 2014.

LASTLY

Opting for something like an iPad slideshow is tempting because it's so much easier than making a physical product, but I also think other designers (i.e. the people who will be interviewing you) agree it looks a lot easier and therefore less impressive. I've personally had people tell me how glad they were to see a physical book rather than a tablet or a laptop. These designers also shared stories about devices crashing, or groups of people not being able to see the work on screen.

ABOUT

Matthew Takach is a graphic designer in New York, NY. Takach received a BFA from Kansas City Art Institute, and is the design director of a small design firm called One Tomato.

> One thing that surprised me was how hard it was to find a case to carry my portfolio around in that wasn't a total eyesore—I ended up borrowing a case.

PRODUCTION DETAILS

STRUCTURE	DIMENSIONS (IN.)	PRINTER	PRODUCTION TIME	PRODUCTION COST
Screw-post book	11.25 × 15	Epson R1800	2 Months	$350

MATERIALS	PAPER	VENDORS	SPECIAL TECHNIQUES	TYPEFACES
Matte Board	Red River 50lb	danger!awesome	Laser-cut	DIN Next
Bookbinding glue	Premium Matte	Dick Blick		
	Double-sided			
	Canson paper			

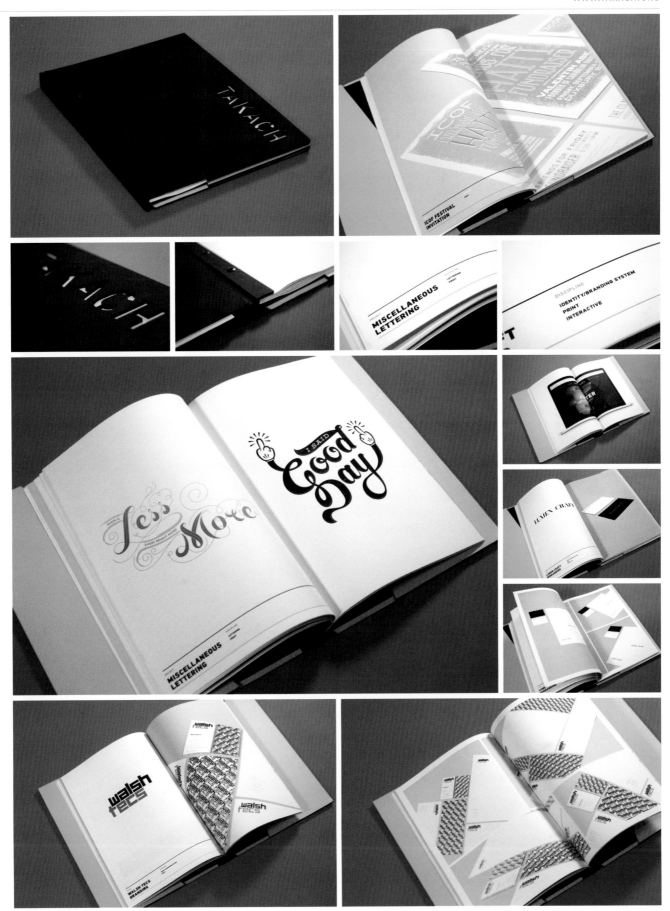

Jon Sorrentino

SIMPLE INTENTIONS WAS CRAFTED AND CONSTRUCTED THROUGH THE WEEK OF MARCH 8TH, 2014. THIS PORTFOLIO WAS TO BE INCLUDED IN MY BFA THESIS EXHIBITION AS A GRADUATING SENIOR AT RUTGERS, THE STATE UNIVERSITY MASON GROSS SCHOOL OF THE ARTS. THE MAIN PURPOSE OF THIS PORTFOLIO WAS TO SHOWCASE AND PRESENT MY WORK TO AN AUDIENCE WHILE ALSO PROVIDING BACKGROUND ON WHAT HAS INFLUENCED ME AS A DESIGNER.

STATUS

The portfolio still attends interviews with me. It really has given employers an idea of my level of craftsmanship and attention to detail as a designer.

APPROACH

The presentation was very important to me with this portfolio. I made the decision to include my actual projects instead of just representations or photographs of them. I wanted to provide the audience with a personal, tactile experience by allowing the work to literally be in the hands of the viewers. I wanted the feeling of opening this portfolio to be similar to opening a treasure chest or a locked safe.

The portfolio is made of a book board that was cut and scored to form the cover and sides. I used a really strong glue to attach the sides to make sure the portfolio wouldn't fall apart.

FLEXIBILITY

I don't think this would be an updatable portfolio, nor would I want it to be. This portfolio is specific to its contents and the time during which it was produced. I also wouldn't want this to become something that I could mix and match with new work. I appreciate the fact that this portfolio represents a specific experience, and would rather create another portfolio using a different approach or piece of inspiration.

DISPLAY

I mostly show this book in person. In fact, there are only two copies of this portfolio and only one of which is in my possession. If something were to happen to it while being delivered the work would be extremely hard to replace.

MEMORIES

On the inside cover of my portfolio I included a section for acknowledgements. I thought I was being sweet by recognizing my girlfriend for always critiquing my ideas. I brought her into the studio the night I "finished" screen-printing to surprise her, but to my surprise she noticed I had a typo in her acknowledgement! I ended up spending that night sanding down that section and re-exposing the screen...so needless to say I wasn't as finished as I had originally thought.

ONLINE

This work isn't complemented by an online version. I have a personal website that encompasses all of my work but not specifically just for this portfolio. I think if there was to be a digital version it would have to be altered in response to its environment.

LASTLY

My advice to anyone who is looking to make a portfolio to present is to always make two copies, because after the first time you'll know where you need to improve. Doing this allows you to really tighten up details and create a final product that is more polished and professional.

ABOUT

Jon Sorrentino is a graphic designer who focuses on creating visual identities, websites, print material, and exhibition spaces. Sorrentino enjoys working on a wide range of projects for clients of all sizes, surveying their surroundings, and defining their visual paths. Sorrentino recently completed his Bachelor in Fine Arts with a concentration in design from the Mason Gross School of the Arts at Rutgers University. Sorrentino was awarded the Paul Robeson Young Emerging Artist award of 2014 which recognizes outstanding achievement in the Visual Arts. In addition to client work, Sorrentino also curates The Yearbook Club *which is a collection of photographs exploring hetertopias and their surroundings.*

PRODUCTION DETAILS

STRUCTURE	DIMENSIONS (IN.)	PRINTER	PRODUCTION TIME	PRODUCTION COST
Custom case with samples	10 × 7.25 × .75	Silkscreen	3 Days	$20
MATERIALS	**PAPER**	**VENDORS**	**RETAIL STORES**	**TYPEFACES**
Book board Glue	Various (for each project)	New York Central Art Supply	FedEx Office	Futura

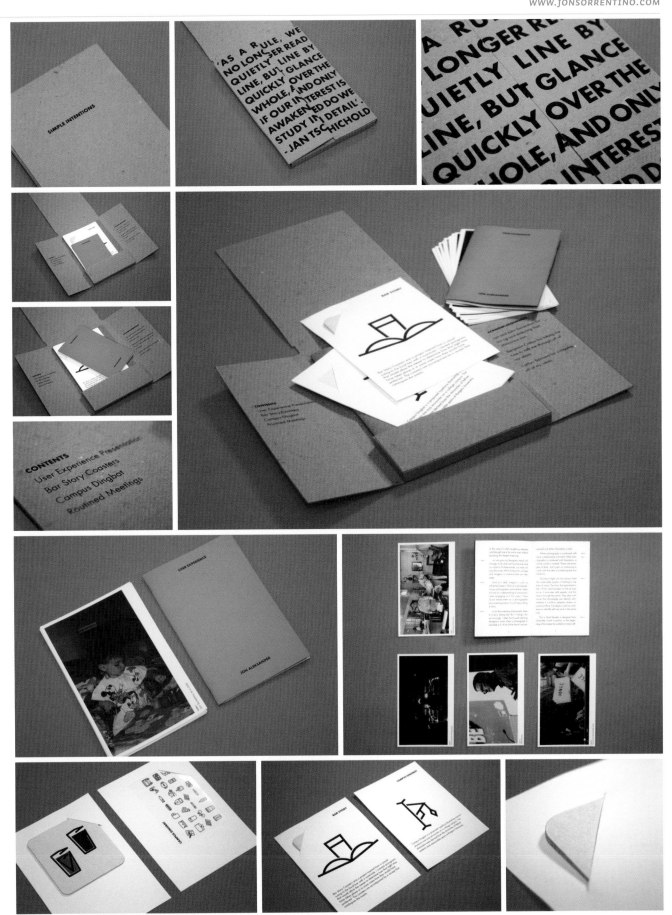

George Cassavetis

MY PORTFOLIO WAS CREATED IN SEPTEMBER/OCTOBER 2013 DURING MY FINAL SEMESTER OF MY BACHELOR OF VISUAL COMMUNICATION DESIGN DEGREE AT THE QUEENSLAND COLLEGE OF ARTS IN BRISBANE. SINCE THIS WAS A GRADUATE PORTFOLIO IT REQUIRED THAT I SHOWCASE WORK PRODUCED DURING MY STUDIES. I MADE THE DECISION THAT THIS PORTFOLIO WOULD TAKE THIS QUITE LITERALLY AND ACT AS A SNAPSHOT OF ME AND MY WORK AT THE TIME OF CREATION.

STATUS

It is currently still in use. The work is quite conceptual and so does not always go down well with those viewing it, but I still show this portfolio to demonstrate that I have a different way of approaching not only design problems but problems in general.

APPROACH

Almost all of my work is print-based. As a result, it can best be presented in print form. The works themselves, as stated earlier, are quite conceptual and require some explanation. By creating this portfolio in print it allowed me to curate the works as needed and guide the reader through a more tactile journey in discovering my voice, my style, and my works.

The covers are book boards that were spray painted with a zinc-based black paint. Gold composition leaf was then applied using a sizing that would let the composition leaf move around a bit as the metals in the leaf interacted with the zinc in the paint. Once dry it was coated in a clear, matte sealant to protect the gold composition leaf and to slow down (but not prevent) any further tarnishing. The photo spreads were printed on a heavier stock, while the smaller text pages were printed on a lighter stock.

There are three supplements within: a personal zine, clear/acrylic currency, and a gilded card with letter-punched numbers. The explanation of these three can be found within the text.

The folio itself was hand-bound using three-core waxed linen thread. The binding method was a coptic bind (one of the oldest and strongest binds). It also created a subtle link to the Egyptian side of my heritage (the other side being Greek).

FLEXIBILITY

While technically the binding could be cut and rebound with new pages, I wouldn't classify this portfolio as updatable. I'd never want to add to this portfolio as it would feel like I would be losing the clarity of myself at the time of creation. On a technical note, the paper itself could probably only take one or two re-binds before becoming too weak along the spine.

DISPLAY

I have only ever showed it in person. It is an unusual portfolio and while it stands on its own and doesn't require me to be beside it for it to be understood, I do enjoy seeing people's reactions to it.

MEMORIES

The pages for the photographic spreads needed to be printed three times. The first time the digital printer was not clean and so I received my prints with roller marks and colour streaks, as well as the pages trimmed incorrectly along one edge so that none of the pages lined up when folded. The second time there was a huge improvement in the quality of the print, but one page was still incorrectly trimmed. Due to time constraints I needed to bind it with this error for submission. The error was in the first leaf, first page and it broke my heart to show it like this. Finally after meeting my deadline I received my portfolio back. I got the page reprinted that was still in error and unbound the folio I submitted. I then re-bound it, along with three other versions. In total I bound four of the five portfolios printed. The last one I left unbound somewhat as a symbolic reminder of what I went through.

It was hard for people to envision what the final product would be like, and I believe the printer dismissed it as an arts and crafts project, and so not worthy of the care and attention other jobs received. I worked hard to create something that I believed would change their mindset.

ONLINE

There is no official online companion to this portfolio. I have some of my work listed on Behance but not as a link back to this folio. This is something I have struggled with internally. I do need to create a proper online presence but it would need to be significantly different from that of my print one as different curatorial steps would be needed to help guide the viewer through my way of thinking and designing.

LASTLY

I created this portfolio knowing and expecting it may not be understood or liked by all. I've yet to secure work with it, and as a result of some negative reactions I hid it away and lost confidence in my work. But I seem to have been slapped out of that state thankfully and I am eager to embrace what I have created, and what I'm capable of creating now and into the future, whether it is loved or loathed by others.

ABOUT

George Cassavetis considers design as being more than just making things look pretty. Drawing on aspects of his Greek and Egyptian heritage, Cassavetis' work is mostly conceptual and often has a social comment attached to it. Cassavetis believes design is a powerful tool that has the power to bring happiness, change, awareness, and progress to the world—and that's exactly what he plans on doing with it.

PRODUCTION DETAILS

STRUCTURE	DIMENSIONS (IN.)	PRINTER	PRODUCTION TIME	PRODUCTION COST
Coptic-bound book	6.5 × 7.5	HP Indigo 7500	6 Weeks	$115 Each × 5 $575 Total

MATERIALS	PAPER	VENDORS	SPECIAL TECHNIQUES	TYPEFACES
Book board Waxed linen thread Zinc paint Gold leaf	Photo pages: Ecostar, 200g/m2 Text pages: Alpine Laser, 100g/m2	Adele Outteridge	Gilding	Neustadt

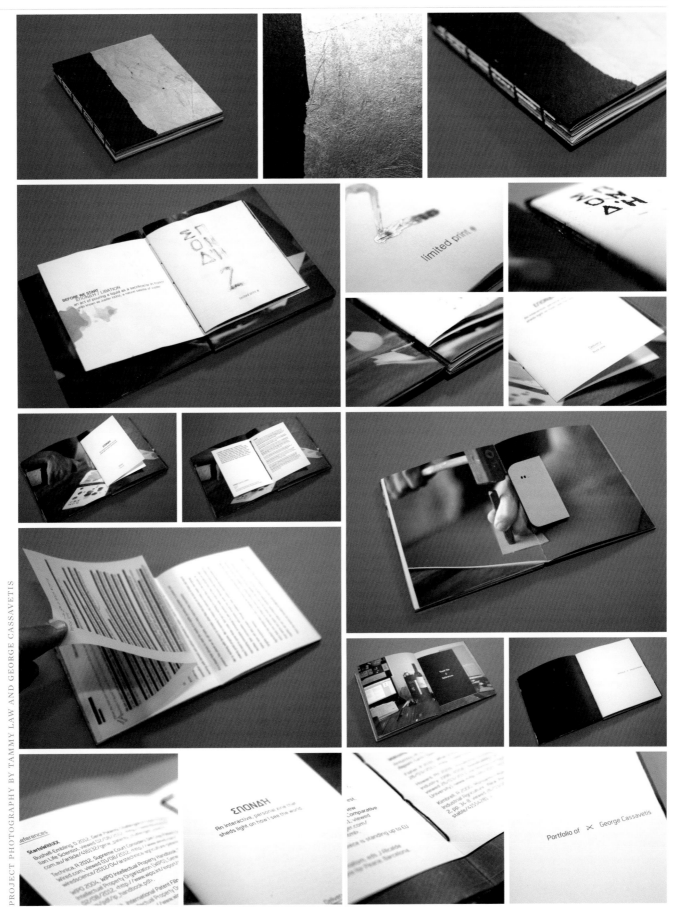

Priya Rajan

I CREATED THIS PORTFOLIO FOR MY GRADUATION AT THE ACADEMY OF ART UNIVERSITY IN 2007. INITIALLY IT WAS USED TO SECURE A JOB AT A DESIGN STUDIO. OVER THE YEARS, I USED IT TO PURSUE FREELANCE WORK AND INDEPENDENT CONTRACTS.

STATUS

I still use it—more as a design project. I created another portfolio that is easy to swap and add projects.

APPROACH

Making a portfolio was daunting as it had to represent me. As a designer, I'm always evolving. It's an organic process. I wanted my portfolio to have that sense and to show my thinking. I'm huge on research. I wanted to include that aspect in my portfolio. Hence, the flap with some of my inspirations.

To highlight the evolving process, I wanted to use a raw form such as the chipboard for the cover. I did silkscreening for the spine. There is a flap for each project to show some of the research related to it. Once the book was bound, I had to attach the flap for each project.

FLEXIBILITY

It's not possible to update as it's a bound book.

DISPLAY

While living in the U.S., I used to drop it off. In India, I show it in person for local clients and I email a PDF portfolio for out-of-state clients.

ONLINE

We didn't create a website along with the portfolio in class. They probably do now. I had a PDF version of my portfolio book that I used to email for out-of-state design firms. When I moved to India, I created another portfolio that has a matching PDF version.

LASTLY

A thoughtful portfolio will always be noticed. Even after creating another portfolio with my current work, I still use my student portfolio as one of my design projects. People still appreciate it.

ABOUT

Priya Rajan is a design consultant in India. Rajan has worked with brands such as IBM, Siemens, Diners Club International, Pepsico, ABD, Wipro, and Mutti, amongst many others. Rajan is currently working on setting up a new venture. Rajan is a graduate in Graphic Design from Academy of Art University, San Francisco, CA, and she has a Masters in Mass Communication from India. Rajan had a stint at VSA Partners in Chicago, IL, before moving back to India. Rajan's student work has been featured in Typography 28, Step Magazine, HOW, and Graphic Design USA's emerging talent.

A thoughtful portfolio will always be noticed.

PRODUCTION DETAILS

STRUCTURE	DIMENSIONS (IN.)	PRINTER	PRODUCTION TIME	PRODUCTION COST
Perfect-bound book	8.5 × 11	Epson	6 Weeks	$100
MATERIALS	**PAPER**	**VENDORS**	**RETAIL STORES**	**TYPEFACES**
Chipboard	Kayenta Photo Matte,	Plotnet	Kelly Paper	Trade Gothic
Cloth	205g/m2	Herring & Robinson	Papyrus	Centaur
	Newsprint paper 45g/m2			

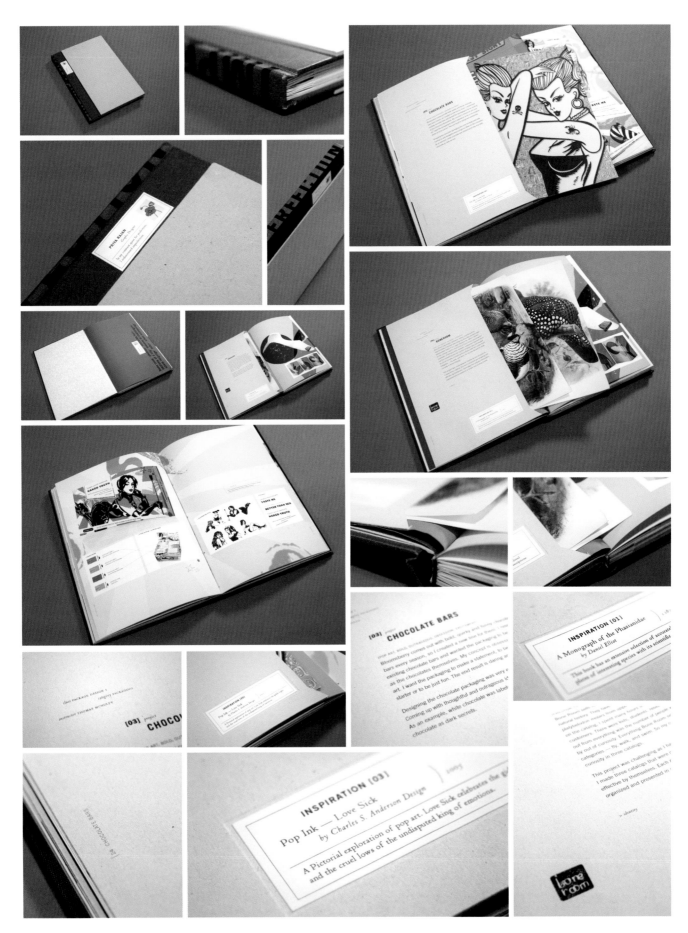

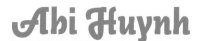

Abi Huynh

I FELT IT WAS TIME FOR AN UPDATED AND EXPANDED PORTFOLIO, SINCE I WAS APPLYING FOR POSITIONS WITH SEVERAL POTENTIAL STUDIOS. ALSO, I WAS GEARING TOWARD A MASTER'S DEGREE, SO IT WOULD COME IN HANDY.

STATUS

This portfolio is still active, primarily because the format is flexible and not dependent on context.

APPROACH

Since I was applying to more than one studio, I chose to develop separate booklets. This made it easier to adjust the content according to the interview. Moreover, I wanted an economical solution that could be laser-printed and readily accessible. With these parameters in mind, I chose to create small individual booklets that allowed for wider flexibility. The booklets were mailed in small, cheap, and sturdy cardboard boxes that retained enough space for samples of my work. This simple production method is analogous to my work in general: economical, reserved, and strengthened by a no-nonsense attitude.

FLEXIBILITY

The booklet template design is so simple that I can add or subtract projects with absolute ease.

DISPLAY

I am mostly hands-on, but on a few occasions I have mailed the portfolio for review. This is convenient, because the client is not under any obligation to send it back to me, as it is easily replaceable. When I am showing a portfolio in person, separate booklets come in handy when there are multiple people conducting an interview. It is then that I can show a broader range of my work, which can be pored over with greater attention, as opposed to many sets of eyes jostling in order to peer upon a single book.

BIO

Abi Huynh is a graphic designer in Vancouver, BC, Canda. Huynh pursued his undergraduate studies in the Communication Design program at Emily Carr University in Vancouver. Huynh graduated from the Type and Media MA program at the Koninklijke Academie van Beeldende Kunsten in The Hague, Netherlands.

> When I am showing a portfolio in person, separate booklets come in handy when there are multiple people conducting an interview.

PRODUCTION DETAILS

STRUCTURE	DIMENSIONS (IN.)	PRINTER	PRODUCTION TIME	PRODUCTION COST
Box with booklets	5.5 × 8.5	Xerox Phaser 6120	6 Days	$115
MATERIALS	**PAPER**	**VENDORS**	**RETAIL STORES**	**TYPEFACES**
Cardboard box	Mohawk, Strathmore, 25% Cotton	—	—	Akkurat Mono

Adam Larson

I STARTED WORKING ON MY BOOK, INTENDED FOR SELF-PROMOTION, IN JANUARY OF 2013 WITH THE HOPES OF RELEASING IT BY MARCH. HA!—WHO WAS I KIDDING? I DIDN'T FINISH THE LAYOUT UNTIL DECEMBER, AND FINALLY GOT PRINTED COPIES IN FEBRUARY OF 2014. IT WAS A COMPLETELY SELF-PUBLISHED PROJECT WHICH I WAS RESPONSIBLE FOR EVERY BIT OF, SO, AS A "SIDE PROJECT," IT BECAME COMPLETELY OVERWHELMING. AT A CERTAIN POINT I HAD TO LET GO OF THE IDEA OF A SPECIFIC LAUNCH DATE AND JUST FOCUS ON GETTING IT PERFECT.

STATUS

I'm not even through the first box of them yet, so I do envision it will be on "active duty" for some time to come. I titled it *Selected Works, Volume 1* with the intention of continuing the series over time.

APPROACH

I wanted to create a more memorable physical context to showcase the work that required a bit of engagement, rather than just passive browsing. After many iterations, I was inspired by a portfolio my old creative director had in a similar format that he had held on to for years—it was well laid out, chockfull of great work, and small enough that it never took up too much space. It's also the perfect size to pass along if someone isn't interested in it.

Being a professionally printed perfect-bound book, the materials are pretty straightforward: paper, glue, and ink. That said I used a classic linen textured paper for the cover along with gold foil for the title and the spine. The interior pages are an uncoated 100lb text in a pure white. The layout was done in Adobe Creative Suite using Photoshop, Illustrator, and InDesign.

FLEXIBILITY

It's updatable in that I will use this same layout for future editions, but the contents of this particular book will remain as is. However, that was an intentional decision. I have my website for updating work on a regular basis. This book acts more like a physical reference or reminder. Much like a business card, it recalls an interaction and hopefully will prompt future actions.

DISPLAY

I often bring a copy with me if I'm going somewhere where I may meet or run into someone who might like a copy. I also ship a good amount of them as well.

MEMORIES

Overall it was an extremely beneficial process for me as a designer. While it took over my "free thought" for a very long time—and was arduous to say the least—I did learn a great deal from the experience. I grew during it and figured out how to position and edit myself for the work I want to be doing next and helped me to grow as a designer. Given the nature of design, a good amount of the work I do never sees the light of day. A lot of assignments change course over time, or are purely conceptual explorations. The pace is also so rapid that at times you wonder what you are actually accomplishing and question the purpose of it all. Holding this piece in my hands reminds me of how fortunate I am to be able to do what I do, and is a refreshing sense of personal accomplishment.

ONLINE

The process of creating this book, and the pressure of creating something that would live in the physical world really forced me to re-evaluate how I present my work in general. Once I completed the book, I overhauled my website as well, updating it with the newly written content, newly formatted images, as well as additional images for larger projects and videos for those projects that have them.

LASTLY

I do have a more traditional acetate-sleeve, screw-post-bound, larger scale leather portfolio that is used for agencies who "call a book in"—but the need for it seems to be less and less over time. It also doesn't allow for the level of description necessary for some projects so it is more focused on high-level art direction and illustration projects. While it was a bit expensive to produce, I've been able to cover the printing costs with just two jobs I've received as a result of using the book.

ABOUT

Before opening Adam&Co., Adam Larson spent 10 years working as a designer, art director, and creative director for various leading design and advertising firms. Having gained incredible experience working across disciplines with some of the world's most respected brands, Larson left his position as VP Creative Director at a global ad agency in 2007 to establish his own boutique design studio. Larson started Adam&Co. with the intent of working closely with individuals, brands, and initiatives to provide world-class creative work. Larson's work has been featured in several international design publications, and has received numerous design and advertising awards.

PRODUCTION DETAILS

STRUCTURE	DIMENSIONS (IN.)	PRINTER	PRODUCTION TIME	PRODUCTION COST
Perfect-bound book	6 × 8.5	Offset printing	1 Year	$9,000

PAPER		VENDORS	RETAIL STORES	TYPEFACES
Cover: Cougar Classic Linen, 100lb cover	Interior: Cougar Smooth, 100lb text	Puritain Capital	—	—

Self-promo examples

Close looks at the ideas and production of 18 self-promotional mailers, gifts, and leave-behinds created to gain attention and remain top of mind in a crowded and competitive environment.

Robby Leonardi

I STARTED THIS PROJECT IN JANUARY 2013 AND I FINISHED IT AROUND OCTOBER—IT TOOK A WHILE SINCE I WORKED ON THIS PROJECT ON WEEKDAY NIGHTS AND WEEKENDS. I CREATED THIS WEBSITE FOR DESIGN COMPETITION PURPOSES AND TO HAVE AN INTERACTIVE RÉSUMÉ; I THOUGHT IT WOULD BE COOL TO SHOW MY SKILLS THIS WAY.

APPROACH

I decided to make my résumé look like a video game because I wanted to make it unique and I happen to love to draw and play video games. I created vector art based on my sketches in Illustrator, then I refined them in Photoshop. Finally I focused on the web scripting and programming such as HTML, CSS, and JavaScript.

RESPONSE

The response was unbelievable. I was overwhelmed because a lot of people contacted me—most of them telling me they really liked my website. I also got several job offers because of the interactive résumé component.

ANECDOTES

Most of them are good. I received lots of emails, messages, and tweets. It took lots of time to read all of them but some of them were funny so it was entertaining. The only bad experience was a server problem: my hosting company could not handle the sudden traffic, so they took it down and asked me to find another hosting company.

PRODUCTION TIME

3 Months (if uninterrupted)

PRODUCTION COST

Just my time

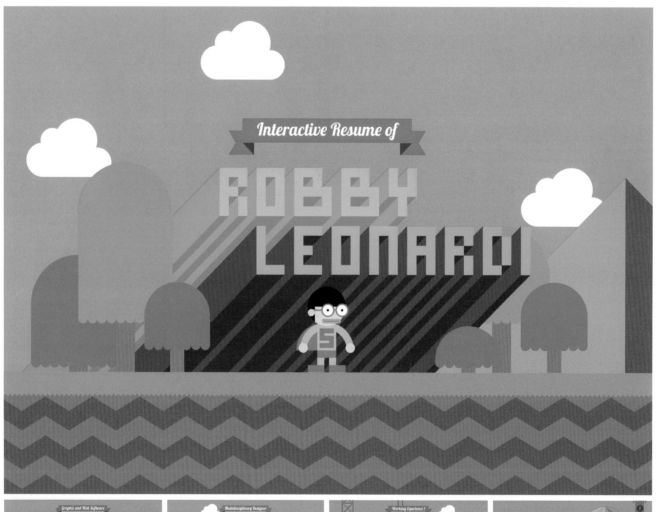

Dax Justin

I CREATED THIS MICRO-SITE AT THE END OF JANUARY 2015 TO DEMONSTRATE MY INTEREST FOR A ROLE WORKING WITH TWITTER IN BRAND DEVELOPMENT/DESIGN/COMMUNITY. THE MAIN PURPOSE WAS TO SHOWCASE MY TASTE FOR DOING SOMETHING DIFFERENT WHILE SHOWING MY APTITUDE FOR BRANDING AND DESIGN IN AN ENVIRONMENT TWITTER IS FAMILIAR WITH—AND TO BE UNEXPECTED.

APPROACH

I wanted to implement Twitter's Bootstrap web framework and use their official Brand Assets to produce a micro-site to effectively communicate why I want to work with Twitter and do so in a way that they would not anticipate. In addition to a formal application and résumé, I felt this would be a unique and more personal way to showcase my skill set and high interest in partnering and working with Twitter.

This entire project was self-initiated and all graphics and materials were produced by myself, using established guidelines and frameworks by Twitter. I wanted to exercise visual concept demonstrating a brand-aptitude in abiding by Twitter's Brand Guidelines. There were no alternate vendors involved as my wish was for this project to display my personality and skill set.

RESPONSE

The response was well received and I hope to collaborate with Twitter on future branding/design initiatives.

ANECDOTES

The most notable instance about this project is that this idea struck me out of nowhere, seemed crazy for two seconds then within five seconds I was acting on my thoughts and began building the website and producing graphics. I sat down and created the entire micro-site from concept to completion in an 8-hour period of time.

PRODUCTION TIME

1 Day

PRODUCTION COST

$950 Worth of time

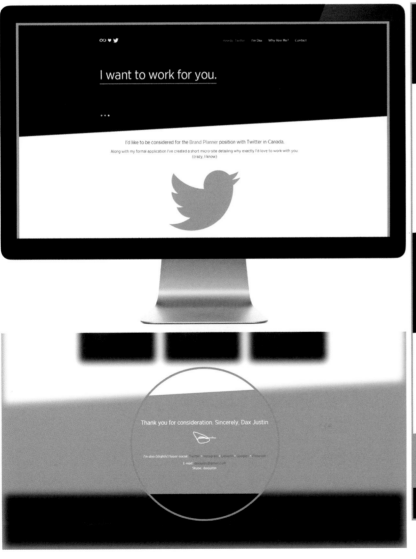

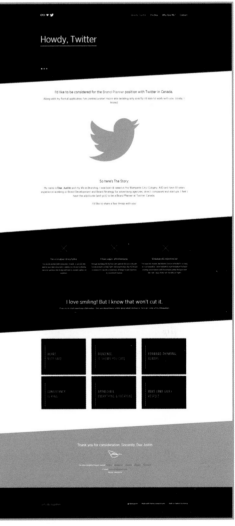

The Study

I CREATED THE PIECE OVER THE 2014 CHRISTMAS BREAK TO THANK CURRENT CLIENTS, GRAB THE ATTENTION OF NEW COLLABORATIONS AND SEND OUT TO FAMILY AND FRIENDS. IT WAS INTENDED AS A NEW YEAR'S PIECE AND IS A REMINDER TO EXPLORE + WONDER IN THE COMING YEAR.

APPROACH

I (Yvonne Perez Emerson) wanted something that was tactile and could be used. Also, I love combining hand-work into my projects and wanted to showcase this along with concept and packaging abilities. I hand-carved stamps and scanned them for the tea towel. The artwork was then silkscreened onto the towels. I printed square Instagram photo cards showcasing a photo I took while hiking in an Oregon state park—on the back of the card I put my personal Instagram address and the coordinates of where the photo was taken. I digitally printed a little postcard using the same carvings and a quote by Emerson about exploring and a handwritten note. I folded the towel to wrap both cards while showing the + sign and a little of the artwork—a piece of orange and white baker's twine was thrown in for an added touch. Next I wrapped the towel in kraft paper and sealed it with travel themed packing tape that I bought at the local office supply store. I hand-addressed them and added another carved stamp. Some of the packages were hand delivered, and others were mailed.

RESPONSE

The response was overwhelmingly good. I sent out 50 of them. From current clients I picked up three huge new projects, from hopeful clients I filled my calendar with personal meetings to begin further collaborations. I was told how much they loved the packaging and personal touches. One new client said I got their attention, like no other. And another new client hopeful loved that it was something they could enjoy by using it over and over again.

ANECDOTES

At first I thought I was going to print everything in house, but ended up having someone else silkscreen the tea towels—it was much faster and cost effective.

PRODUCTION TIME	PRODUCTION COST
2 Weeks	$11.50 Each × 50
	$575 Total

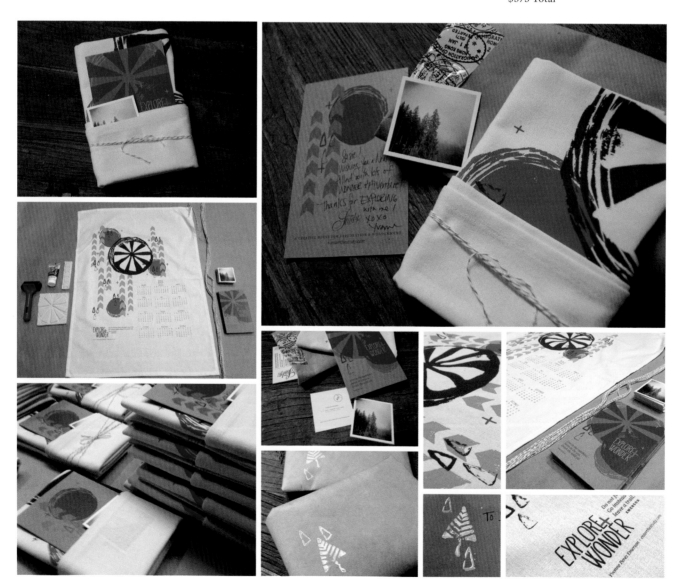

Jamie Reed

I CREATED THIS SELF-PROMO IN MARCH 2011 WHILE EMPLOYED AS A PACKAGING DESIGNER FOR A LARGE CONSUMER PACKAGED GOODS COMPANY, BUT WAS IN THE PROCESS OF LOOKING FOR A NEW DEIGN POSITION—PREFERABLY IN A MORE CREATIVE ENVIRONMENT. THE MAIN PURPOSE WAS TO OPEN SOME DOORS, GET MY NAME OUT THERE—ULTIMATELY HOPING FOR AN EMAIL, CONVERSATION, OR INTERVIEW WITH A PROSPECTIVE EMPLOYER.

APPROACH

If you're not familiar, Wooly Willy is a cheap magnetic toy that lets you create hairstyles by moving metal filings around with a magnet wand. I used to play with them as a kid and remember drawing beards, mustaches, mohawks, then quickly shaking it clean to start again. I wanted to make something that I hadn't seen before—something that wouldn't be thrown away and maybe even displayed—most importantly it would have to showcase my personality and creativity. Years later as a much older "kid" I saw one in a store an immediately thought how cool it could be to use my face as Willy. It was especially fitting since I had a shaved head and slightly resembled Willy. I started thinking how I could use different characters to describe my personality traits and strengths as a designer and began brainstorming in my free time. I sent the final piece in a padded envelope with a copy of my standard résumé and portfolio on a flash drive. I liked to think of it as a portfolio disguised as hours (or at least minutes) of fun.

RESPONSE

I did all of the work myself and it was all very manual so keeping everything clean and crisp was my top priority. The main plastic components, metallic filings, and magnetic wand were all reused from existing toys. I bought a dozen or so and had to gently disassemble each so I didn't damage the plastic parts or spill the filings. I poured the filings into a bag and then soaked each plastic cover in warm water to get any excess paper or glue off.

I used heavy chipboard for the backing and 100lb cover stock for the printed top. Luckily I also happen to silkscreen in my spare time, so I was able to do all of the printing on my own to keep costs low. It was a simple two-color print with silver metallic and black ink. With some trial and error I figured out a process to reassemble everything while keeping it clean. With the filling and wand added, I super glued the plastic cover to the cardstock (upside down so the filling didn't spill)—everything had to be precisely aligned. After the plastic portion was dried I glued the top printed portion to the chipboard and trimmed both so they were flush. I used a corner punch to clean up the edges and give it a finished look.

ANECDOTES

I only sent promos out to a few specific places and happened to hear back from a couple. Most were only looking for contract work or not currently in need of a designer. One of the recipients happened to tweet out a picture of the promo, which got quite a few views. It also eventually appeared on FPO extending my reach exponentially. I received some great feedback online, a handful of emails asking about the process and a few offers for freelance work. Overall it seemed to be well received and I had a great portfolio piece to boot.

PRODUCTION TIME

1 Week

PRODUCTION COST

$8.30 Each × 12
$100 Total

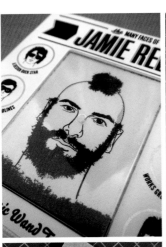

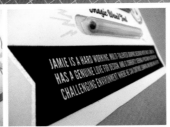

Trish Ward

AS A YOUNG DESIGNER FRESH OUT OF SCHOOL, AT THE END OF 2010, I HAD A VERY SMALL BUDGET TO CREATE MY SELF-PROMO—IT HAD TO BE RESOURCEFUL, UNIQUE, AND CHEAP.

APPROACH

I aimed for quality not quantity. Instead of sending out a big stack of postcards, I decided to send something practical that might stick around on someone's desk. I narrowed my wishlist to ten top contacts; a mix of advertising agencies, design studios, and solo designers whom I admired.

The whole package centers around up-cycling. I painted empty Altoid tins a flat white color, then I poured peppermint-scented soy wax in each. I was interning at Stitch Design Co. at the time, so I'd make a point to rescue any nice letterpressed scrap paper that was in the recycle bin. I cut down the scraps and stamped each to make my business cards. The sticker on the inside of the lid and the custom rubber stamps were sourced from vendors, but other than that, it was pretty fast, resourceful, and cheap.

RESPONSE

60% of the recipients responded to the promo; a few just said thanks for the gift, while others led to a conversation about work. I got a call from HOOK to freelance, which ultimately turned into a full time gig. How's that for ROI?

PRODUCTION TIME

1 Week

PRODUCTION COST

$7 Each × 10
$70 Total

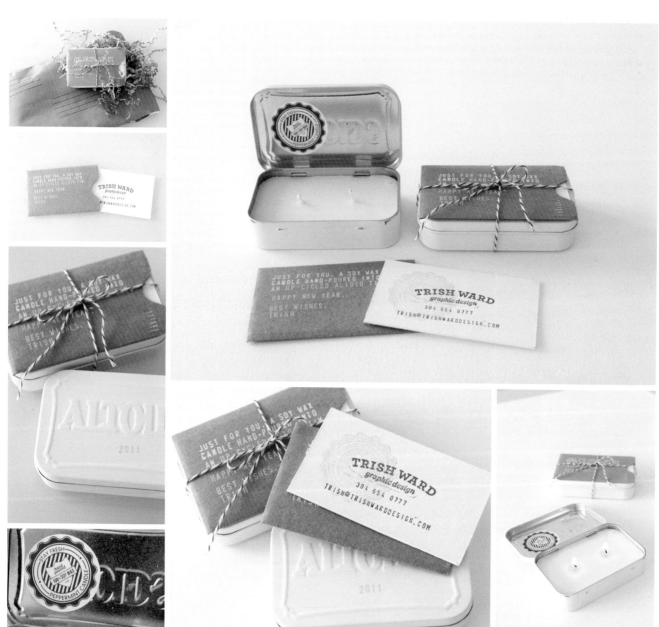

Peter Kortleve

I WANTED TO CELEBRATE ANOTHER (SUCCESSFUL) YEAR AS AN INDEPENDENT DESIGNER AND TO SHARE THAT JOY WITH MY CLIENTS, FRIENDS, AND FAMILY BY GIVING THEM A RETROSPECTIVE OF THE LAST YEAR TOGETHER WITH SOMETHING FUN OR COOL THAT THEY COULD USE. IT'S MY WAY OF SAYING THANK YOU, WHILE GETTING THEM TO TALK ABOUT MY WORK.

APPROACH

I wanted to create something that lasts and represents me—not just as a designer, but also as a person. I love printed matter. Love the smell of it. Therefore, I chose to present some of the highlights of the past year in a small photo book. To me it's fun to look at what I've done over the past year—looking back I feel proud of what I've done and what I've achieved, and I'm grateful to all the people that helped and supported me to get to where I am today. That's why my clients, friends, and family get a copy.

RESPONSE

I silkscreened the cover of my first booklet and learned that while fun it was also a lot of work. This time I didn't have as much time to work on it as I did the year before, so I outsorced the covers. I wanted my pennants to be top quality and ended up working with Oxford Pennant, a better choice than DIY. I embossed my booklets by hand with my embossing stamp and signed each one saying "Thank you!". I want all of my stuff to have a personal touch like that. I want people to know that I'm not a machine. There's a real person behind all of it.

ANECDOTES

Some people send me pictures of the pennant (where they put it). Others are asking what to do with it. I tell them to do whatever they feel like; it's theirs now. A few told me their son or daughter ran off with it. That's okay by me! I can sense that they cherish it. They're proudly showing it to other people. That's really fun and rewarding to me. One of the best responses I got was with the first booklet that came with a pencil; I challenged everyone to go out and draw. A songwriter told me he couldn't draw (which I think is BS), so he wrote a song for me using the title of the booklet! That really blew me away! Never expected that.

PRODUCTION TIME

2.5 Weeks

PRODUCTION COST

$10.61 Each × 100 bundles
$1,138 Total (bundles + extras)

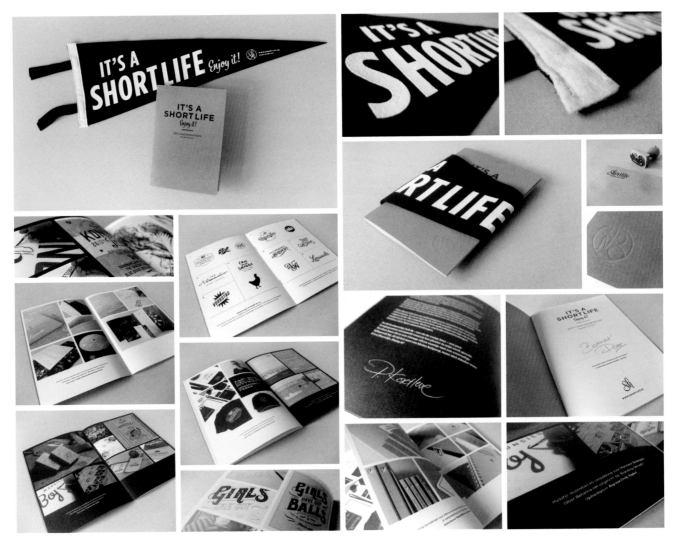

Yana Makarevich

THIS PROJECT WAS COMPLETED IN MID-2011. THE MAIN PURPOSE WAS TO IDENTIFY MYSELF AND SHOW MY POSSIBILITIES AS A DESIGNER. THE PROJECT INCLUDED NAMING, LOGO, IDENTITY, AND ADDITIONAL PROMO MATERIALS.

APPROACH

The designer's identity must reflect the essence of his work: have the unique approach to each client, permanently search for new ideas, and choose the best solution of possible variants. It was decided to base on the spontaneity of paint. New images are created by overlaying the elements, this allows to get an endless variety. A set of cards gives a new sound to the logo, here it appears as a sculpture.

The basic material is high quality white paper with a nice matte touch, it was like a background for a transparent part of the identity. The business cards are made of 1 mm PET with UV-printing, and the letterhead is made of Lomond inkjet film. Each business card kit includes 15 pieces that can be used separately.

RESPONSE

Absolutely positive feedback from clients and designers.

ANECDOTES

Some clients asked me to send them more business card kits that they could present to their clients as a gift or like an art object. Others thought that the kits were for sale and tried to buy a few.

PRODUCTION TIME

3 Months

PRODUCTION COST

$1–5 Each kit

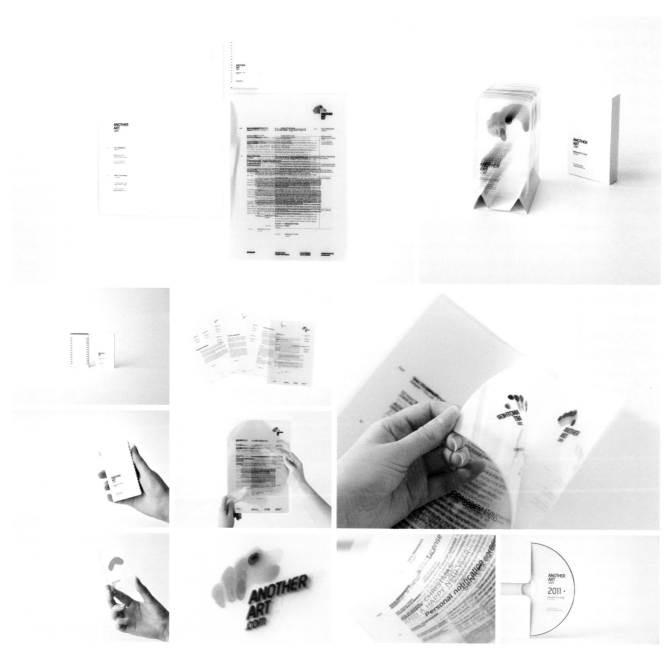

Vidar Olufsen

IT WAS DESIGNED AND ASSEMBLED IN 2010, NOT LONG AFTER I GRADUATED FROM UNIVERSITY. AT THE TIME VERY FEW DESIGN STUDIOS/AGENCIES WERE HIRING, AND IT APPEARED THAT THE DESIGN MARKET WAS QUITE "FLOODED"—IF I WAS TO GET NOTICED IN THE CROWD I HAD TO DO SOMETHING COMPLETELY DIFFERENT AND GET A TRUE "WOW" FROM THE PEOPLE REVIEWING APPLICATIONS.

APPROACH

My first phone conversation with a studio just proved me right in being "another in the queue". His remark of filing my work for a later opportunity made me think of dusty old file cabinets from the cold war that my application never would escape from. That's when the concept formed, and I decided to make something they actually would keep and file in their *office*, not in the *trash*.

Also, I strongly wanted my résumé to physically display a number of skills and disciplines from the world of graphic design, and represent who I am and what I love doing. Digital stuff is great, but as a designer I still think it's best to be able to grasp your hands around a real-life piece, where you can feel the texture and smell the ink.

My goal with the design was to make the person reviewing it feel like he had an actual Cold War/World War II dossier delivered to him or her, triggering their curiosity to study all of its contents—and in the end, hopefully to turn a big smile on their lips or give them a good laugh.

Each piece was printed, folded, cut, and assembled piece-by-piece at home without any vendor help. I had a decent printer and the fundamental tools for working with paper, but had to invest in some other necessary equipment like a long reach stapler in order to assemble the little CV booklets.

RESPONSE

The dossier was a success and performed better than I had imagined. I got a lot of positive feedback and praise from practically everyone that received it—mainly for its playfulness, attention to detail, and for actually landing a physical piece at their desks. (Some humorously promising to file the dossier for a later opportunity in their file cabinet).

I got a lot of the informal portfolio reviews I was hoping for, gaining me some good advice, contacts, and actual help with the road ahead. Quickly I got a short term contract at a design studio in Oslo that helped me settle in the city, followed by full-time employment at one of Oslo's largest printing offices with its own design/advertising department.

ANECDOTES

There have been some fun and interesting remarks in the comment section of blogs and articles where it's been published. Comments on how this is well made but would never actually work, that it's just a fake publicity stunt or would never get read by the recruiter because it fails to meet the résumé standard.

PRODUCTION TIME	PRODUCTION COST
Bits and parts of a summer	$17 Each × 30
	$510 Total (including postage)

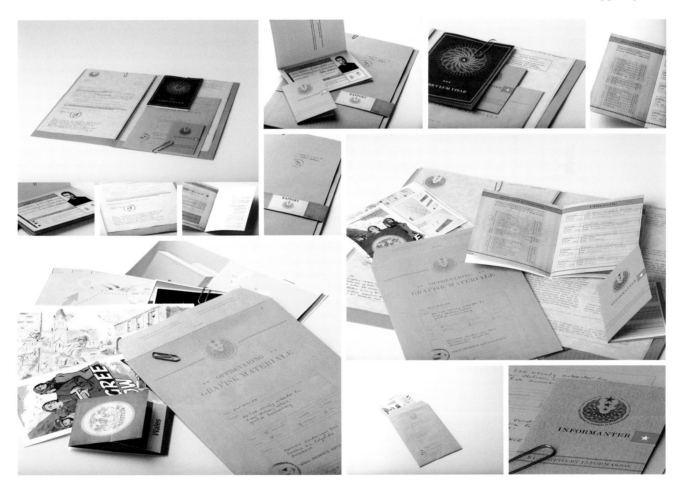

Chew Lijuan

I CREATED THIS SELF-PROMOTION KIT IN JUNE 2012 WHILE LOOKING FOR A JUNIOR GRAPHIC DESIGNER POSITION AFTER GRADUATING FROM DESIGN SCHOOL. I WANTED TO MAKE MYSELF STAND OUT FROM THE POOL OF FRESH GRADUATES WHILE SHOWING MY UNIQUE POINT-OF-VIEW, PERSONALITY, AND EXPERTISE EFFECTIVELY.

APPROACH

The idea came from a poster that shows 29 ways to stay creative. Sometimes, designers do get stuck in the thinking process—so do creative directors and art directors. Therefore, my promotion kit is a guide to boost their creativity. The most important message is that I will be available to help them when they are stuck with ideas.

All the items in the kit are DIY except for the printing of the work. I pasted the label over the Milo tin, I sewed the pouch and ironed the transfers on to the pouch, I made the tea envelope, hand-bound the idea book, and finally ironed-on the résumé transfer onto the fabric.

RESPONSE

While working on my self-promotion, my only aim was to have it land at the doors of my desired agencies. However, I got quite a number of offers from clients and other agencies after posting my work on my online portfolio.

ANECDOTES

I am in awe that this self-promotion kit that I made several years ago is still getting attention. The most satisfying result is when my design communicates effectively to not only the design community but also with the general public.

PRODUCTION TIME

2 Weeks

PRODUCTION COST

$7 Each × 5
$35 Total

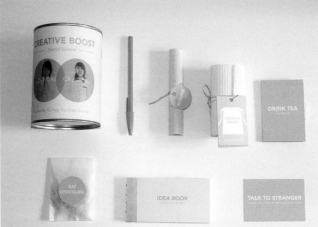

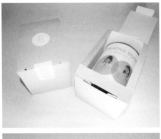

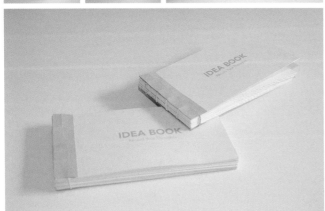

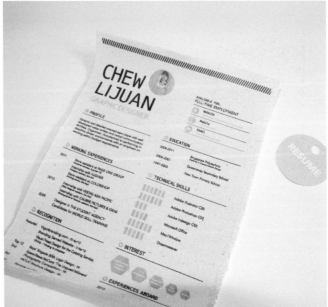

Daniel Blackman

INITIALLY I CREATED THE BURGER BOX PORTFOLIO IN 2013 WHEN I DECIDED TO GO ON THE HUNT FOR MORE FREELANCE CLIENTS AND OPPORTUNITIES TO FIND FURTHER EMPLOYMENT. IT WAS CREATED AS A WAY TO CATCH EMPLOYER'S EYES AND BRING A SMILE TO PEOPLE'S FACES.

APPROACH

It's something a little different which stems from my website URL, Fries With That. I have the design printed by a local printer, they're delivered as flat sheets, and then I cut, glue, and assemble each one individually by hand.

RESPONSE

I've received great feedback and it's created a lot of conversation. As someone online describe it, it's a "whimsical social commentary," and people appreciate the fun aspect to my approach.

It was also featured on the portfolio-centric blog No Plastic Sleeves (blog.noplasticsleeves.com).

PRODUCTION TIME

2 Weeks

PRODUCTION COST

$2.50 Each

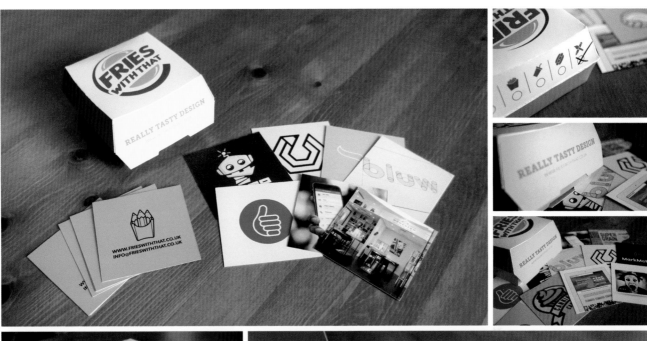

Andy Jamieson

TOWARDS THE END OF MY FIRST DESIGN JOB I DESIGNED THE MAILER TO PROMOTE MY SKILLS AND WORK IN HOPE OF SECURING A JOB. I WANTED TO MAKE SOMETHING THAT HAD A BIT OF PERSONALITY AND SHOWED OFF MY SELECTION OF GRAPHIC DESIGN AND BRANDING WORK IN A MEMORABLE WAY.

APPROACH

It's quite easy to send an email with a PDF attached these days but I wanted to make something that would stand out—going with the Newspaper Club seemed like a good way to achieve this. The mailer is my self-promotional identity that I have created to get myself a job in the design industry. The concept was based upon icons of things that I like and use in my professional and personal life. I silkscreened the box and the die-cut divider, letterpressed (thehunterpress.co.uk) the business cards, and had the Newspaper Club print the newspaper and cover letters.

RESPONSE

I secured quite a few interviews at different agencies throughout Scotland, eventually landing me a job at Teviot Creative in Edinburgh.

ANECDOTES

All the feedback has been nothing but positive, the biggest thing for me was being featured on For Print Only and the Newspaper Club.

PRODUCTION TIME

4 Months

PRODUCTION COST

$10 Each × 40
$400 Total

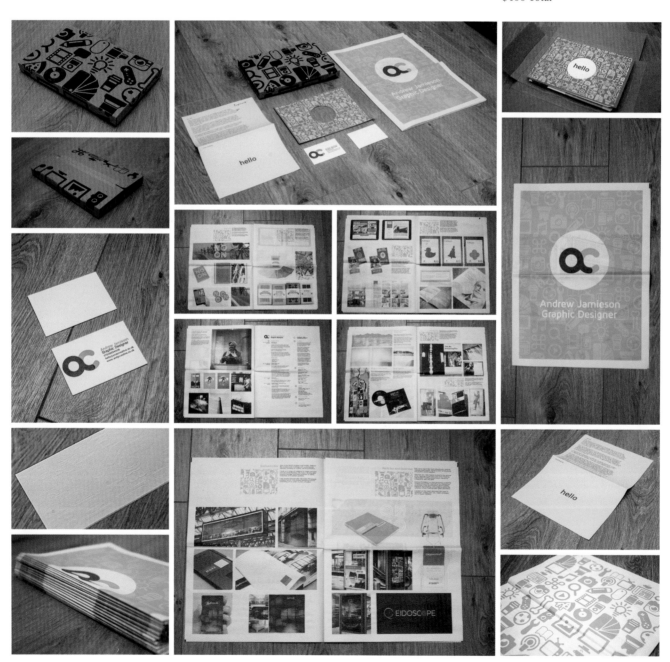

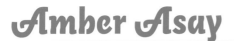

I CREATED MY SELF-PROMO IN EARLY 2013 AS PART OF AN AIGA MENTORSHIP PROGRAM WHERE THEY PAIRED EACH DESIGNER WITH A SEASONED MENTOR. I WAS A RECENT GRAD AND HAD JUST FINISHED MY ONLINE PORTFOLIO AND WANTED TO BE ABLE TO HAVE A PRINT VERSION THAT ACTED MORE AS A TEASER—I WANTED TO CREATE SOMETHING MAILABLE OR AS A LEAVE BEHIND AT INTERVIEWS.

APPROACH

I've always been fascinated by newspapers and the nostalgic quality they have. Since newspapers are centered on providing new information, I thought that concept would be a good fit for me, a fresh-out-of-school designer. Plus, I love the irony of mixing carefully crafted design on such a temporary medium—so often we throw out newspapers or use them as scrap, but this one is meant to be held onto.

It was printed by the Newspaper Club, which seems to be the top pick these days for designers. I needed a small run and went through several local printers that would only print a 1,000 minimum. It took a lot of research to find the right printer. But the part that really completes it for me is the bellyband. That was a last minute decision I made after receiving the newspapers and realizing they needed an extra oomph. Attaching my business card front and center to the metallic copper bellyband was a way to give out a smaller leave behind. With that finishing touch, it feels more like a self-promo.

RESPONSE

I first shared it at the AIGA event where mentees shared their self-promo and competed for a grand prize. I thought it would be fun to have a large banner that read "Extra! Extra!" and all the newspapers displayed like it was a newsstand. Most attendees loved it , and when I photographed it and posted in online it caught like wildfire and ended up spreading around blogs, which was very exciting.

ANECDOTES

Originally, I wanted to offset the black and silkscreen some metalic copper details but it was coming out to be a little pricy for me. To this day, I wish I had taken the leap (and expense) to do this.

PRODUCTION TIME	PRODUCTION COST
10 Days	$2.33 Each × 100
	$233 Total

Alex Anderson

I CREATED THIS PROMO IN MAY OF 2014 FOR MY GRADUATION FROM THE VISUAL COMMUNICATION PROGRAM AT THE UNIVERSITY OF KANSAS, AND THE ENSUING JOB SEARCH. THE PURPOSE WAS TO TRY AND GET IN TOUCH WITH CREATIVE DIRECTORS AND DESIGNERS AT FIRMS THAT I ADMIRED WHICH I WAS HOPING WOULD LEAD TO INTERVIEWS.

APPROACH

I have always been interested in all things print making—specifically silkscreening—and wanted something that showcased my interests as well as my work. I wanted to go big for my final project of design school, and I admired the great promotional pieces I had seen from Tad Carpenter, Dan Cassaro, Jay Fletcher, and many others.

My goal was to showcase all the work I created in school that may never see the light of day after I graduated. I thought a lot about what specific form this piece should take. I wanted to make something memorable, something that might be harder for people to throw away. This led me to a large format poster as the central element with smaller pieces that I could leave behind easily.

It was about 50/50 between DIY and vendor. I printed all of the smaller materials myself and used a local printer (Vahalla Studios) to print the large 18-by-24-inch posters. Simon Stamp Company made the stamps.

RESPONSE

The response I received was really awesome. People were really excited to receive it in the mail and I heard back from almost everyone who I sent one to. It was a great talking point during interviews and helped me get my foot in the door at a few places that I had always been interested in working for and I am not sure I would have had the opportunity to interview with had it not been for sending my self-promo. Lots of professionals commented that it was refreshing to see something a little different and a little outside the box.

ANECDOTES

Sweating the small details really pays off. I agonized over the details and at one of my first interviews the interviewer pointed out an error on the poster printing. He turned out to be joking, but I immediately went home and checked that everything lined up.

I learned reviewing self-promos from the other side how important the details really are. Recently a job seeker sent an awesome and elaborate self-promotional piece to the firm I currently work at, but the name of the company was spelled wrong. I felt so bad for them because it was clear they had worked really hard on it, but it didn't make the impression they were hoping for.

PRODUCTION TIME	PRODUCTION COST
2.5 Weeks	$10 Each × 25
	$250 Total

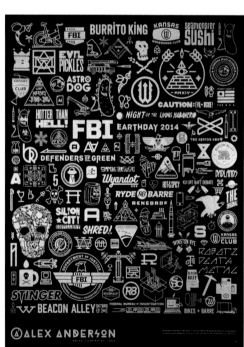

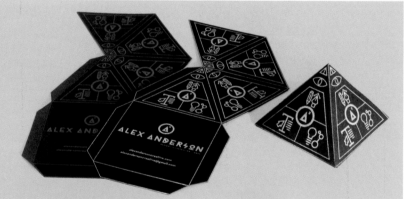

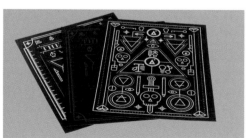

Janssen & Valkenberg

BACK IN NOVEMBER OF 2013 WE INTRODUCED OURSELVES WITH A BORING KEYNOTE PRESENTATION— WHEN WE WERE DONE, WE DECIDED TO DO SOMETHING DIFFERENT MOVING FORWARD. WE CREATED A BIG POSTER ABOUT OUR STUDIO—IT ALLOWS FOR INTERESTING IN-PERSON CONVERSATIONS AND IT IS ALSO A NICE ITEM TO SEND THROUGH SNAIL MAIL TO POTENTIAL NEW LEADS.

APPROACH

We chose to create a self-silkscreened poster because it stands out. But more important: the introduction is not fixed to the order of a keynote. All the content elements are placed randomly on the canvas. The conversation can start or end at any point. This way, it's a dialog instead of us giving a presentation which makes it a monologue.

RESPONSE

Almost all people are enthusiastic about something not digital. Not only other designers, but also the slick advertising person and the old fashioned client. Everyone appreciates the form, the content, and the effort that was put into it. Especially presenting in a non-linear way helps to have a real and unique conversation. Most of the meetings end up in "Can I have one" or, "Can you make a poster like this for me?"

ANECDOTES

We gave them away too easily. We're trying to make new ones, but that's not going too well. I guess we had beginner's luck.

PRODUCTION TIME

5 Evenings

PRODUCTION COST

$7.08 Each × 48
$340 Total

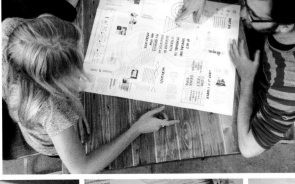
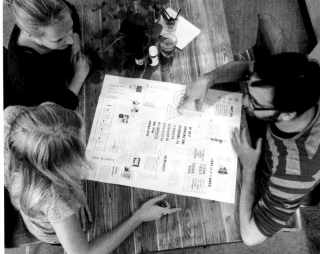

PAGE **111** SELF-PROMO EXAMPLES

Mark Longworth

I CREATED THIS SELF-PROMOTION PIECE IN FEBRUARY 2014, READY FOR THE SUMMER BREAK BETWEEN 2ND AND 3RD YEAR WHEN I PLANNED ON GETTING SOME INTERNSHIPS TO HELP CATAPULT ME WHEN I FINALLY GRADUATE UNIVERSITY. I LIKE THE IDEA OF A DESIGN BECOMING INTERACTIVE AND PERSONAL AND IT REALLY PAID OFF AS I ENDED UP LANDING A COUPLE OF INTERNSHIPS AND COULD HAVE ACCEPTED MORE IF I HAD MORE TIME FREE.

APPROACH

I'm a bit older than most of the other students, so I worked on the positives such as my extra life experience and my previous career as a chef. The result was a mailer in the form of a book all about me! The book is designed to be open to interpretation on many levels and to entice the reader to be creative with their own style and humor. The recipient has the chance to rewrite my past in whichever way they like, but most importantly they have the power to write my future.

The book was bound by hand using waxed thread. And a high quality paper that has little show through. The front cover was slightly thicker glossy card. The box that holds the book was a photography box into which I added a divider to hold the book and pencil separately.

RESPONSE

I received good feedback, it showed my ability to craft but most importantly everyone was impressed with the idea behind it and that it opened up a communication between us before a formal interview.

ANECDOTES

If you write a story about yourself with blanks for people to fill in, don't ask to read it after they have... You'll find people are much weirder than you think!

PRODUCTION TIME

1 Week

PRODUCTION COST

$5.50 Each × 60
$330 Total

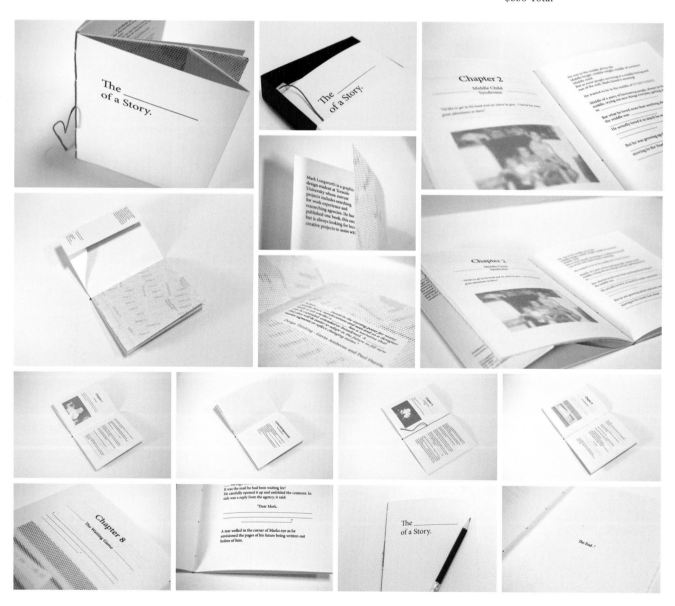

Sandra Winner

I CREATED MY SELF-PROMO IN THE FALL OF 2014 TO AID ME IN OBTAINING WORK IN CLEVELAND, OH, AS I WAS PLANNING A MOVE ACROSS COUNTRY FROM SAN FRANCISCO, CA. I WANTED TO GARNER SOME GENERAL INTEREST TO START MY TRANSITION TO THE CLEVELAND MARKET, GETTING A FEEL FOR THE AGENCIES AND THEIR PERSONALITIES.

APPROACH

Moving to a new market, I wanted to gain some name recognition. I decided on the booklet mailer because it would allow me to speak in detail about myself. It also allowed me to keep my costs low while giving me the ability to personalize each book—swapping out projects so each page is relevant to the agency. The stitching and personalization of each booklet allowed me to showcase my attention to detail and personality.

The paper I used to create the self-promo was Mohawk Via Felt 65lb cover for the cover and Via Smooth 80lb text for the interior. The printing was done by a local print shop on a Xerox machine and all pages and covers were hand-cut and hand-assembled with the cover wrapping around for the binding. A home sewing machine using a zigzag stitch with industrial strength thread created the binding.

RESPONSE

It was very positive and helped me obtain work. I think agencies appreciate it when you put a lot of time, effort, and thought into something for them. Unfortunately I didn't receive immediate response from most of the agencies that I mailed these to, but when I would follow-up with an email they always remembered the book.

ANECDOTES

There were many problems that happened during the sewing process and when those problems did occur, the whole book unfortunately had to be scrapped. This cost me time, money, and many trips to the printer. My home sewing machine became my best friend and my worst enemy. Threads breaking half-way through caused the most heartache. Experimenting with different threads and needles helped solve the issue. Eventually, I succeeded.

PRODUCTION TIME	PRODUCTION COST
3 Hours per promo	$18.50 Each × 10
60 Hours total	$185 Total

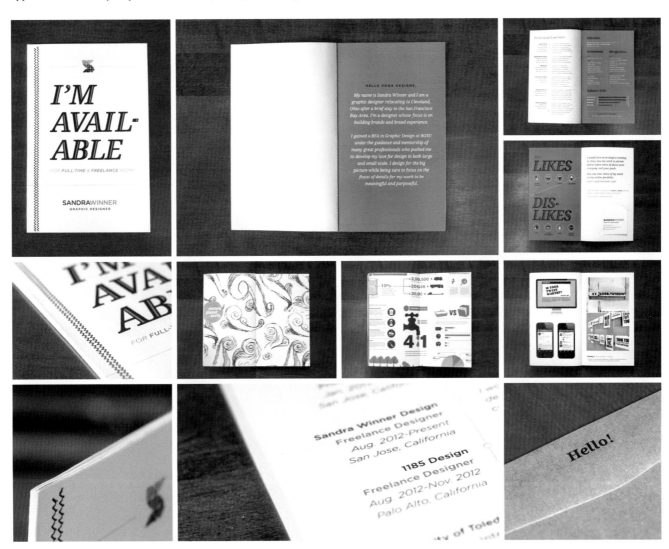

Andrew Gallagher

WWW.ANDREWGALLAGHER.ORG

I CREATED THIS BOOK IN JUNE 2014 AFTER GRADUATING FROM MY UNDERGRADUATE PROGRAM IN GRAPHIC DESIGN TO SUBMIT BY MAIL TO PROSPECTIVE EMPLOYERS. THE BOOK COMBINES MY CV AND PORTFOLIO AND, WITH A WRAP-AROUND COVER LETTER, PROVIDES A COMPLETE JOB APPLICATION.

APPROACH

My primary design interest is print, and I considered it appropriate to submit projects such as letterpress prints and books in physical form (though I have adapted the design to a PDF). I also found I had more control over the work's presentation in book form—in terms of project order, explanatory text, and image size and quality—than I would digitally. It was important to me that the portfolio be a piece of design that demonstrated the same approach as the projects it contains.

The book is printed on matte paper in two weights (heavy text stock for the interior and card for the cover) and saddle-stitched—it is 8 × 10-inches, with a full bleed. A local shop printed the pages, which I finished by trimming and binding. The book started on the computer and ended up on the old-school guillotine at Typecase Industries, a letterpress studio in DC where I held an internship at the time—their help with the production was invaluable.

RESPONSE

The response was positive! More than one designer told me the book was an effective way of presenting my portfolio. I think most studios, though, were just excited to receive something in the mail, rather than by email. I was also pleased that a few studios took the time to send me rejection letters, rather than ignoring my application outright.

ANECDOTES

At least one copy is lost in the postal system of New York, NY. I've tried to recover it, but I'm sure it'll be collecting dust in a corner of the post office for years.

PRODUCTION TIME

6 Days

PRODUCTION COST

$10 Each × 20
$200 Total

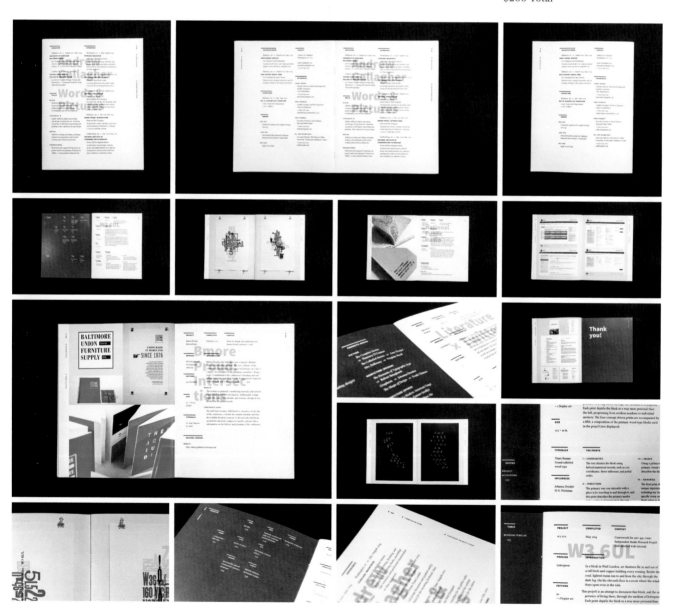

Dennis Fuentes

I MADE MY SELF-PROMO MAILER IN THE LAST QUARTER OF 2013 DURING MY MOVE FROM DUBAI TO TORONTO. BEING NEW TO CANADA WITH NO CONNECTIONS, REFERENCES, NOR LOCAL WORK EXPERIENCE, I KNEW I HAD TO COME UP WITH SOMETHING THAT WOULD CAPTURE THE ATTENTION OF MY PROSPECTIVE INTERVIEWERS. I REALIZED FROM THE BEGINNING THAT MY RÉSUMÉ WAS NOT ENTICING ENOUGH TO BE CONSIDERED FOR AN INTERVIEW.

APPROACH

I knew my portfolio had to work harder for me to get noticed and be considered for an interview. I needed my portfolio to work on two levels: First was to bring my work forward and make up for the part where my résumé falls short. Second was to display some of my characteristics such as patience, dedication, and craftsmanship when it comes to work, through the use of materials and with the way the whole suite is crafted.

The materials used were card stock, fabric, regular printing paper and iron-on transfers, plus rubber bands to secure the folder and bulldog clips to keep the fabric pouch closed. The whole suite is 100% DIY, hand-cut and folded. I used a sewing machine to bind the pages together and attach the label to the booklet covers as well as to create the fabric pouch. I used iron-on transfers to personalize the pouch with the recipient's name printed on the fabric.

RESPONSE

Out of seven the mailers that I sent out, I received two invitations for an interview. Not really as good as I wanted it to be, but I heard about someone who sent out about 200 résumés with zero response. So I guess that wasn't bad after all.

ANECDOTES

The senior creatives who invited me for the interviews were actually not hiring at that time but because they liked my work and the way it was presented, they decided they wanted to meet me anyway.

PRODUCTION TIME

2–3 Weeks of photo shoots and image prep.
1 Week putting together.

PRODUCTION COST

$350

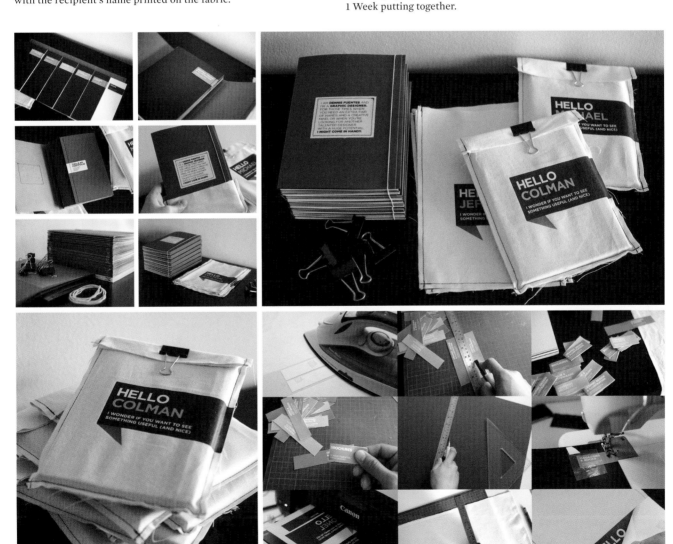

Photographing your own work

Overview of equipment, approaches, and tricks of five non-photographers on how to present, photograph, and retouch your physical work.

Kevin Cantrell

AN ART DIRECTOR BASED IN SALT LAKE CITY, UT, WHO HAS WORKED WITH CLIENTS SUCH AS HARVARD, NIKE, NEENAH PAPER, AND THE MUSEUM OF ART AND DESIGN, KEVIN CANTRELL EXPLAINS IN DETAIL HOW HE GOES FROM PHOTO TO FINAL IMAGE IN PHOTOSHOP.

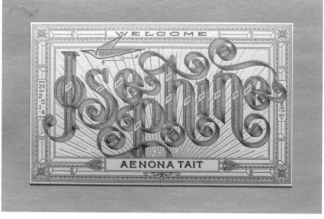

This example of my process will focus on a birth announcement but can also be applied to stationery or anything else that can be laid down flat. The original photos are shown above and the composite, final image is shown above, right. Other before/after examples are on the opposite page.

PHOTOGRAPHING

I shoot with a Canon camera and I highly recommend getting a tripod, as the natural hand is typically going to blur. I prefer a cloudy day shooting at midday, as the lighting is very neutral. Sunny days can work, as long as you shoot in the shade. Shooting by natural light means that light will be changing, so planning ahead can help expedite the process. Take advantage of the light quickly so all of your components have similar lighting.

I create a flat area that is well lit. On a cloudy day, I prefer to shoot in direct light, as this will give enough contrast and even lighting to capture the detail I need. I can brighten and make further adjustments in post-production.

On the flat surface (whether a large cardboard sheet, concrete floor, or something else firm), I'll place white paper. You don't even need very large paper. I can edit out seams in post. But I need a clean background to shoot on for color balance and easy clipping.

For the invite, I'll position it on the paper, and then shoot as straight on and above as possible. Don't worry too much if it's at a slight angle, you can fix that later, but get as close as you can. After I shoot a straight-on

shot, I'll double check my image to make sure it's clear and crisp. Then I'll take detail shots at various angles.

Once I feel good about the shot selection, for this specific type of image, I'll position several envelopes on the page to capture a lovely rose/quartz color and texture to overlay the card on top of in post. I'll shoot it straight on with the same light. It's ok if there are seams between a couple envelopes, you can clean those up in post.

EDITING

To clip the image, I convert the Background layer into a regular layer and select the Erase tool at about 3 – 4 pixels (just select a small circumference), with a soft edge. Then I'll proceed to cut out the image by clicking my first point, then holding Shift and clicking another point parallel to the edge in order to create a long straight cut. This ensures that I am cutting straight, and following the edge well enough. Once I've created a very thin cut around the whole object, I change my Erase brush to a hard edge, and progressively increase the size, and work my way out until I can erase the entire background and leave the object I am clipping on the page by itself.

If the object doesn't have perfectly straight edges (has some creases, or areas where it might bow in or out) the next step is to increase the canvas size so you can see the edge of the layer. Now select Edit › Transform › Skew. Position guides on all sides of the object so you'll know where you need to skew the object to get the perspective straight on. Then proceed to skew each side until it's perfectly square to the guides. If some of the edges bow in or out, we'll then use the Warp tool.

For bowing edges or sides, select Edit › Transform › Warp. Using the same guides as checks, begin to warp ONLY the areas that are bowing. If this warps certain parts out of proportion, you can skillfully and gradually warp the areas next to the adjusted spot so the warp gradually dissipates towards the center of the object. If you have type that might get warped by adjusting those bowed areas, make adjustments proportionately throughout the card/object.

Create a new layer, name it "Background," and move it underneath the existing layer. Paint the new layer white with the Paint Bucket tool. This will help you see what true white is for adjusting the lighting and color balance. And also the shadow you're about to create.

Create a layer and name it "Shadow" or "Eternal Darkness" if you prefer. Then select the Brush tool. We'll want a large circle circumference with a soft edge. Change the color to 100% black (just do the K, not the CMY). Now, with the shadow layer selected, click on a corner of the

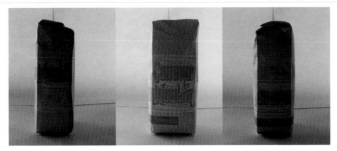

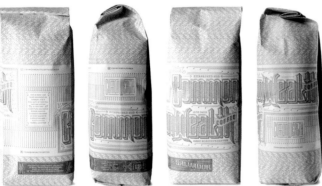

object, hold Shift and click to the opposite side in a straight line, and then the opposing side again. Basically, draw an L around the object that is slightly offset. Now, select the erase tool and make sure it's not too wide of a shadow, and make sure the shadow feels natural and the offset feels natural. Adjust the opacity of the layer so it feels a little bit softer and not so harsh or deep on your white or colored surface—if you plan on having a colored paper or texture underneath the object you are editing, make sure to use Multiply on the layer so it will blend into the color beneath it and appear more natural.

For the background open up the texture layer using the same steps as listed above (except don't worry about clipping this one out). An additional step will be the Clone tool. We'll use the Clone tool or Bandaid tool to take out the seams and blend them into the overall texture. Sometimes, if it's too complicated of a texture, I will only shoot one piece of the texture rather than trying to overlap multiple sheets and blend the seams together. I'll open it up, and then duplicate the layers and then invert them side by side so that the textures blend seamlessly together. This will duplicate similar lighting from one side to the other so the two layers appear nice and seamless and like a cohesive whole.

I'll merge the layers and create one solid block of texture, then drag it over my other file and it will magically appear in my previous card file.

Move the layer underneath the card layer you were previously working on, that is now nicely clipped with a lovely shadow.

Now let's work on the lighting. You might want to hide the texture layer so you can see true white for reference (especially if the card or collateral you are editing is on a white paper, or slightly off-white paper, you'll want to see what true white looks like to get as close to it as possible).

Add a new Levels adjustment layer. You might want to isolate this effect to the collateral piece only, and not the texture, and do a separate level adjustment to the texture layer, but sometimes this one level adjustment can work well for both.

Proceed to adjust the levels so that the whites feel natural and congruent with the white background layer. Be careful not to blow out images so that the whites are so bright that details disappear. Usually, a combination of adjusting the mid-tones and highlights will create the desired lighting.

If needed, make a separate level adjustment to the texture layer if the lighting differs from the collateral layer.

If needed, adjust the hue/saturation of both layers. I almost ALWAYS need to do this. I don't want to exaggerate anything too much as I'd like the piece to reflect the true nature of what I designed and created. However, sometimes giving it a little color boost can help. Additionally, sometimes the colors will be a little off, so learning how to adjust the hue/saturation of specific colors can be a big help. Sometimes, you may only want to adjust the yellow in it, or turn down the red so it's not looking so hot. If the lighting is very warm, I recommend toning down the red. Again, I want the whites to be very neutral, and the colors to stand out. So use common sense to proportionally adjust the colors to appear as natural as possible. If needed, drop the saturation entirely on some of those colors. My card is primarily white, red, and gold. So I don't really need blues in there. Sometimes the lighting can be a bit blue, so I'll select the blue and cyan levels and drag the saturation all the way to the left so the whites are nice and neutral.

That should just about do it. Good luck!

Guts & Glory

DESIGN AND BRANDING STUDIO FOUNDED BY MEG PARADISE AND FAUN CHAPIN IN OAKLAND, CA, GUTS & GLORY REVEALS HOW TO "FAKE IT 'TIL YOU MAKE IT", OR "PHOTOGRAPHY FOR DESIGNERS" IN THIS DETAILED TELL-ALL.

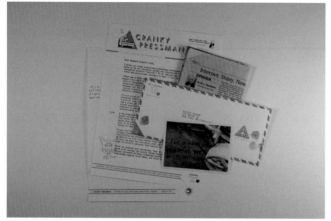

OUR PHILOSOPHY

PHOTOGRAPHY IS AN ILLUSION We tend to see photography as a record of reality, but photography has a long history of manipulating an image both in the lens and afterwards to construct an image that suits the photographer's vision. The beauty of a well executed magic trick is that you don't see how it's performed. A good photo is a very well executed magic trick.

KNOW THE BASICS There are tons of basic photography tutorials online that will give you a good foundation to creating a decent image. Better yet, find a local photo studio or store that offers classes.

WORK WITH WHAT YOU'VE GOT You're not a photographer. You're a designer using the skills you've got to construct an image to suit your needs. And that's A-OK!

PHOTOSHOP IS YOUR BEST FRIEND This is the most powerful tool in your designer toolbox to get you a good image. Proper color balance, contrast, and saturation can get you very far.

FAKE IT TIL YOU MAKE IT As you grow in your career, your budgets should increase and include resources for working with professional photographers. Or if all else fails, make friends with a photographer and trade services.

THE SETUP AND THE GEAR

RECRUIT A BUDDY You can do it on your own, but if you recruit a buddy to help you, you'll have someone to help with the setup and adjustment of your set while you're focusing on what you're seeing through the lens.

THE STUDIO We use our conference table to set up most of our shoots. But you can use pretty much any large, clean, flat surface.

 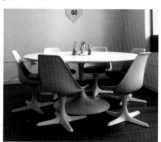

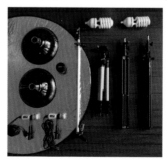

INVEST IN A GOOD WHITE SEAMLESS BACKGROUND This will give you a much cleaner surface to work from in post-production. Use painters tape to tape it down so you can reuse your seamless since a roll of seamless paper isn't cheap.

USE WINDOW LIGHT WHEN POSSIBLE It's even, balanced, throws nice shadows and will give you the best overall lighting.

BUY A LIGHTING KIT Doesn't have to be fancy. B&H has a great selection of entry level kits that will get the job done for under $200. We could probably use a strobe light but that becomes more complicated to use than a set of hot lights. The helpful people at our local photo store recommended we upgrade the lightbulbs from the standard kit to higher watt bulbs. You can't really have too much light. Pro tip: Hang out at a photography shop and ask questions. Most people are more than happy to help outfit you with gear that fits your needs and budget.

GOOD CAMERA, BETTER LENS Pretty much any camera will do. Mine is from college and is over 10 years old. My iPhone probably has more megapixels than this SLR. But a good lens will change everything.

Along the way we picked up a Nikon Nikkor 40mm Micro lens for around $400 and it takes beautiful photos for super tight closeups and midrange product shots.

THE SHOOT

HANDHELD VS. TRIPOD Use a tripod if you need consistency between shots or don't have enough light to shoot handheld shots. The slowest shutter speed you can usually hold a camera at without getting a blurry image is about 30 if you have a super steady hand and hold your breath while depressing the shutter button.

STAY ORGANIZED I watched a photographer friend on a professional shoot once and was amazed at how organized he was with all of his gear. It made the shoot run so much smoother than if everything was strewn about willy nilly, and things get messy fast when you're constantly losing things and tripping over stuff. It's dangerous and inefficient.

ARRANGE YOUR COMPOSITION For this shot, we wanted a nice grouping of all of the elements. We're going to replace the background and add a wood texture background (that I found on a design resource site, or you can shoot your own) so I want to make sure I'm squared off directly above my composition.

SHOOT IN RAW FORMAT This gives you the most flexibility once you start to pull everything into Photoshop.

POST-PRODUCTION

CHECK YOURSELF BEFORE YOU WRECK YOURSELF Before you break down your set, dump your photos onto your hard drive and make sure you have a decent amount of images to work from. The biggest thing you're checking for is that they're in focus. You can do a lot of wizardry in post, but you can't bring a blurry photo into focus. If you want to get fancy, you can tether the camera directly to a laptop while you're shooting so you can view the images as you're shooting them.

BREAK IT DOWN Once you check your photos for general OK-ness, break down your set. You'll be happy you did it now rather than at the end of your day.

PRE-PROCESS YOUR RAW FILES Use the RAW dialog box in Photoshop to adjust overall color balance, temperature, and contrast. Watch your histogram (the box that looks like a bunch of mountains and valleys) and try to keep most of the mountains in the middle of the graph without clipping the highlights or the shadows off. You will continue to refine the color balance and contrast using Levels, Hue/Saturation, and Curves once you pull the image into Photoshop but right now you're looking for a good, middle of the ground image. Not too contrasty, not overly saturated, not overly blown out. Now you're ready to bring your pre-processed image into Photoshop.

ALWAYS USE ADJUSTMENT LAYERS Using layers allows you to work in a non-destructive editing way that gives you the most flexibility and allows you to adjust the image back and forth until you arrive at something you're happy with.

LEVELS, CURVES, AND HUE/SATURATION These are the three main tools I was taught to process images. Use Levels to adjust the individual color channels to affect the overall color balance of your image. Use Curves to adjust contrast. Generally, a nice smooth S curve will give you a good amount of contrast without appearing overly contrasty. After you've adjusted the color balance and the contrast, add a Hue/Saturation layer. I usually increase the master contrast a bit, and then use the individual color dropdowns to affect any additional colors individually (eg. saturating red or blue while desaturating yellow).

PEN TOOL TRUMPS MAGIC WAND Use your Pen tool to create clean cutouts or selections, and zoom waaaaay in to make sure you're getting an accurate edge. It takes a bit more time up front than using the Magic Wand, but it will give you a much cleaner selection. I often find when I use the Magic Wand, I spend more time trying to clean up my selection than I would if I'd just spent the time to draw a clean cutout with the Pen tool to begin with. Once you have your selection, use a mask rather than delete your background. Apply a .5 or 1 pt Gaussian Blur to your mask to soften it slightly and help it blend more realistically into your background.

By now, you should have a pretty decent image (bottom). It's not museum quality, but it should be more than enough to give you a good image for your portfolio. This is not to say that there isn't a huge difference between what you and I can do, and what a professional photographer can do. The image below/left was one we shot in-house and edited heavily, and the one below/right was shot and edited by a professional product photographer with years of experience. There is a clearly a HUGE difference in quality across the board, but the one we shot in-house served us quite well for what we needed it for.

GET GRANULAR Create individual selections and adjustment layers for areas you want to adjust contrast or color on separately. In my image, the dark photograph was adjusted separately from the rest of the image since it was so different.

SHADOWS I've used a combination of the Drop Shadow layer effect and hand drawn shadows to mimic the original shadows created by the paper. Good drop shadows can make a huge difference in creating a realistic-looking composite image. Creating your shadows on a separate layer gives you the most flexibility in creating realistic-looking shadows which you can then multiply onto your background layer.

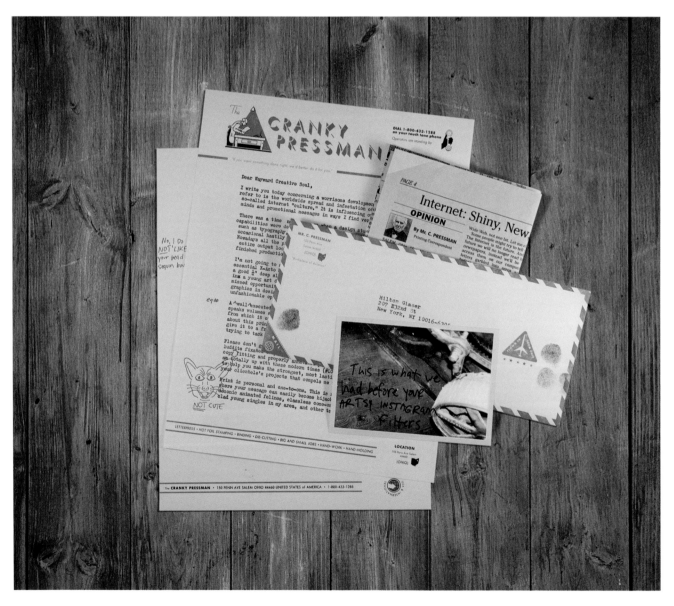

CODO Design

A BRANDING AND WEB DESIGN FIRM BASED IN INDIANAPOLIS, IN, WORKING WITH THE FOOD AND BEVERAGE INDUSTRY, SMALL BUSINESSES, AND NOT-FOR-PROFITS, CODO DESIGN SHARES HOW A CONSISTENT BACKGROUND HAS TIED TOGETHER THEIR PORTFOLIO FOR YEARS.

We decided early on, back while we were still in school and planning to start CODO, that we wanted all of our portfolio photos to be consistent. Knowing almost nothing about photography, we strove to control what few variables we could—using the same background, compositions and always using soft, natural light.

To start, we repurposed an old privacy fence from outside our office into a simple, rustic photo backdrop. This allows us to easily shoot in different locations, so long as the weather cooperates. If you go far enough back into our archives, you can see snow in the background at times. In others, I've had to Clone Stamp sweat that had poured from my face and onto the work.

We generally shoot in the late afternoon, trying to capture as much of the "golden hour" light as we can. Sometimes we use a tripod, sometimes we don't. For composition and details, we try to take large contextual photos to show what the entire piece looks like and then dive into the tighter, detail shots to highlight typography, hierarchy, texture, production methods, etc.

Now that we're busier and starting to attract national work, we've started to pay a professional photographer to shoot our work for us, albeit with the same wood backdrop. It's almost painful how night-and-day the difference is between my old photos and the photographer's.

GEAR

CAMERA Nikon D40X sporting an 18 × 55 lens
TRIPOD Cheapo Targus
BACKGROUND Wood
Removable Tape
Compressed Air

TIPS

1. Make sure to capture the larger piece itself before diving into detail photos. I love seeing tiny details as much as any designer, but make sure to give people an idea of what the overall artifact looks like first.

2. Removable tape and compressed air are your best friends. The tape can keep work in place (whether you're in the wind or not) without damaging it and compressed air can save you hours of time Clone-stamping dust, hair, and Cheetos crumbs off of your photos during post-production.

3. Use small items (gravel, a pocket knife, an eraser, etc.) to subtly prop some pieces of stationery up on top of others. This provides gorgeous shadows and makes for more interesting photo compositions.

4. Realize that "good" photos can add a huge layer of quality to your work. Having great photos in a nice portfolio is like showing up to an interview dressed nice and talking confidently about your work, etc. It's a representation of you and your capabilities.

RoAndCo

A MULTI-DISCIPLINARY CREATIVE AGENCY IN NEW YORK, NY, WORKING FOR FASHION, CULTURAL, AND RETAIL CLIENTS, ROANDCO PRESENTS THEIR WORK CONSISTENTLY THROUGH RECURRING ANGLED SHOTS AND A SHIFTING RANGE OF COLORED BACKGROUNDS.

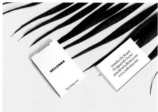
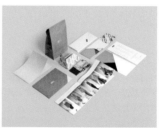

GEAR

CAMERA Canon 7D
LENS Canon EF 28-135mm
FLASH Impact Digital Monolight 300W/s (120VAC)
LIGHTING 1 Impact Medium Luxbanx Softbox 24 × 32 × 17″
BACKGROUND 1 Roll of White Seamless Paper 53″ wide
SURFACE Table

TIPS AND TRICKS

1. Determine a unique combination of lighting and styling to characterize your portfolio image style. These photos are a visual representation of your skills and attention to detail, and the proprietary way you present your work says a lot about what you're capable of.

2. Maintain consistency with angles and framing across images. If you are shooting a book spread from above, all spreads should be framed in the same way so the resulting size of the book in the image does not vary. Although each project is different, the goal is to create a dedicated style that showcases your personal "branding." Consistency is key!

3. Aim to capture as much detail as possible while shooting to minimize the need of post-production or retouching. This can be particularly challenging for effects such as foil stamping or blind embossing, but gets easier with experience. One trick for shooting metallic foils is to hold a black card floating close to the piece so it reflects in the foiled area without showing in the frame. This gives the foil the depth and highlight it needs to pop in your portfolio.

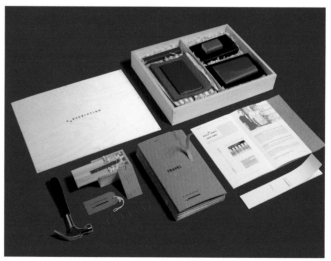
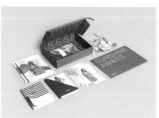

UnderConsideration

A GRAPHIC DESIGN ENTERPRISE THAT RUNS A NETWORK OF BLOGS, PUBLISHES BOOKS, ORGANIZES LIVE EVENTS AND JUDGED COMPETITIONS, DESIGNS FOR CLIENTS, AND AUTHOR OF THIS BOOK, UNDERCONSIDERATION IS CONSTANTLY PHOTOGRAPHING THEIR WORK TO PUT UP FOR ONLINE PURCHASES AND TO DOCUMENT THE MATERIALS PRODUCED FOR THEIR EVENTS.

As the in-house photographer, I—Armin Vit—have pretty much learned on the go how to photograph design work. I had some photography classes in college but we never learned to do studio shots so everything I have learned has been from trial and error and, perhaps most oddly, from having played with 3D rendering programs years ago since you have to set lighting sources in that environment. This is what I have managed to figure out over the years and perhaps it will inspire you to find your own way.

GEAR

CAMERA Canon EOS Digital Rebel XTi (from 2006!)
LENS Canon EF 28-80mm
LENS FOR CLOSE-UPS Canon EF 50mm f/2.5 Compact-Macro
FLASH Canon Speedlite 430EXII
BACKDROP CowboyStudio Photography 6 × 9 ft Black
SEAMLESS PAPER Savage, 53″ wide × 12 yards, in gray and white
LAMP 12″ basic lamp stand
LAMP DIFFUSER Smith Victor DP12, 12″ Clip-On Style Light Diffuser
LIGHT BULBS WIKO Ebw 120V 500W Blue Inside Frosted PS-25 E26

EARLY YEARS

Since 2006 we have had the same camera: an entry-level Canon EOS Digital Rebel and have slowly upgraded the photographic accoutrements over the years. I started taking photos of design stuff in a small table-top light booth, which was great for small things like business cards and letterhead but photographing the spread of a book was impossible. As a beginner's tool, though, it was fantastic as it provided a simple, compact, and very controlled environment where I could take basic photos straight-on. The thin fabric on the sides served as a wonderful diffuser for the really yellow light bulbs I was using at the time and I was able to get very nice, soft photos. I highly recommend this as a starting point.

I have never been able to get good photographs with natural light. I have tried sunny days, cloudy days, foggy days, and in every hour of the day possible. Somehow I never get the shadows that I want or the colors that I expect. Not to mention that the wind is always blowing letterheads away. Some people swear by natural light photographs and I'm sure it can be done—I will not be the one providing any words of wisdom about it.

FIRST UPGRADE

My next step was buying white and black fabric to use as seamless backdrops so that I could photograph bigger objects and to be able to shoot at angles. The table-top light box is not seamless on the sides and it's a whole other kind of light that you get if you catch the side walls in the frame of the photo. Back to the fabric: the fabric provides a cool, soft texture but—guess what?—every time you fold it to put it away it creases and you have to iron it with every use. It became a real pain to do this, but the pro was that it was easy to store. With the fabric I would lock myself in the window-less bathroom and anchor the fabric on the edge of the bathtub dropping onto the floor creating the seamless effect. At this point I also started using some more hardcore light bulbs that would heat up like crazy and would make the bathroom unbearably hot in summer days, even with the air conditioner at full blast. Nonetheless, these light bulbs (specified in the gear list above) have been the best I've ever used. They are very bright and are the least yellow I've found. They cast a very strong, "hot" spot so I bought some

diffusers to attach to the lamps and these soften the light a lot like the table-top box.

Another important purchase was an outer flash for the camera (also specified in the gear list). I never use it as a party-like photo flash where you direct it at the subject and it lights up all white. I must have read somewhere that the trick is to point it upwards and a little bit backwards so that it fills the area around the subject with a nice, white blast. It works particularly good in small-ish rooms where the light of the flash bounces off the walls.

So, with the seamless background, the hot-ass lamps, the flash, and some patience I took probably two or three years worth of photographs using this set up. Photos came out nice. It was easy to position lights and eventually I became pretty good at Photoshopping out the creases in the fabric. The trick for me here was that I was able to block out all natural light and focus on the light generated by the lamps.

LAMP PLACEMENT

I'm sure I would benefit from taking a course or watching some online tutorials or something but I place my lamps in pretty ambiguously helpful spots and heights. I first think about where I want my main shadow to be: if I want an object to cast a shadow on the bottom and to

ISO to 400 if I am using a white backdrop and 800 if using the dark gray. I don't use a tripod as I like to move around and catch different angles; about a quarter of my shots are blurry usually, but I can take hundreds of shots without worrying about film waste and I can quickly edit out the bad ones.

One thing I do that works wonders is establishing a custom white balance, which most cameras today allow for. This is basically shooting a close-up of the paper of the object (or the seamless background, with the lights on) and telling the camera, "This is our white, now". This changes the overall color of the photos somehow and I've found that my photos require less retouching when I do custom white balance than when I don't.

I like to shoot the objects at angles in part because taking straight-on shots is really hard as you invariably get bowed edges and in part because I think it presents design work really well. For close-ups, it's almost like I'm a war journalist, and it's not rare to find me laying fully on the floor trying to get a cool angle.

CLOSE-UPS

No one can resist a juicy close-up of a nicely printed piece of design. No one. Especially if it's letterpress. Even if you have used Comic Sans, a super zoomed-in close-up will shoot straight to your viewers' hearts. The main 28-80mm lens I had initially took decent enough close-ups but as I took more photos I got greedy and I made the expense of buying a macro lens to get really up close and personal with the work. I could shoot with this thing all day long. It generates awesome detail shots with a great fuzzy edge and it elevates the presentation of the project by making the viewer feel as if they could touch the printed piece.

the right like the default drop shadow in InDesign, I'll place one lamp to the left and back from the object. How far to the left, how far back, or how high up? Basically whatever the room and length of the cables allow me. Then I place the other lamp on the opposite of the first lamp as far away as possible so that it still illuminates the scene but it doesn't cast a competing shadow. Sometimes I will put a white foamcore or board on the opposite side of the main lamp and turn the second lamp directly towards the foamcore or board to bounce a softer light unto the subject.

I use this set-up for when I want to show the full object so that viewers can see the whole thing. Once I get into detailed, close-up shots, I change the lamps to both point directly at the object and as symmetrical as possible. This way I get even lighting on the detail and avoid having half of the photo be dark and half be light.

Basically, it's all about trying different approaches and seeing what works and feels right to you. But I think you do need a good pair of lamps and bulbs to take consistent photographs.

SECOND UPGRADE

After years of shooting in the bathroom and ironing fabric I decided enough was enough. I was also spurred by a rearrangement of our kids' bedroom—we work from home—that opened up a big area in the middle of it. My next important purchase was an expandable frame-tube-bracket structure to use as the frame for a really wide roll of paper that you can unspool and spool with each session. Bonus: the paper doesn't need ironing! This has been the best set-up so far as I now have a lot more space and a bigger area of seamless to shoot on. The new room has much higher ceilings than our bathroom so the flash behaves in different ways now.

The moral of these set-ups is that, at the end of the day, what you really need and can achieve in various ways is some kind of even and consistent surface, one or two light sources, and plenty of space to operate.

SHOOTING STYLE

I put the camera in "P" and let the camera figure stuff out. I will set the

PHOTOSHOP

Even though I have already written over 1,500 words, the battle to make a convincing image has just begun. No matter what equipment you have or how many photos you've taken you are (most likely) not a photographer and your source photos will look underwhelming because you are a designer and this is not your area of expertise. Before doing this section of *Flaunt* I thought I was the only person spending more time on Photoshop correcting my unimpressive photos than on taking good photos to begin with. Hearing from Kevin Cantrell and Meg Paradise at Guts & Glory, it's nice to know I am not alone! There is a lot of color correcting and retouching that needs to happen in Photoshop

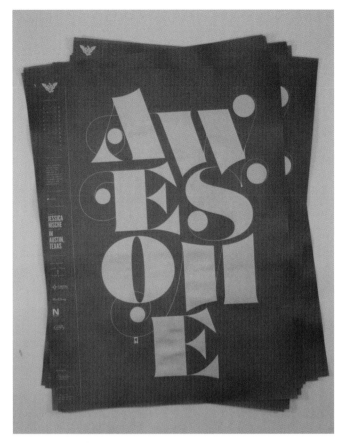

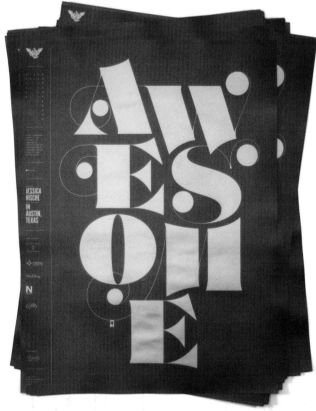

and just like with my photos any color correction techniques I have learned have been the result of trial and error.

I do all of my retouching in RGB color mode since most of our images are for online consumption and I read somewhere once that that's what you are supposed to do.

My first order of business is creating a Levels adjustment layer and going channel by channel moving in the outer arrows to where the black mountains begin. What this does is that it gets the whites whiter and the blacks blacker, which is what I want to happen. At this point you have to be careful to not blow out the whites and have really bright spots or darken it so much that you start to lose dimensional detail. What I want to achieve right now is a semblance of reality. I'm not doing final color correction here.

Next, I will outline the object using the Pen tool. Yes, it's a pain but it's the absolute best way to get the color you want on the object while not messing up the backgrounds. It allows for better control overall. If I shot on a gray seamless I will load the path as a selection, select inverse, Feather of 1, and take the color saturation out of the background with a masked adjustment layer. This will ensure my backgrounds are always a neutral gray and not cool grays in some or warm grays in other photos; having the Hue/Saturation layer will also allow me later to darken or lighten the gray background. If it's a white seamless photo I will load the path as a selection, select inverse, Feather of 1, and create a new Levels adjustment layer where I will make everything lighter until it becomes white. This will usually keep the original shadows in there, but you might need to darken those in the same Levels layer.

From there I will do another set of adjustment layers using the path so that I can focus on the object itself. I will usually do another Levels layer to get the colors closer to the real thing; then another Hue/Saturation layer to mute the colors a bit so that it's not an overly colorful photo. I have never been able to figure out the Curves, so only if I'm desperate will I move some knobs on it and pray something works out.

If I have easily selectable colors I will do Select › Color Range to isolate those colors and perhaps brighten them up or adjust them. Once you load a selection it's always a good idea to do a Feather of 1, to smooth out the selection.

DO WHAT WORKS FOR YOU

As you've gathered by now, I'm not the biggest expert on this subject. I've just experimented and tested enough times that, now, I can get relatively convincing results. What has worked best for me is trying, trying, and trying. This is a particularly helpful mindset when color-correcting: "What happens when I move this value up? Oh, it gets green, okay then, let's go the other way." It's good to have a basic understanding of what Photoshop adjustment layers do—sometimes I feel like they control me instead of me controlling them. There are images where it's taken me five or six hours to get to something passable and sometimes in thirty minutes I'm done.

I also keep experimenting with new bulbs, different lamp positions, and weirder angles to see if I can improve on my sometimes aleatory techniques so that I can get better photos, more consistently, with less time spent in Photoshop.

If you figure out any tricks, let me know.

Census of portfolio etiquette

Results of online surveys comparing the expectations of 550-plus interviewees and potential employees with those of 270-plus interviewers and potential bosses.

Portfolio basics

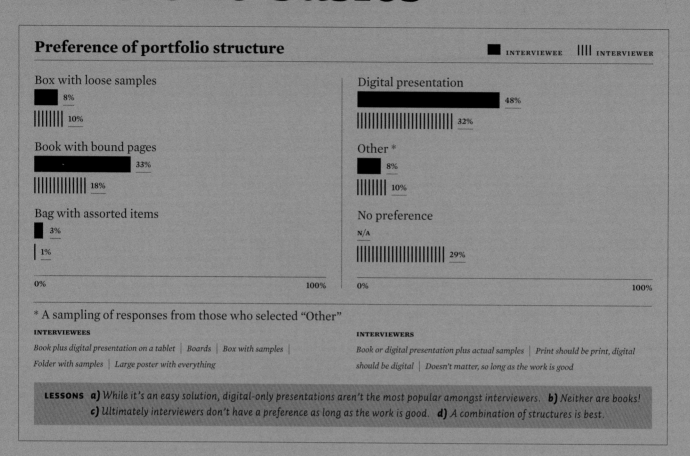

Preference of portfolio structure

■ INTERVIEWEE ⦀ INTERVIEWER

Box with loose samples
- 8%
- 10%

Book with bound pages
- 33%
- 18%

Bag with assorted items
- 3%
- 1%

0% — 100%

Digital presentation
- 48%
- 32%

Other *
- 8%
- 10%

No preference
- N/A
- 29%

0% — 100%

* A sampling of responses from those who selected "Other"

INTERVIEWEES
Book plus digital presentation on a tablet | Boards | Box with samples | Folder with samples | Large poster with everything

INTERVIEWERS
Book or digital presentation plus actual samples | Print should be print, digital should be digital | Doesn't matter, so long as the work is good

LESSONS a) *While it's an easy solution, digital-only presentations aren't the most popular amongst interviewers.* **b)** *Neither are books!* **c)** *Ultimately interviewers don't have a preference as long as the work is good.* **d)** *A combination of structures is best.*

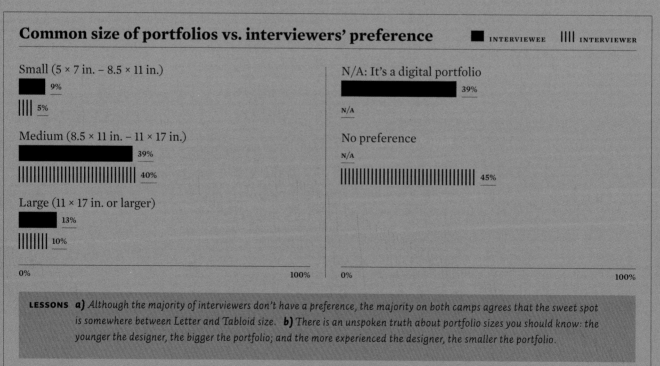

Common size of portfolios vs. interviewers' preference

■ INTERVIEWEE ⦀ INTERVIEWER

Small (5 × 7 in. – 8.5 × 11 in.)
- 9%
- 5%

Medium (8.5 × 11 in. – 11 × 17 in.)
- 39%
- 40%

Large (11 × 17 in. or larger)
- 13%
- 10%

0% — 100%

N/A: It's a digital portfolio
- 39%
- N/A

No preference
- N/A
- 45%

0% — 100%

LESSONS a) *Although the majority of interviewers don't have a preference, the majority on both camps agrees that the sweet spot is somewhere between Letter and Tabloid size.* **b)** *There is an unspoken truth about portfolio sizes you should know: the younger the designer, the bigger the portfolio; and the more experienced the designer, the smaller the portfolio.*

Project aids

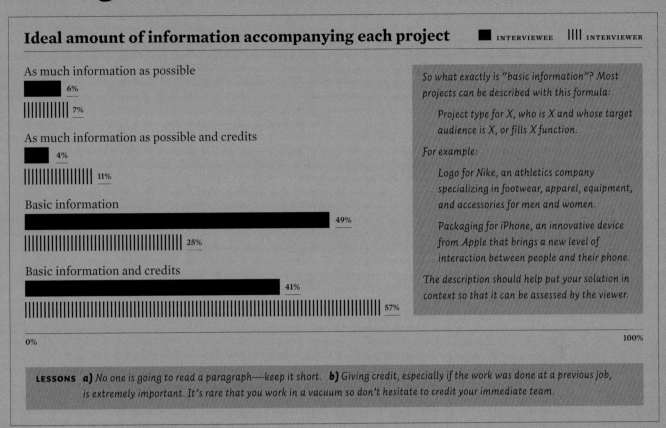

Ideal amount of information accompanying each project ■ INTERVIEWEE |||| INTERVIEWER

As much information as possible
6%
7%

As much information as possible and credits
4%
11%

Basic information
49%
25%

Basic information and credits
41%
57%

0% 100%

So what exactly is "basic information"? Most projects can be described with this formula:

Project type for X, who is X and whose target audience is X, or fills X function.

For example:

Logo for Nike, an athletics company specializing in footwear, apparel, equipment, and accessories for men and women.

Packaging for iPhone, an innovative device from Apple that brings a new level of interaction between people and their phone.

The description should help put your solution in context so that it can be assessed by the viewer.

LESSONS a) *No one is going to read a paragraph—keep it short.* **b)** *Giving credit, especially if the work was done at a previous job, is extremely important. It's rare that you work in a vacuum so don't hesitate to credit your immediate team.*

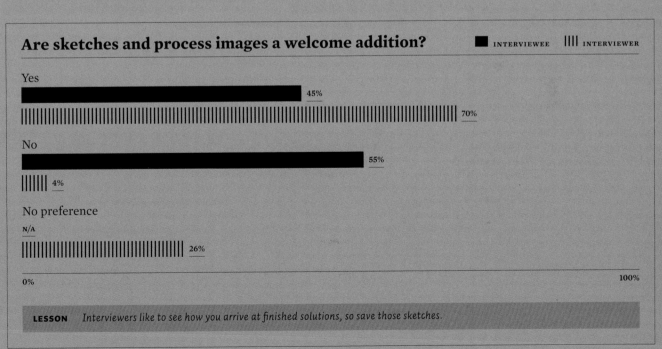

Are sketches and process images a welcome addition? ■ INTERVIEWEE |||| INTERVIEWER

Yes
45%
70%

No
55%
4%

No preference
N/A
26%

0% 100%

LESSON *Interviewers like to see how you arrive at finished solutions, so save those sketches.*

Digital presence

Does your website match your portfolio? Should it?

■ INTERVIEWEE |||| INTERVIEWER

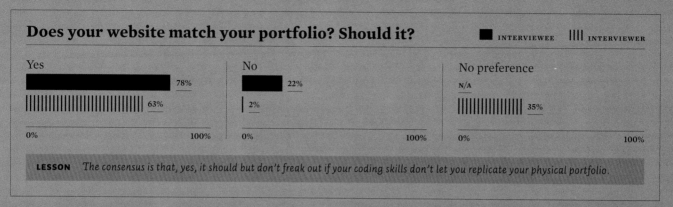

Yes
78%
63%

No
22%
2%

No preference
N/A
35%

0% — 100% 0% — 100% 0% — 100%

LESSON *The consensus is that, yes, it should but don't freak out if your coding skills don't let you replicate your physical portfolio.*

Common vs. preferred website development method

■ INTERVIEWEE |||| INTERVIEWER

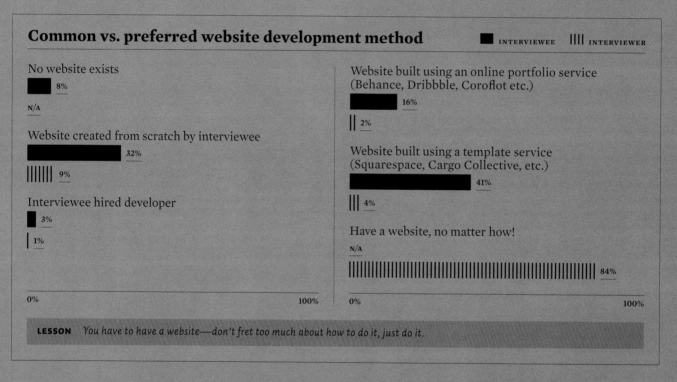

No website exists
8%
N/A

Website created from scratch by interviewee
32%
9%

Interviewee hired developer
3%
1%

Website built using an online portfolio service (Behance, Dribbble, Coroflot etc.)
16%
2%

Website built using a template service (Squarespace, Cargo Collective, etc.)
41%
4%

Have a website, no matter how!
N/A
84%

0% — 100% 0% — 100%

LESSON *You have to have a website—don't fret too much about how to do it, just do it.*

Behance-based portfolios, love 'em or hate 'em?

■ INTERVIEWEE |||| INTERVIEWER

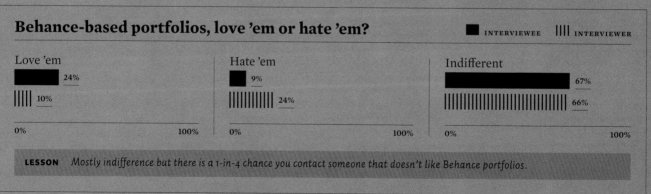

Love 'em
24%
10%

Hate 'em
9%
24%

Indifferent
67%
66%

0% — 100% 0% — 100% 0% — 100%

LESSON *Mostly indifference but there is a 1-in-4 chance you contact someone that doesn't like Behance portfolios.*

Making contact

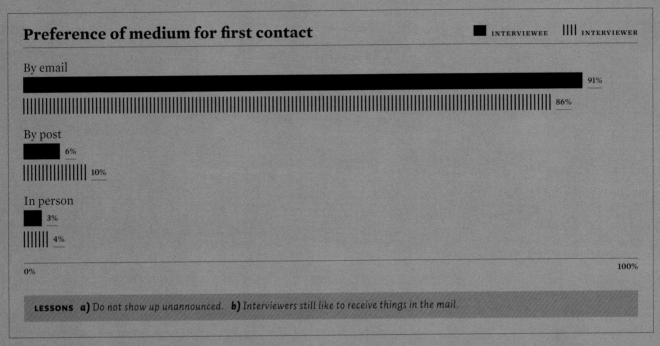

Preference of medium for first contact

■ INTERVIEWEE |||| INTERVIEWER

By email

91%

86%

By post

6%

10%

In person

3%

4%

0% 100%

LESSONS a) Do not show up unannounced. **b)** Interviewers still like to receive things in the mail.

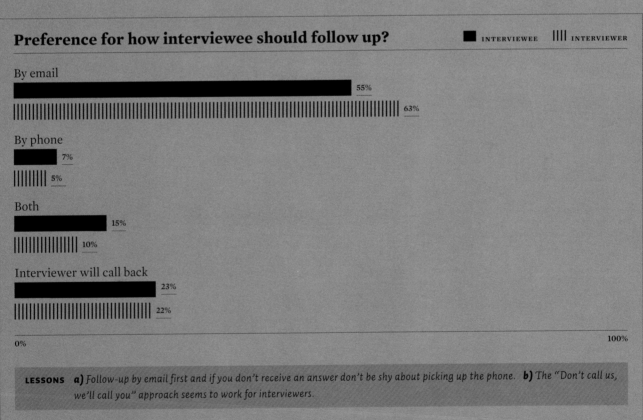

Preference for how interviewee should follow up?

■ INTERVIEWEE |||| INTERVIEWER

By email

55%

63%

By phone

7%

5%

Both

15%

10%

Interviewer will call back

23%

22%

0% 100%

LESSONS a) Follow-up by email first and if you don't receive an answer don't be shy about picking up the phone. **b)** The "Don't call us, we'll call you" approach seems to work for interviewers.

Email contents

What should be included in a first-contact Email?

■ INTERVIEWEE　⦀ INTERVIEWER

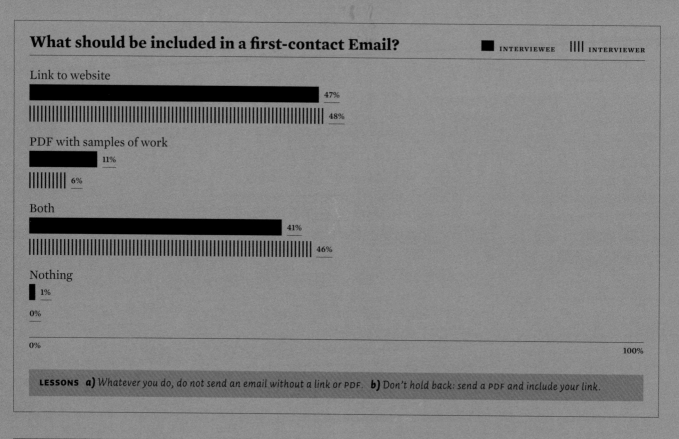

Link to website
47%
48%

PDF with samples of work
11%
6%

Both
41%
46%

Nothing
1%
0%

0%　　　　　　　　　　　　　　　　　　　　　　　　　　100%

LESSONS　a) *Whatever you do, do not send an email without a link or PDF.*　**b)** *Don't hold back: send a PDF and include your link.*

Should recommendation letters be included at this point?

■ INTERVIEWEE　⦀ INTERVIEWER

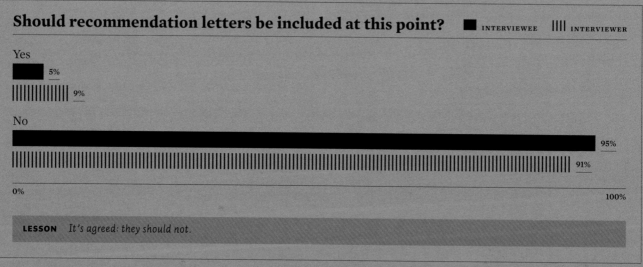

Yes
5%
9%

No
95%
91%

0%　　　　　　　　　　　　　　　　　　　　　　　　　　100%

LESSON　*It's agreed: they should not.*

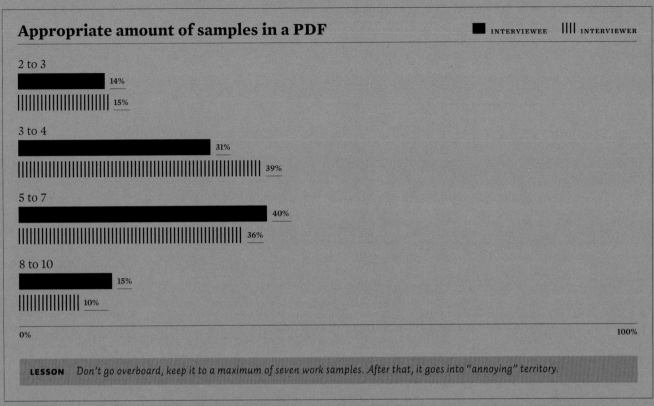

Appropriate amount of samples in a PDF

■ INTERVIEWEE |||| INTERVIEWER

2 to 3
14%
15%

3 to 4
31%
39%

5 to 7
40%
36%

8 to 10
15%
10%

0% 100%

LESSON Don't go overboard, keep it to a maximum of seven work samples. After that, it goes into "annoying" territory.

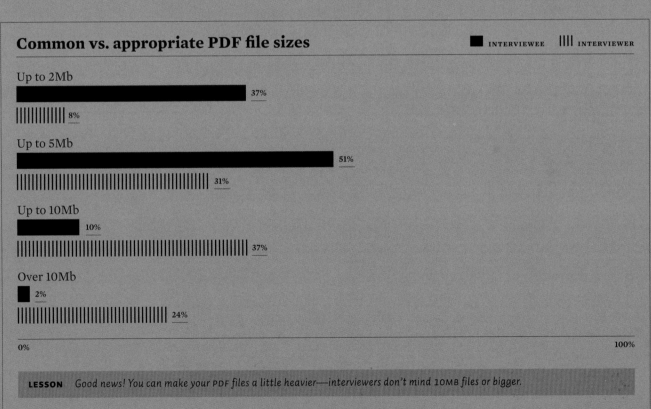

Common vs. appropriate PDF file sizes

■ INTERVIEWEE |||| INTERVIEWER

Up to 2Mb
37%
8%

Up to 5Mb
51%
31%

Up to 10Mb
10%
37%

Over 10Mb
2%
24%

0% 100%

LESSON Good news! You can make your PDF files a little heavier—interviewers don't mind 10MB files or bigger.

Interview protocol

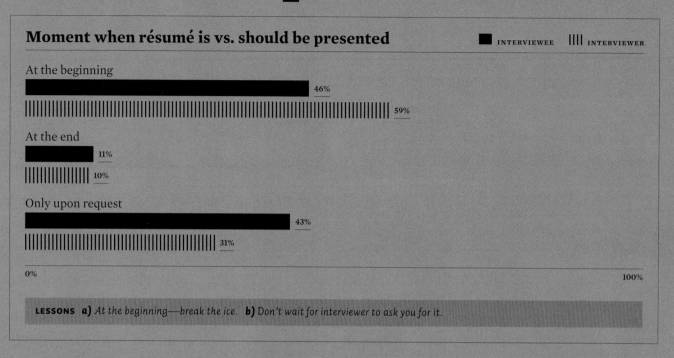

Moment when résumé is vs. should be presented

■ INTERVIEWEE ||| INTERVIEWER

At the beginning

46%

59%

At the end

11%

10%

Only upon request

43%

31%

0% 100%

LESSONS *a)* At the beginning—break the ice. *b)* Don't wait for interviewer to ask you for it.

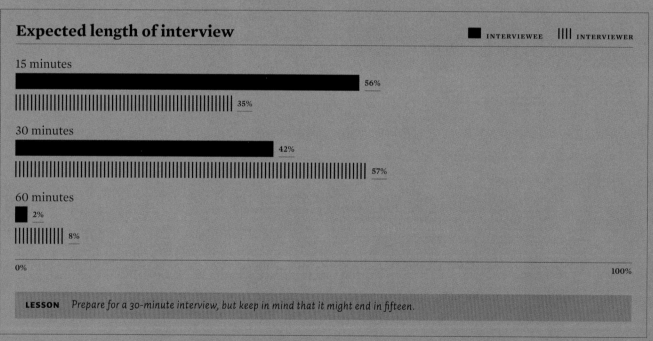

Expected length of interview

■ INTERVIEWEE ||| INTERVIEWER

15 minutes

56%

35%

30 minutes

42%

57%

60 minutes

2%

8%

0% 100%

LESSON *Prepare for a 30-minute interview, but keep in mind that it might end in fifteen.*

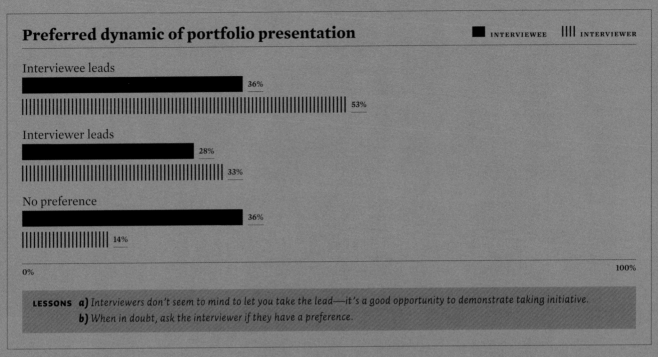

Preferred dynamic of portfolio presentation

■ INTERVIEWEE |||| INTERVIEWER

Interviewee leads

36%

53%

Interviewer leads

28%

33%

No preference

36%

14%

0% 100%

LESSONS *a) Interviewers don't seem to mind to let you take the lead—it's a good opportunity to demonstrate taking initiative.*
b) When in doubt, ask the interviewer if they have a preference.

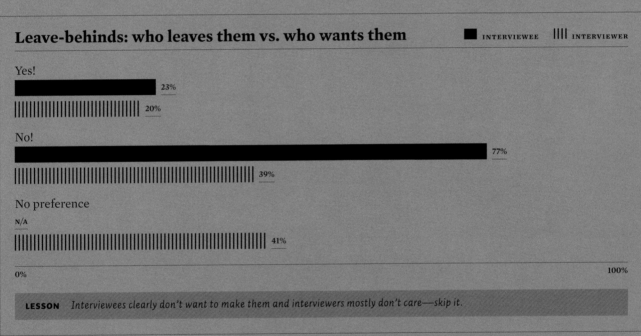

Leave-behinds: who leaves them vs. who wants them

■ INTERVIEWEE |||| INTERVIEWER

Yes!

23%

20%

No!

77%

39%

No preference

N/A

41%

0% 100%

LESSON *Interviewees clearly don't want to make them and interviewers mostly don't care—skip it.*

Showing digital work

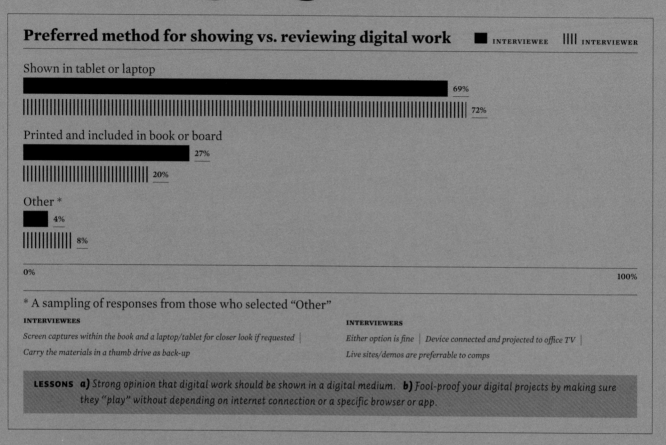

Preferred method for showing vs. reviewing digital work ■ INTERVIEWEE ||||| INTERVIEWER

Shown in tablet or laptop

69%

72%

Printed and included in book or board

27%

20%

Other *

4%

8%

0% 100%

* A sampling of responses from those who selected "Other"

INTERVIEWEES

Screen captures within the book and a laptop/tablet for closer look if requested | *Carry the materials in a thumb drive as back-up*

INTERVIEWERS

Either option is fine | *Device connected and projected to office TV* | *Live sites/demos are preferrable to comps*

LESSONS a) *Strong opinion that digital work should be shown in a digital medium.* **b)** *Fool-proof your digital projects by making sure they "play" without depending on internet connection or a specific browser or app.*

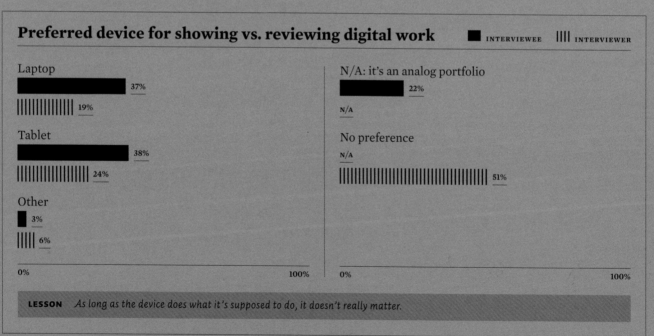

Preferred device for showing vs. reviewing digital work ■ INTERVIEWEE ||||| INTERVIEWER

Laptop

37%

19%

Tablet

38%

24%

Other

3%

6%

0% 100%

N/A: it's an analog portfolio

22%

N/A

No preference

N/A

51%

0% 100%

LESSON *As long as the device does what it's supposed to do, it doesn't really matter.*

Preferred software for showing vs. reviewing digital work ■ INTERVIEWEE |||| INTERVIEWER

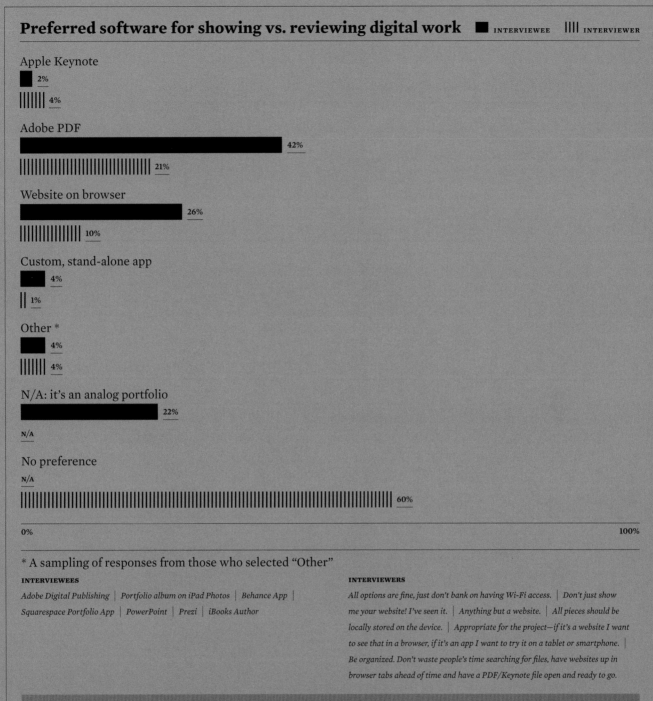

Apple Keynote
■ 2%
|||||| 4%

Adobe PDF
42%
||||||||||||||||||||||| 21%

Website on browser
26%
||||||||||||| 10%

Custom, stand-alone app
4%
|| 1%

Other *
4%
|||||| 4%

N/A: it's an analog portfolio
22%
N/A

No preference
N/A
||| 60%

0% 100%

* A sampling of responses from those who selected "Other"

INTERVIEWEES

Adobe Digital Publishing | Portfolio album on iPad Photos | Behance App | Squarespace Portfolio App | PowerPoint | Prezi | iBooks Author

INTERVIEWERS

All options are fine, just don't bank on having Wi-Fi access. | Don't just show me your website! I've seen it. | Anything but a website. | All pieces should be locally stored on the device. | Appropriate for the project—if it's a website I want to see that in a browser, if it's an app I want to try it on a tablet or smartphone. | Be organized. Don't waste people's time searching for files, have websites up in browser tabs ahead of time and have a PDF/Keynote file open and ready to go.

LESSONS a) *Fellow interviewees will most likely be using a PDF, so perhaps prepare a Keynote with some subtle effects and transitions to stand out from the crowd.* **b)** *One thing is for certain: do NOT use your website for your in-person presentation.*

Interviews with the interviewers

Valuable insights from 25 experienced interviewers on multiple, pressing topics of portfolio preparation and presentation.

How many portfolios do you see on average per month, or per year?

If we are hiring we may see ten in a month, but generally we see two to three.

STEVE LISKA

About fifty a year. And an additional 100 PDF portfolios.

STEFAN SAGMEISTER

One to two dozen per year. Our design team interviews fall, spring, and summer interns. We interview designers for full-time positions as well as development, video, and copywriting partners.

OCD

I probably see between 300 and 500 portfolios a year. I find most of them pretty fascinating.

ALLAN CHOCHINOV

When I had my own studio I regarded it as part of my job to see people and view their work. So I held regular sessions—two or three a week, sometimes more. Heads of small studios who use recruiters to find staff are admitting to a real lapse in their responsibilities. Now that I spend most of my time working on my publishing company—Unit Editions—I see fewer people. But if someone approaches me and requests a portfolio review, I rarely say no.

ADRIAN SHAUGHNESSY

I don't really see student portfolios because I have taught Senior Portfolio at SVA for many years and my job there is to help the students create portfolios. Therefore, I have a pretty large number of portfolios to choose from if I'm looking for someone to hire. I have been invited to portfolio reviews from other schools from time to time. I am usually more impressed with the portfolios I see from SVA. They tend to be more ambitious and broad.

CARIN GOLDBERG

I see a small handful. Most of the time, I go to portfolio sites like Behance, or (even better) personal sites.

MARK KINGSLEY

I only look at portfolios when I need to hire somebody, or when someone whose opinion I value suggests I check someone out. All in all, it probably comes out to around forty a year.

PETTER RINGBOM

Forty to fifty a year.

JAKOB TROLLBÄCK

About ten a month, if I'm feeling particularly generous. On a regular month, about three or four.

PATRIC KING

Ten to twenty per month.

JOSH HIGGINS

Thirty to forty a year.

JOHN FOSTER

Thirty a month. Often double that amount if we've just advertised a position at SomeOne. Last month we got 237 applicants for a junior designer opening. It's busy. But then we did take the entire studio to Ibiza for our annual summer party. The weekend was an all expenses paid trip to an amazing club, with a day on a yacht, and a private party in our own castle. SomeOne then popped a photo on our website. So that may have boosted our appeal a tad!

SIMON MANCHIPP

I see student portfolios each May when the School of Visual Arts hosts its annual senior portfolio review, as well as earlier in the semester when we review sophomore and junior books. I imagine I must view at least seventy-five portfolios a year, including the ones that I see at my office at Anderson Newton Design.

GAIL ANDERSON

Eight to ten a month, including online.

MICHAEL BIERUT

Back in the day I'd probably see thirty or more portfolios a year, most of them PDFs.

MARC ENGLISH

I receive about twenty-five a month, most via email but some through the mail or (shudder) Facebook messages. That number spikes up a bit around May/June when kids are graduating from college, and to a lesser extent in the fall as their summer jobs/internships wrap up. Of these I may review one or two in person.

CHRISTOPHER SIMMONS

I see six to eight portfolios a year from recent graduates from programs around the country who are looking for an entry-level design position at my studio or with other LA design offices.

PETRULA VRONTIKIS

Three to ten a month.

NOREEN MORIOKA

I receive unsolicited requests from students requesting advice on everything from the design and content of their résumés, to website portfolio critiques, to PDF-replications of actual portfolio pages. The actual, physical portfolio is a more infrequent occurrence, which is both good and bad: good, because online reviews are more time-efficient, but bad because I truly believe students benefit from the one-on-one tangible showing of their work, where actual presentation skills are critical.

JESSICA HELFAND

I see at least 125 as I teach the class that requires them to prepare portfolios.

MARY SCOTT

We get about twenty to thirty a year (that I actually look at). We get about twenty a month.

JUSTIN AHRENS

Three to five a month.

PETER BUCHANAN-SMITH

What advice would you offer to a designer when creating their portfolio? Or when presenting it?

Show your best work. Have a story for each piece. SPELL CHECK. Whether you present your work in a book or on screen, bring a few actual pieces with you that I can experience first-hand. Know every typeface you used. Don't pretend that pretend things are real. Don't overdress. Don't underdress. Don't chew gum. Don't smoke until after your interview (preferably, don't smoke at all). Know who you're talking to. Have some of your own questions prepared. Listen. Praise others. Practice your manners. Have a favorite designer, book, and artist (and reasons why). Be early. Know what to do if you're offered a job. Relax. Don't get starstruck. Leave with a commitment (even if it's just that you'll follow up in x interval).

CHRISTOPHER SIMMONS

Make it well rounded and targeted towards the type of work you want to do. Example: If you want to design for the web, don't put all print-based projects in it.

JOSH HIGGINS

Do good ideas and execute them well. Do not spend an extraordinary amount of time mulling over the size and the form of the portfolio itself. Put your best piece first, your second best piece last, everything else in the middle. Think beforehand of how to explain the work in concise terms. Think of how the work can benefit the person you are showing it to.

STEFAN SAGMEISTER

Package your portfolio so the work is the one-and-only star attraction—no pink, fur-covered portfolios.

CARIN GOLDBERG

Show your work to the person you are presenting it to, and not to yourself. Sounds obvious, but I'm still surprised by the number of people who seem to think it is more important that they see their work than the person interviewing them. By this I mean, don't position your work in such a way that only you can see it clearly. Your work should be placed directly in front of the person viewing it, and not in front of you! It's glaringly obvious, but I'm staggered by the number of designers—young, and not so young—who make it difficult to view their work. This applies equally to print and digital portfolios.

ADRIAN SHAUGHNESSY

Tell us a story about you through your work. Are you mad about commissioning illustration or bats about typography? All about layout or obsessed with CGI? Please don't think sticking the same logo on a variety of objects counts as interesting. Equally, unless it is pretty unbelievable in its craft, I really don't want to see it in black and white on a blank page. Context is everything. And have a bloody opinion. A really good, smart, intriguing opinion. A conversation starter. An argument. Do not—whatever you do—be bland. There are thousands of designers out there. Why should you get the gig? This doesn't mean stroll in like you own the place. You don't. "Strong opinions, lightly held" is a good way to open a chat.

SIMON MANCHIPP

In web portfolios, I look for functionality, simplicity, beauty, and restraint. Make the site thoughtful.

HILLMAN CURTIS

Unless s/he's an interaction designer, I might advise against designing the actual portfolio site (when digital) as opposed to populating it with really great work. For graphic designers, I could go either way on this. For any other kind of designer (product, service, social, environmental, etc.), absolutely don't spend your time on the code. Spend your time presenting strong work strongly.

ALLAN CHOCHINOV

Don't include work just because it's real. The fact that something was actually printed and used doesn't make it more valuable.

PETTER RINGBOM

The work should be current—ideally from the past year. It should not be a retrospective of your time in school or proof of all of the classes in your program. It's good to think of the collection of work in the portfolio as "evidence" of your skills and conceptual abilities.

PETRULA VRONTIKIS

For a physical portfolio: don't worry about making a perfect object—à la something you would get after graduating from Academy of Art University. There is a pervasive method of portfolio creation at schools like that where you're advised to have one identity project, one liquor packaging project, a handful of sketch pages, etc. After a while, they all blend into each other.

For an online portfolio: Have your own URL. Make your own site. And write something more interesting than "brochure for hair dresser," "logo for airline," etc.

For both: Show your personality or point of view.

MARK KINGSLEY

Creating a portfolio is your opportunity to set yourself apart from other designers. It allows you to share your process as well as show the finished product. Employers want to know how you think, and when you are good at telling the story in a smart way, it gives the hiring person a sense as to your potential value.

I normally tell students to present their work and simply say, "I'll be happy to answer any questions you might have as you look at my work." This way you don't end up jabbering when all the person wants to do is look at the work. Some reviewers like to ask a lot of questions, other do not.

MARY SCOTT

Think about where you are now, and where you want to go, and build your portfolio accordingly—even if it means doing personal projects to show your eagerness and hunger.

OCD

Show your best work in a sequence that makes sense. Make sure your résumé is flawless and has excellent typography. Keep it simple: no gimmicks whatsoever—unless the gimmicks are abso-fucking-lutely amazing. But keep in mind that they're probably not.

MARC ENGLISH

Less is more. Don't put anything in unless you believe in it. I hate unfinished work, or when people apologize for something incomplete or unresolved.

JESSICA HELFAND

Include only the work you're proud of. The work should speak for itself. Absolutely no spelling mistakes.

MICHAEL BIERUT

It strikes us that the digital form of the portfolio has now taken on paramount importance. We're much happier clicking through a straightforward PDF of greatest hits than having to waste time hearing about someone's issues with their typography tutor or how they passed their cycling proficiency test. By pre-vetting electronically, it speeds things up massively.

MICHAEL JOHNSON

Good communication skills in the age of email can't be overemphasized.

GAIL ANDERSON

Think about presentation, flow of work, consistency, the mediums that are used, and the details, quality, and printing. Basically, look at a portfolio as you would a design project—it is one, after all—and design the hell out of it.

STEVE LISKA

Avoid having to over-explain your work to the viewer. Walk into a review, or interview, prepared with the best work possible. Let the work speak for itself.

CARIN GOLDBERG

Make sure that your craft is tight and clean. Pick a device that comfortably holds your work—be it a leather-bound box or a fur-covered suitcase—and reflects the type of work you hope to do. It makes a big difference, since it is usually resting on a table, in plain sight.

JOHN FOSTER

Design is about taking information and being able to tell the story well so I am more interested in whether a potential designer can articulate himself or herself.

NOREEN MORIOKA

Your portfolio is, for better or worse, you. It represents to the interviewer the potential of what you can bring to the company. Make it unique. When presenting it, make sure you practice hundreds of times in the mirror/car/wherever beforehand. Think of any question you may be asked. Write questions of things you want to know about the company. Be thoughtful. Do your homework.

JUSTIN AHRENS

Be nice. Most people don't want to work with talented assholes.

STEFAN SAGMEISTER

What do you look for in a designer's portfolio?

It depends on the role they are applying for but generally I look for craft and projects that were done outside of school or work. "Passion projects" are a good indicator.

JOSH HIGGINS

The basics have to be there: solid typography, color sensibility, and composition. If those elements are not there, I lose interest right away. If they are there, I then look at concepts, personality, and style.

PETTER RINGBOM

Craft. Thought. Ambition. And the ability to speak clearly about all three at any given time.

Craft: the work and the presentation of the portfolio itself need to be beautifully put together. Consider scale, pacing, process. Thought: design isn't just about making beautiful work, it's also about thoughtful considerations that inform the audience. Be sure your portfolio shows your concept development and thought process. Show that you have goals beyond simply getting a job to pay the rent. Ambition: show that you want to get involved in the design community by joining organizations and volunteering. Have a plan to guide your career.

OCD

The cold hard truth is that I am usually looking "through" their work for a deeper insight into how they would work as potential employees. I expect a level of competency, and craft in particular, but I am also closely listening to them in order to form an assessment.

JOHN FOSTER

The two most important things I look for are context and credit. It's pretty easy to look at a design solution and say, "That looks cool" or, "That looks shitty." It's a lot more difficult (and much more important) to determine whether the solution is an example of effective design thinking. What was the problem? What were the constraints? What was the strategy that led to the choices you made and which you're showing me now? I need to know the context.

Credit is also tremendously important. I want to know who your instructor was, who wrote the copy, if those are your images, or a friend's, or "found". Did you have collaborators? Did you design the logo or just typeset the business card? Is this your code? It's a matter of professional ethics and a demonstration of character to acknowledge everyone involved on a project. It can also help (when crediting your instructor, creative director, or fellow designers) if I happen to know one or more of them. There have literally been times when I've said, "Oh, you worked with so-and-so? When can you start?"

Exquisite craft. Solutions with meaning. Superb typography. Range (of styles, media, approaches). Clarity. A unique—or at least individual—approach/point of view.

CHRISTOPHER SIMMONS

As you know, a portfolio is a presentation, not a one-sided conversation. What annoys the hell out of me and ends an interview early is when someone does not care about my time, interest, or needs. It's important to ask at the beginning of an interview these things and perhaps edit out or change what you plan to present. It's amazing when you love someone's work that they are very compassionate and empathetic to the viewer. Those are most likely the people who get hired.

NOREEN MORIOKA

A spark of life, intelligence, passion, anything... between the ears. Evidence of someone who can bring more to the project than production skills and the ability to kern.

MARK KINGSLEY

An opinion. A push. An urgency to get things done. A belief in their craft. Beauty. Laughter. Contrast. A delight in the commercial power of creativity. A portfolio I can describe to someone at SomeOne: "The one with that mad rabbit" or, "The one where he's shot all those nipples" or just "The one that must have taken AGES". Most of what we look for is someone who could turn their hands to a multitude of tasks. To be versatile is ace. We're not hiring pigeons, so we don't pigeonhole.

SIMON MANCHIPP

The usual stuff, same as everyone else... lack of waffle ... good ideas ... good execution. Personality. Really, when I think about it, I'm often more interested in the person sitting in front of me than their work. If I'm going to work with this person, I need to know that, as well as being a good designer, they are also reliable, honest, and industrious.

ADRIAN SHAUGHNESSY

I look for depth and breadth. Does the work look appropriate for the problem it is trying to solve? Good typography is critical. No one wants to hire someone who doesn't know how to set type well and create good layouts that have strong hierarchy of information. This way the reviewer has a chance to see how the student organizes information.

MARY SCOTT

I look for point of view. Skills are great, talent is terrific, and hard work is probably more important than both of those. But I want to assume those three things, really immerse myself in the work, and concentrate on if, and how, the person's point of view is coming through.

ALLAN CHOCHINOV

At its core, a portfolio is a packaging assignment. You need to "craft" the experience that the reviewer will have with your work. I assess graduates' ability to choreograph strong narratives as their work is revealed to me through this process. I find their level of discernment through seeing the choices they make.

PETRULA VRONTIKIS

I look for a genuine spirit behind the work, a commitment to design, and a desire and skill to speak convincingly and compellingly to the world. I appreciate designers who take risks (for better or worse). I love to see the process, and how someone got from point A to point B.

PETER BUCHANAN-SMITH

Skills: primarily typographic skill, how to crop a photograph, bookbinding, and so forth. Editorial sensibilities: how to sequence images, a sense of what to leave in and what to take out. Ingenuity. Computer skills and software knowledge can be listed on résumés, not demonstrated in overworked Photoshop pieces.

JESSICA HELFAND

The work of course needs to be great. I look to see if it's relevant and classically solid. I look for the approach, process, and anything unique about the designer. We very seldom hire the best portfolio. Of course, we hire the person with a great book, but it also matters if that person is prepared, hungry, and interesting.

JUSTIN AHRENS

A portfolio should tell you a little bit about the person who created it. It's helpful to get a sense of someone's interests, whether it's politics, fashion, pop culture, or Satanism. A sense of humor to the work is always a plus, too. Stay away from hot button or sensitive issues since you never know who you're potentially offending. Making people think or even stirring them up is a good thing—but just be careful not to let your passion overshadow your better judgment.

GAIL ANDERSON

I look for four things. 1) *Thinking*: Are you eager to explore, to be curious, to know more? Have you been able to play with the rules, but still find ways to instill the work with a spirit of your own? 2) *A point of view*: Have you figured out your place in the world, or are you still searching? 3) *Humor*: do you have wit or is the humor only [just] crass and pointless? 4) *Design*: Do you possess the courage and the skills to fail in your attempts? Do you have a foundation in the core design principles? Are you a student of history?

MARC ENGLISH

How many pieces would you say make the perfect portfolio?

There's no silver bullet. Enough to give the work the best airing. But no less than five projects. The thing that makes it perfect is generally one standout project. The one you talk about. The weird one. The crafted one. The big one. The smart one. Ideally all of those. In one. Most of all, big ideas beautifully made. That's our mantra at SomeOne. If it's got that, we generally take a second look.

SIMON MANCHIPP

Eight to ten.

HILLMAN CURTIS

Few designers have a consistently stellar book. I begin to wonder when a portfolio has less than eight pieces, and there is a good chance I might get bored if it has more than twelve. Ten might be the sweet spot. However, don't include pieces just to make numbers! A weak project does more harm than good, even if it means only having seven to present.

JOHN FOSTER

Depends on the depth of the work. If the pieces are really evolved, such as full corporate identities, you can put less in there; if you have mostly one-offs, you need to put more in there.

PETTER RINGBOM

Generally no fewer than eight, no more than fifteen. Range is important, so whatever it takes for you to demonstrate your abilities across a variety of media and scales is probably the right number.

CHRISTOPHER SIMMONS

Hard to say. Depends on the student. An MFA portfolio might include fewer pieces but more depth. An undergraduate portfolio benefits from showing breadth. In both, personal work (drawings, photographs) and non-client work can be helpful particularly if the schoolwork is workman-like and tedious, which, depending on the school, it can be. (Less so today than when I was a student!) Here, I would advise including work that represents a part of the prospective employee's capabilities ONLY IF it doesn't exist elsewhere. Judicious inclusion of personal pieces reflects thought and care and self-awareness, all good things in a junior designer!

JESSICA HELFAND

Three great ones to get me interested and ten more to seal the deal.

NOREEN MORIOKA

In the digital realm, once we've been persuaded to open the PDF or visit the URL, a dozen or so pieces works best for us. Generally, students rarely have more than ten killer ideas. In fact, if we're honest, it's quite rare to see anyone with more than four or five. Trouble is, we're suspicious if people only show us six projects. We start thinking, "Where's all the other stuff?"

MICHAEL JOHNSON

Usually ten. But it is better to have nine that are strong than ten with a clinker.

MARY SCOTT

At least seven to eight projects are necessary to show versatility and approach. A few of them should include multiple components to demonstrate transmedia skills. One of the main parameters for a portfolio review is limited time. Presenting the work should take a maximum of 30 to 35 minutes. Many designers show and say too much, leaving little time for an authentic conversation to develop.

PETRULA VRONTIKIS

I am not sure there is a perfect number. I have always heard ten but if you were to go deep and explain ten projects, that might be too much. I might think of it as a combination of time and projects. Example: I would have enough projects to give a good overview but make it so you can get through them in 45 minutes or less. I think that combination is a good approach.

JOSH HIGGINS

I have no magic number. It just needs to feel right, and making a book feel right is a magical skill that all good designers possess. Even if it kills you, be concise and sparing. Self-indulgence is the most fatal (and popular) trap.

PETER BUCHANAN-SMITH

It is important not to have too much. As a general rule, don't show more than one or two examples of the same sort of work—if you've designed three logos for three bars, only show one, two at most.

ADRIAN SHAUGHNESSY

If the work is really strong, it probably doesn't matter. But if you held my feet to the fire, I'd say eight to twelve.

ALLAN CHOCHINOV

Don't overwhelm the interviewer with too much work. If you're good, it'll be evident in ten to fifteen pieces.

GAIL ANDERSON

Fifteen to twenty. If we're talking, I feel like I have about an hour of attention to give. Anything more than that brings us into the long-meeting zone, and I start to wonder if my clients are calling.

PATRIC KING

I'll tell you what I don't want to see: a logo that is applied to nothing; a letterhead that has no further applications; a magazine cover, with nothing else; and a magazine spread, with no table of contents or cover. I don't want to see one poster, one ad—I don't want to see one of anything, unless it is so good that it knocks me silly. A dozen or so, well-conceived projects should do the trick.

MARC ENGLISH

Present five really well, then be prepared with more, if requested.

OCD

Ten to twelve. That would include two to three larger, more complex, multi-faceted projects.

CARIN GOLDBERG

Seven to nine.

JUSTIN AHRENS

How many hairs make a beard? I dunno... probably at least ten for a more junior person. More experienced people can have less, as long as they also convey something interesting about their approach to each project, their strategic contribution, etc.

MARK KINGSLEY

Twelve to fifteen.

STEVE LISKA

What kind of projects should be included in, or excluded from, the portfolio?

A portfolio represents how a designer visually and verbally approaches a problem, and how this relates to the intended audience. Anything that helps me to understand that process is great. Personal photography, illustration, and paintings are usually not worth including.

STEVE LISKA

Please, for the love of God, stop creating versions of classic book covers, album covers, or film posters done in the style of Swiss Modernism/Minimalism/Geometric Reductionism or with Lego/Food/Random objects. I hate seeing that shit on Tumblr and really hate seeing it in portfolios.

The portfolio should show how you think. Or at the bare minimum, IF you can think. Listen, design schools are turning out at least 50,000 graduates every year! And they can kern!

Take a moment and ask yourself: "What makes you different from all that?"

MARK KINGSLEY

I really can't believe the amount of awful self-initiated rubbish that creeps into even the best portfolios. It's okay to have one. But seriously, don't bore us with your holiday photos, your life drawing class, or the kooky mapping project you did at school. UNLESS IT'S A SHOW-STOPPER. Test it out on people. If they all go nuts over it every time, pop it in. You want to rock our world.

SIMON MANCHIPP

Nothing weak. I've said that "it's important to show strength, but it's critical not to show weakness," and I think that's still true. Exquisite photography. Error-free text that's been run by an editor. And risk. If I don't see risk, I'm not especially interested.

ALLAN CHOCHINOV

Students should use their time in school to push the boundaries of what's possible in graphic design—we're not terribly interested in the dodgy logo for the local hairdresser, or tacky gig flyers (unless they are brilliant). The placement/intern system works well for us, because we can see how someone whose mind is open can handle the day-to-day realities of graphic design. The colleges that stuff vocational, "real world" projects down their students' throats don't get much support from us because the students seem to have closed themselves too early. They develop an inability to think outside the box and that is a real pain. We have to undo all their preconceptions before they begin to work properly.

MICHAEL JOHNSON

Only the good ones. The projects should show range and versatility. Some are heavy in packaging and branding as that is what the student is passionate about, some want to work in the digital space and have lots of interactive projects, i.e. websites and apps. The important thing is to incorporate projects that show systems thinking and reflect the ability to make complex subjects understood and visually compelling.

MARY SCOTT

I prefer projects that solve real problems. Maybe one fantastic personal project is all right, but generally those don't address whether or not the student knows how to solve problems.

CARIN GOLDBERG

Include projects that truly represent what you want to do. I like to see projects in the medium for which they were designed. For example, I enjoy seeing a poster full-size, paging through a bound book, or interacting with an app. Touching the work makes me appreciate it on a deeper emotional level.

PETRULA VRONTIKIS

I don't mind seeing one or two examples of personal work, but I'd much rather see how a young designer tackled an identity for a local dentist or something mundane. How designers design mundane stuff is a good measure of ability. Anyone can make a gig poster look good.

ADRIAN SHAUGHNESSY

I think any projects you are not proud of should be excluded. Don't just put work in because you are trying to fill out your book. Include the memorable ones that you are proud of—when you speak to them it shows if you are not satisfied with them.

JOSH HIGGINS

Personal projects are fine, but they can't be too esoteric.

GAIL ANDERSON

I hate "create an identity for a fake company" projects. I also don't want to see exploratory pages, wherein you examine how you put a single page of type together in black and white. I want to see projects that tell me who you are as a designer, and I want you to reinforce it again and again.

PATRIC KING

I really don't want to see samples from life drawing. Anything that doesn't directly apply to your unique approach, story, or work, keep it out.

JUSTIN AHRENS

Here's the big secret about portfolios: they're not about the work you've done, they're about the work you will do. Assemble a body of work that says, "Here's what I could do for you." Pick pieces that tell a story about how you think, how you make, and how you improve your work. Select work that demonstrates intelligence, unique insight, and flexibility. Exclude work that is trendy or derivative (unless intentionally). Unless you are a brilliant (and I mean really brilliant) photographer or painter, leave your personal "artistic" profiles at home.

CHRISTOPHER SIMMONS

One personal project and the rest real-life scenarios.

NOREEN MORIOKA

I am fine with whatever you think best showcases your potential as a designer. If your portfolio is comprised of all posters or personal projects, then so be it. I'd love to see some real experience, only this usually comes in the form of a dentist's website or a brochure for a landscaper.

JOHN FOSTER

Show us work that you want to do more of. If you hated it, if you were in over your head or if it was someone else's idea, then exclude it. What we see in the portfolio, is what we'll expect you to deliver.

OCD

You should include the projects that best represent you. If you've done a lot of gig posters and CD packaging, you're probably not looking to work for a firm that engages in corporate communication. Be honest.

PETTER RINGBOM

Do you see any advantages and/or disadvantages between a digital and a physical portfolio Do you have a preference?

A digital portfolio will get you in the door: if I like what I see online, that's the best first step. Yet an actual, physical portfolio—a collection of actual projects (unless they are all media-driven)—is mandatory. There is no substitute for understanding craft, which is too often lacking.

MARC ENGLISH

I see the need for both. My students create a stand-alone case-bound (or other style) narrative that is well crafted, and well designed. They also have a website which shows all their projects and has an embedded ISSUU version of their actual portfolio. It has all their contact info and project information. Some put in a bio and photo of themselves as well. Students have the option to also do an iPad DPS version of their portfolio.

MARY SCOTT

I have to say I rather dislike a website that I have to investigate when it comes to a portfolio. A site that I can rapidly slide down and gives me a good indication at first glance is great but I find the infinite number of Cargo and Behance sites rather dehumanising and pretty rubbish at showcasing a person's creative talents in any kind of ownable way. If you must do a website, and you probably must, then do it more like IWC watches. Show. Then tell. Clearly. Simply. Beautifully.

Honestly speaking, a really good PDFolio will do the trick every time. Ideally with a sexy bit of print for when you meet face-to-face.

SIMON MANCHIPP

I prefer to see projects in their native environment. I want to be able to properly evaluate interaction solutions on the appropriate devices, scrutinize typography at actual size, page through a bound book, or hold a packaging project in my hand. This process triggers a more meaningful investment in the work.

It's a big disappointment for me when someone takes the time to meet with me in person, then just shows me their website. It seems convenient, but convenience isn't the most important thing in this context. Exceptions include motion projects, which are fine presented on a laptop or tablet. Also, it's awkward if interviewees have to ask for a Wi-Fi password just to present their work. An interviewee takes a terrible risk if his or her entire presentation depends on someone else's Internet connection.

A savvy interviewee will have thought through how his or her work should be presented in a way that creates meaning. It sounds facetious to say that presentation is an art; but it bears repeating that it is essential to realize that the level of consideration apparent in a portfolio is emblematic of the level of consideration that will be applied to future projects. Ultimately, can the interviewee effectively persuade, convey meaning, and present a message in diverse media formats, and without a pack of cigarettes rolled up in his sleeve?

PETRULA VRONTIKIS

I encourage people to have digital portfolios—always a URL—and if they get a chance to meet in-person, to bring printed "project books"—especially if they're something special. More and more, the lingua franca of design is video, so links to Vimeos can also be nice. I'm really fussy about the URL and the printed book; I'd actually say never send jpegs, never an 18MB PDF attachment, NEVER a zip folder with assorted elements, and NEVER a DropBox link. Post your work on a website and keep it updated. And don't ever say that your website isn't finished; I think we can all have a sense of humor about this and agree that nobody's is.

ALLAN CHOCHINOV

I think it's unlikely you'll land a job without the former, but to keep a job, you'll need the latter! It's ridiculously easy to make things look slick and sophisticated on the screen, but you still need to know how to make real things.

JESSICA HELFAND

It's likely an age-related preference, but I still do like to look at a physical portfolio rather than a digital one. It's important to see the craftsmanship and attention to detail that just isn't evident on an iPad or laptop. I like to view the work up big, though even most physical portfolios these days are pretty compact.

GAIL ANDERSON

Definitely see an advantage to a digital portfolio. It is a quick way that I can see if the work matches what we are looking for. It saves time for both parties. In addition, if the interviewee is in another state, it is the only way we can connect on a first pass.

JOSH HIGGINS

A combination of the two seems to work best. We're media agnostic, so we like to see that you are too.

OCD

I think digital portfolios are great unless you are showing a publication. Personally, I'm more interested in the way someone thinks, executes their ideas, and articulates their choices. In whatever form they feel is the best way to present, I say go for it.

NOREEN MORIOKA

There is a kind of leveling effect: they tend to look more alike. The same for websites. The challenge for designers remains to design your portfolio as thoughtfully as you've designed the pieces in it.

MICHAEL BIERUT

There are some obvious factors to consider—if your work is all digital, all moving-image, or all code-based, then of course your work needs to be viewed on a screen. Likewise, if you are a print-based designer, I want to see samples of print work. It is common today to see hybrid presentations—some printed samples, some onscreen work—even the occasional 3-D object. This is fine.

ADRIAN SHAUGHNESSY

For an interview I do prefer a physical portfolio, even combined with animated pieces shown on a laptop. When it is not a person-to-person presentation, a PDF or website link is MUCH preferable.

STEFAN SAGMEISTER

I think it used to be easier to make a physical portfolio that stood out. But with the closing of independent art supply stores, like Pearl Paint in New York, NY, and the general corporate sameness that is overtaking retail shops across the world, it's becoming harder and harder to find something unique. I see the same stuff in Paris, France, as in New York as in Singapore. If you want different and unique, you now have to go to a shop like Tokyo Hands in Shibuya, Tokyo, Japan.

MARK KINGSLEY

I need to see both. Because the digital portfolio can look better than real life. The digital gets a call back, the physical gets you the job. I want to see you present. I want to see the craft close up. I want to see how they packaged themselves. They all work together.

JUSTIN AHRENS

It really depends on the work. A digital portfolio is obviously convenient and adaptable. It stays relevant longer, reaches more people, is less expensive to produce and maintain, etc. But if you're designing books and posters and objects there's nothing better than experiencing them firsthand. Similarly, digital or interactive experiences suffer when confined to a printed page.

CHRISTOPHER SIMMONS

Which has been the most memorable portfolio, or presentation (good or bad), you have seen?

I can tell you about the portfolio of Matthias Ernstberger, a former intern of mine, who showed me his student portfolio five years ago. I hired him right away. His most memorable piece was a fake visual history of a band that never existed, including elaborate photo shoots, all their (non-existing) album covers, live shots, studio happenings, etc. The piece proved he can make complicated, difficult things happen—in my mind, the most important trait of any designer. It was also meticulously photographed and designed, with a lot of attention to detail. On top of that it was well written.

STEFAN SAGMEISTER

A thesis project on body piercing. Great topic, but horribly done.

NOREEN MORIOKA

We've had portfolios where there are just the most awful pencil sketches in. Reams of them. We've had stalkery ones where they've found out TOO MUCH about us. Even ones with naked pictures of the applicants. A stack where people have just applied for the wrong job. Of course a couple of classics where the files were corrupt, the URL link didn't work or they had not included as attachments. Last week someone sent us a beautifully knitted poop. They got a call back.

SIMON MANCHIPP

The good ones I can remember had projects that were part of a system and had a great idea behind them. The bad ones were more about how they were presented, than the work. Don't make excuses for a project. If you feel compelled to, leave it out. Have something to say about each piece, don't just say, "Here's a logo I did for X company," and leave it at that.

JOSH HIGGINS

Several years ago I interviewed a woman named Rachel Berger. She was fresh off an internship at Pentagram New York and looking to move to San Francisco, CA. She came with the recommendation of a friend (though a stint at Pentagram is endorsement enough). Her work was highly experimental and somewhat abstract—very different than the kind of work we do. I knew right away she would not be a good fit for us on a practical level, but conceptually she was in a league of her own. Although the work was fairly esoteric, she described it with remarkable facility. We ended up talking for more than an hour and then I drove her to her next interview so we could continue chatting.

Rachel ended up at SYPartners and is now the Chair of the Design Program at CCA.

CHRISTOPHER SIMMONS

What stands out in my mind are the people that I actually offered jobs to. It's the people, not the portfolios that are memorable.

ADRIAN SHAUGHNESSY

About a year into my first job, a new graduate, one year younger than me, dropped off his portfolio. My boss had us all look at it. It was the best portfolio I've ever seen, perfect in terms of design, craft, stylistic, and technical virtuosity. It made me want to give up. It belonged to a kid named Clement Mok, who went on to be design director of Apple Computer, founder of Studio Archetype and Sapient, and president of AIGA.

MICHAEL BIERUT

The most memorable ones always have the best work. While I have seen a lot of good work over the years, the ones that have made me rethink what we do here at the studio are those of the Academy of Art University, in San Francisco, CA, and those of the Portfolio Center, in Atlanta, GA. Students from the former are required to design an actual hardcover book that has their best schoolwork in it, along with résumé and some aspect of process. The books present a unity to their work, and are quite manageable, particularly to book lovers. The school also makes sure that each designer knows how to photograph their work for presentation. The students from the latter create very elaborate constructions that house several of their projects. Portfolio Center and its students take pride on their hand skills, which are sorely lacking in most schools.

An illustrator/designer once made twelve exquisite boxes—like miniature installations, really—and sent them to a dozen people with whom she wanted to work with. I was one of those fortunate enough to receive this treasure and I was stunned and touched and contacted her immediately. This isn't the right thing to do for most young designers seeking work, but I was truly moved by it—it sits on the shelf next to where I work every day still. (We made immediate contact and became friends instantly.) I mention this not to suggest that students try to make their prospective employers their new best friends, but because the effort that went into personalizing the portfolio was simply fantastic.

JESSICA HELFAND

Some guy showed us his work scattered around an Adobe Illustrator document. It was, to say the least, memorable.

OCD

We had a portfolio presentation where the person did no research on us, and stated that we would be fortunate to have him/her join our team. Then asked for twice as much as we were offering and assumed s/he would be a senior designer or art director out of school because the portfolio was that awesome.

JUSTIN AHRENS

There have been portfolios with forgotten wallets and journals inside, and books that seemed way too intimate for public display. But I think that the best one was the book that a live cockroach crawled out of.

GAIL ANDERSON

I had a student who applied to the MFA Products of Design program at SVA who was 50 years old. He had multiple decades-full of work, but it was all over the place and not especially visual. So he wrote a book—his life's story—with all the creative stops along the way and what he learned from each of them. It was fascinating reading. And we accepted him. And he's killing it.

ALLAN CHOCHINOV

When I was at Landor in San Francisco, CA, I needed to build a small team. Having recently moved to the city from New York, NY, I wasn't yet tapped into the local design community and needed to rely on colleagues' suggestions.

One suggestion was a recent graduate from Academy of Art University. That portfolio was astounding! A large-sized bound book, beautifully photographed comps, and skillful execution all around. This person could do ole-timey vintage typography, perfect for a whisky bottle... they could make a geometric abstract logo... and they sketched by hand. I was amazed.

Then a week later I met with another candidate from the same school. Again, a large-sized bound book with beautifully photographed comps of ole-timey type on a whiskey bottle, hand-done sketches, and so on. The individual pieces were different, but the makeup of the book was exactly the same.

When I asked around as to why this was so, I learned that that particular school had a portfolio class with a very set methodology. While they saw it as a formula for success, I quickly learned to avoid graduates from that school.

MARK KINGSLEY

The worst case, was a graduate who actually brought their collection of work in a paper sack. That's something we'd always joke about in class, but I was appalled to actually see someone do that.

MARC ENGLISH

The worst experience I had was with a young guy who had just graduated from a school in Texas. He started his review by standing up from the conference table and saying, "You see, in Texas, we have 'concept'..." His work was good, but his first comment was so condescending, it was the only thing I remembered about him. Another guy showed up at the studio with a pack of cigarettes rolled up in the sleeve of his dirty t-shirt. And one woman's breasts were bursting out of her blouse. The "twins" were always there—fighting for visual prominence with her work.

PETRULA VRONTIKIS

What would you say are the most common mistakes in portfolios and presentations?

Asking for the Wi-Fi then logging into your portfolio site. We've already seen it.

OCD

Not doing enough research about their reviewers ahead of time is a common mistake. Knowing more about the person looking at your work will help stimulate and guide the conversation. Not asking enough questions after the person has looked at the work—missing an opportunity to gain valuable insights is another common error. Interviewees should never make excuses about anything. Doing this tells the reviewer more about personality issues than anything about the work. Typos in the work say one of two things: either he or she didn't see the error, or he or she saw it and decided it was okay to leave in. Both of these are unacceptable, and will eliminate him or her as a candidate.

PETRULA VRONTIKIS

No question: Spelling mistakes. One could argue that your portfolio is "the most important document in your life" and so any kind of error is, well, pretty inexcusable. Same thing for the résumé and the cover letter. The person hiring you is looking for someone who will take extraordinary care with their work, with their client's work, with their organization's work. If you can't even take enough care to have your portfolio error-free, I don't think you can play.

ALLAN CHOCHINOV

Thinking that you have to make it look a certain way according to someone else. Listen to advice, but always try to make it unique to you.

MARK KINGSLEY

— Too much work.

— Work that doesn't apply at all to the kind of projects I typically do.

— Bad spelling or grammar.

— No contact information, résumé, or leave-behind enclosed (this has happened more than once).

GAIL ANDERSON

Putting in work that was for a large company (Nike, Google etc.) and after digging in, it ends up it was a school project or idea which is fine but represent it as such up front, not just if asked.

JOSH HIGGINS

Sloppiness and bad editing—editing is difficult for everybody (I'm still a lousy editor of my own work). Another common mistake is showing everything the same size (usually too small), digitally printed on glossy paper. It makes body copy impossible to see, and it pretends to present the work as "real."

CARIN GOLDBERG

They don't make it clear to the reviewer what the project was about and what problem it was solving. A brief description with the objective and solution, audience, research, etc., makes it clearer and shows that careful thought was put into the work, not just surface decoration.

MARY SCOTT

Spelling. Accidentally CC-ing all the other companies you are applying to. Not including how quick you can start. Not reading the job description. Trying to be too "matey" and over-friendly. The number one thing with selling yourself is to be positive and have boundless enthusiasm. There's a saying "enthusiasm wins over talent" and it's recently been scientifically proven by MIT. Even if you are the next Saul Bass, if you do not have a visible and aural energy for your craft you will lose out to those who have. The squeaky wheel gets the oil.

SIMON MANCHIPP

Self-indulgence; messiness; apathy towards the work, education and design itself; no sense of history; passivity; boredom; tardiness; and, above all, bad breath (seriously!).

PETER BUCHANAN-SMITH

Editing. That goes for the design and content. You see a lot of typos and careless visual choices. The most common error is evident in the introduction letters. Many of these sound very entitled. I'm never impressed by arrogance.

HILLMAN CURTIS

Taking the wrong approach when explaining the work is a big problem. The second is lack of self-editing—you have to remember that you will always be judged by the weakest piece. The third is feeling the need to show a "real" project, usually some relative's business card or a band poster—work that is essentially unimportant.

STEVE LISKA

Thinking that an interview is only about the skill and design work. It really is about finding an individual who we feel we can collaborate with and who can feel vulnerable to make mistakes.

NOREEN MORIOKA

1. To include a letter starting with "Dear Madam/Sir." In my studio they go into our trash can. If somebody does not take the time to find out my name, I don't feel obliged to read the letter.

2. To only include posters and book covers. Most design studios make a living organizing large amounts of information; posters and book covers are usually not good mediums to show off that ability.

3. To include pieces where the prominent part is a found piece of art. With an itsy bit of type on it. It is easy to make a site look good when it features a great photograph, and it also says absolutely nothing about the talent of the designer.

STEFAN SAGMEISTER

Not putting your strongest piece first. You may only get the one-minute chance to open your book before the interviewer is pulled away, so be sure to make the right impression!

JOHN FOSTER

Designers who talk too much, and designers who think I have unlimited time to spend with them. Having said that, I'm very sympathetic to people looking for work. It's not easy and a certain amount of pushiness is required. I like people who are determined, and I'm vain enough to like it when people know something about me and my activities. People who have plucked my name out of a list without doing any research are making a big, and common, mistake.

ADRIAN SHAUGHNESSY

We are turned off immediately when our names are spelled incorrectly. I mean, for heaven's sake, MICHAEL JOHNSON is pretty easy to spell. And a résumé littered with spelling mistakes: one is forgivable, and any more than that is just plain lazy. We're really not fans of unjustified over-confidence. Huge, unwieldy, server-smashing PDFs are a bit of a drag, too, as are overly complex and over-engineered websites (we're judging you on your ideas, not your Flash Rollover coding skills). We'll very rarely put a student CD-ROM in our machines, as we've experienced horrendous crashes caused by dodgy ones before.

MICHAEL JOHNSON

In portfolios, spelling errors and typos are heartbreaking. Do whatever you can to ensure there are none. In presentations, I'm often aghast at how little designers sometimes know about their subjects. Example:

— [Me] "I love the exhibition title *Everybody Will Be Famous* for this pop-art exhibition, did you come up with the Warhol reference, or did your instructor give you the title?"

— "No, my instructor's name is Johnson, not Warhol."

— [Me] "I meant Andy Warhol. The artist."

— "Oh. I'll look her up."

CHRISTOPHER SIMMONS

A poorly written or designed cover letter—you need to make sure that all your work is tight and focused. Packaging or CDs that don't have a nicely printed label on them will wind up in the garbage immediately. Even after those caveats, you don't have to be intimidated by us. We are actually nice people who have been in your position before.

JAKOB TROLLBÄCK

A résumé that is poorly designed. This sends a big red flag that you are not detail conscious or that, left to your own devices, you are incapable of making sound judgments about something as marketing-specific (résumés are, after all, marketing you) as a résumé. Easy to overlook, but so important not to dismiss, since it is the résumé that remains behind on employers' desks, the sole reflection of you once the interview is over.

JESSICA HELFAND

Poor typography, not knowing a single thing about your interviewer, and not even bothering to check out our work to see if you are the least bit compatible with our sensibilities.

MARC ENGLISH

I don't like it when people give a prepared lecture about every piece I'm examining. Slow down, silence is okay. I don't like sales pitches. I also don't like it when people put on a suit and tie when they come in to interview with us. I know you're supposed to do that at certain places, but we're not that kind of firm. I like to see what you wear on a regular basis, because your style says a lot about you, and I can't get a sense of that if you're wearing formal attire.

PETTER RINGBOM

They haven't practiced. They haven't looked at the website. And they don't have any questions.

JUSTIN AHRENS

What is your process for reviewing portfolios?

They always come to me in online form. I look at the work first, taking note of the idea, craft, and type, and then I look at experience level via the résumé.

JOSH HIGGINS

I usually have an informal approach. I like to chat about different things with the interviewee, not just about design. Personality is really important when running a fairly small design studio. One of the first things I think about is, "Can I imagine sitting next to this person every day?"

PETTER RINGBOM

Unless we're hiring, I usually just review designers' portfolios online. I try to get back to everyone (eventually) but sometimes it's many months later. I feel bad about that, but it's just the reality of my time. I bookmark the good ones and check in on them from time to time.

Maybe once or twice a month I'll have someone in for an informational review. It's a bit of a crapshoot as to how I decide who to make time for. If they come with a recommendation from someone I know, that's almost a guarantee. If the work is particularly interesting, or they have an obvious skill like lettering or icon design, those are obviously factors too. Other than that it's pretty arbitrary—a great cover letter can do it, or I could just be in a good mood.

If we meet in person, we let them run the show for 10 to 15 minutes, then we take another 10 or 15 just to talk. Sometimes those conversations go on much longer. I'm more interested in people than in work, so as long as the portfolio shows competence (which is to say, excellence) I'd learn more about the creator than the creation.

CHRISTOPHER SIMMONS

Ninety-five percent of the people who come through my door are students who have little interview experience. So I usually take far too much time—an hour or more—trying to set them on the straight and narrow, as one particular guy did for me many years ago. This is what I learned:

1. Ask how much time you have. This lets the interviewer know you appreciate the value of time, and allows you to then take control as much as possible.

2. Divide your interview into thirds:

 First third: get personally professional. Ask about things you quickly observe in the environment. For example, "Did you climb Machu Picchu? I see that photo... I noticed you love art deco and modernist posters... I see that you collect shrunken heads and Victorian dildos..." Or you can ask about the interviewer's path to the business, etc.

 Second third: show your portfolio. Never say anything negative about it. And be sure you don't explain each piece, because the work should speak for itself. Also, if there is a relevant way to bring some of the information gleaned from the first third of the meeting into play, do so, because it shows the ability to connect ideas. When you ask for feedback, make sure to take it professionally, not personally.

 Final third: build your network. If the company you are applying to isn't hiring, ask for referrals, ask for directions, ask for advice, but make sure not to overcompensate with heaping portions of prattle.

MARC ENGLISH

First, I look through the entire portfolio to get an overall impression of the work. For me, setting context before I comment is very important. I can be more effective as a reviewer when I get a sense of the whole picture. Sometimes nervous chatter interrupts the intuitive relationship I want to have with the work. I'll then go back to most of the pieces individually, ask for details, and feel more confident in giving considered feedback. In the dialog we have during or after the review, I expect to be asked thoughtful, well-researched questions. I am also looking for the interviewee to demonstrate an understanding of what's going on in our field and in the world at large.

PETRULA VRONTIKIS

I can usually size portfolios up pretty quickly. It's like a lecture, where you have to start strong, get your audience's attention instantly or you lose them. The first few pages or screens in a portfolio can say a lot. I am really turned off by messiness, trendiness, chaos. I like to see something of the person in the portfolio, and there is a tendency today for work to look too polished and professional: the tools make it easy to do so. I am always a sucker for really great typography, even ornate and decorative type if it's done well. Editorial strengths—books and book covers, a sense of how to shape a publication—are interesting to me and it is the rare student who has not designed at least ONE book. Advertising turns me off, but that's just me: it smacks of a kind of commercialism that I resist, and feel somewhat hell-bent on advising students to resist.

JESSICA HELFAND

I basically just look at it and let the designer take me through it. Presentation skills are needed to sell any idea or design, so the designer should be adept at selling their talent.

JAKOB TROLLBÄCK

It's kind of like a date. We want to know your life story; your hopes and dreams. We want to see what you can do. And we want to know why you're here and who else you're seeing.

OCD

I look at portfolios more quickly than their owners would like. I can usually, almost right away, tell whether or not someone's work appeals to me. If I'm reviewing in-person, I try to say something constructive. It's actually interesting to see how different people take advice. If it's a drop-off or something emailed to me, I almost always write a note. I remember dropping my portfolio off at a place I admired back in 1979, and how disappointed I was to find no evidence that it had been looked at when I picked it up.

MICHAEL BIERUT

When I'm meeting with someone in-person, I confess that I like to drive. To generalize, designers move through their work way too slowly, and typically focus on the obvious. I'm looking for the not-obvious, the exception, the surprise. And fundamentally the work needs to speak for itself (typically aided by the accompanying paragraph of text). I usually apologize, then I ask to grab the trackpad.

ALLAN CHOCHINOV

I look at it... while trying to keep in mind how this person can add to the team beyond their formal skills.

MARK KINGSLEY

We give everyone a fair hearing. But it's tough to get in. We review the PDFolio or URL. The first person to see them traffic-lights the file on the server red (awful), amber (hmmm), green (wow) and then it's passed on to another senior member of the team. This happens about three or four times. Eventually, those that survive get asked in for a chat. Truthfully, if you get an interview you stand a good chance of getting in. If you get to that point you are—in theory—brilliant. The interview is all about that chemistry thing. If that's not there, it's over. We spend more time together working than we do with the people we are having babies with! Something's got to click in the meeting.

SIMON MANCHIPP

I begin by telling people how much time I have, which is usually about 15 to 20 minutes. Then I like to look at work at my own speed and volition. I like people to give a brief description of the work, and I like to be able to ask questions.

ADRIAN SHAUGHNESSY

We sit, we talk, you show, I ask. It lasts about an hour. The portfolio is much less important to me than the portfolio owner. The portfolio is an embodiment of how you relate to the ideas you work with, as well as the people around you. I feel like the two coexist, so when we see each other, it's a bit of a test, to determine what sort of person you are.

PATRIC KING

My preference is not to be talked through each piece. I'd rather ask questions than have to listen to the thought process on every single project. I ask about school and instructors and what the designer is interested in, to get some insight into their education, personality, and likes and dislikes. A sure sign of my impending old age is the fact that I really appreciate a follow-up thank you note if I get one. It's a classy gesture.

GAIL ANDERSON

I don't have a specific process. I always prefer meeting with someone in person, and I spend more time talking about their dog, their commute, or their favorite restaurant, than I do about their work. The thing to remember is that I not only want to hire a good designer, I also want someone that I can work with, whose company I enjoy.

PETER BUCHANAN-SMITH

The students are advised to send out their collateral packages which are an integrated part of the portfolio with a cover letter and a request for an interview. They follow up (using worksheets that they have created) with a phone call and ask to schedule an interview.

MARY SCOTT

I try very hard to make sure I have adequate time to meet with someone. I spend a few minutes just talking and going over their résumé. I usually let them "drive," or flip the pages, as they explain each piece. I am more interested in hearing "how" they explain the process, rather than "what" they explain. It lets me know how they will interact with clients and staff.

JOHN FOSTER

We prefer an email with a link to a website, or sample printed materials. If we like either, we put you on the list of people we will see, so long as you bother to call and follow up. If we are not looking for help, we will try to give a half-hour informational interview, followed by referrals. We are generally honest and straightforward, and will try to help you with the process of finding your first job.

STEVE LISKA

I don't have a process. I am a quick read and have looked at hundreds of my students' portfolios over the years. But I will say that excellent typography is a priority. If a student doesn't have a decent handle on type, then they are often unemployable.

CARIN GOLDBERG

Two of us handle the inquiries. We sieve them with PDFs and websites: the people we think are possibilities get an interview, the good ones come on placement. We'd never employ now without a placement/intern period first. It also gives them the chance to form their opinion of us.

MICHAEL JOHNSON

If the designer is there, I normally look through it quickly, saying little and getting an overall impression. And then I repeat the whole process with comments.

STEFAN SAGMEISTER

I rarely look at portfolios, but if someone I respect calls me to look at one, I'm there. Our profession is based on referrals and personal guarantees. It's important to remember that where you go to school, what organizations you belong to, and where you've worked all matter.

NOREEN MORIOKA

When someone first gets to the studio I ask him or her to talk to me for the first 15 to 20 minutes. We don't even open the book until we can have a conversation about what they are all about. Why they want to work here, their dreams, etc. We then go over their book. They ideally take us through it in 15 to 20 minutes.

JUSTIN AHRENS

What was your first portfolio like? Is it still with you?

It was very professional looking, of course. I'm a perfectionist. I have it somewhere but I don't really like the work in it. I was young. There's no crime in that.

JAKOB TROLLBÄCK

Awful. I had a big portfolio bag with 90% illustration. Apparently my business card did it for me. It was a guy blowing a trumpet so hard that he was farting. My name was the fart and the tagline read "That little extra".

OCD, MATT KAY

My first portfolio was a set of twelve slides prepared for my School of Visual Arts MFA Design application. Co-chairs Steve Heller and Lita Talarico have since confirmed that it was my interview that got me in.

OCD, JENNIFER KINON

I obsessed over my portfolio. It was a leather portfolio with clear acetate sleeves that I slipped my work into. For my first job interview at a magazine in New York, NY, I set up a photo shoot with a classmate a week or so prior, then designed my own cover and spreads for the magazine. When I came across those spreads during the interview, they were totally surprised and impressed with going the extra mile. I had come to the interview determined not to leave without them offering me a position. It worked.

OCD, BOBBY C. MARTIN JR.

My first portfolio is absolute garbage. I still have it and often show interns the before and after to help give them hope.

JUSTIN AHRENS

It was all 4 × 5-inch slides and beautifully matted and mounted. I went on over a hundred interviews in Japan and around fifty in the U.S., I was incredibly well rehearsed in both Japanese and English to present. Moral of the story, pick the right pieces for interview, practice what you are going to say, prepare way before you go, and think that you need to perform.

NOREEN MORIOKA

Oh no, that one is long gone. It was a gigantic 30 × 40-inches piece. I had lots of printed posters and could not bear to fold them in half. It quickly proved to be an incredible schlepp up and down the subway stairs. I think I took it out twice, and then gave up and developed something more portable.

STEFAN SAGMEISTER

By today's standards it was extremely primitive! But I will say this: when I was applying to graduate school I had been working for an old traditional book designer, and the work I was turning out made me want to invent projects, which I did, to show more range. I invented companies, named them, designed their identities. I redesigned projects I'd done as an undergraduate to represent what I thought was an enhanced maturity and skill level. And the funny part is that after I went to graduate school, as I was preparing my thesis show, I chose very few school projects to show: again, I invented what I wanted people to see, made a whole new body of work for the show. Would I advise a student to do this? In a way, yes: but only with a more objective, critical eye to what they want to communicate. Portfolios benefit from both macro and micro: macro in the sense that the designer should be thoughtful, objective, and circumspect in crafting a kind of miniature exhibition of their work; and micro in attention to rigorous, unrelenting, and passionate detail in the work.

JESSICA HELFAND

I graduated from Central Saint Martins in London. At the time, the course was smack-bang in the middle of Covent Garden, a really popular place. We had loads of people come in and see our graduation show. I listened a lot to what lots of people said about my portfolio and adapted it. I got the first job I went for, so it must have worked! Trial and error is definitely a big part of it. If, as you present a part of your portfolio you see the interviewers face drop, they look elsewhere, or heaven forbid yawn, make a note. If it happens again you need to up your game or change the work. Presenting yourself is an iterative and ever-changing process.

SIMON MANCHIPP

I still have my first portfolio, as well as subsequent iterations. It was a 20 × 24-inch leather portfolio that had a removable metal spiral. It had cool vinyl pockets, not the crap acetate ones. I had attached smaller vinyl pockets to the larger pages, so I could present brochures and small pieces in an easy-to-access manner. It definitely looked "designed," and the pocket in back held résumés.

MARC ENGLISH

My first portfolio was appalling. I'd completed a Marketing and Visual Art degree that left me with half a portfolio consisting of dodgy, two-color posters for the local theatre group and the college art gallery. Absolutely awful. Not surprising that I couldn't get a job anywhere. Soon after, I traveled the world looking for work and kept my projects on 35-millimeter slides—again a nightmare, because no one could ever be bothered to project them. So my early career was based on people trying to judge my work by peering at tiny glass slides. On the bright side, I noticed that I started to design projects that would work well "small"—a good rule when you think about it, and I still catch myself wondering, "What would it look like on a slide?"

MICHAEL JOHNSON

My first portfolio was strange, inconsistent, and clumsy. It was, and still is, a work in progress.

STEVE LISKA

You should never consider your portfolio finished, and you should always be dissatisfied with it. The day you sit back and say, "My portfolio is great," is the day you are dead in the water. Your portfolio requires endless work, and few things are more important than it. This never changes no matter how successful you have become. That's really the only thing I've learned about portfolios.

ADRIAN SHAUGHNESSY

I asked an old girlfriend, who was a photo major, to document my work just before I left school. I then trimmed and mounted these photographs into a blank sketchbook, numbered and titled each page with an interchangeable rubber stamp kit, and then headed off to Europe to get a job at either Hipgnosis in London, UK, or ECM Records in Munich, Germany. Sadly, that didn't happen.

But in those travels, I found a cool case in London. It had a bright red bulbous and ribbed body with yellow closures and handle. And most importantly, it had an endorsement sticker from the Design Centre London on the inside. I was thinking that if the sticker didn't have transitive properties, at least the case stood out from everyone else's black faux-leather portfolios.

This was the configuration that I dropped off at M&Co. in 1985. I didn't get that job, but Tibor wrote a lovely note telling me to "stay nutty." I still have that note, by the way, and I still try to follow that advice.

Several months later, that same portfolio/case combo got me my first job in the Designer Fragrance Division at Cosmair, as part of the team packaging Ralph Lauren, Armani, Paloma Picasso, and Drakkar Noir fragrances.

M&Co. was too small to take on an ambitious, but inexperienced, designer; while a large corporation like Cosmair could.

MARK KINGSLEY

Ha! I was always told your portfolio should be a reflection of you, which I still believe. When I graduated, portfolios were only physical, not online yet. Being a musician, I had a guitar case cut down and redone to fit my boards and that's what my work was housed in. Black 16 × 20-inch boards with prints of the work adhered to them. I still have it in the garage somewhere.

JOSH HIGGINS

Oh goodness, my portfolio was done in the dark ages. I had my first interview at Capitol Records and all I had was some boards with C-prints of various projects mounted to them and one of those textured zipped cases. But, I did put the objective of the project and the rationale for the solution on a typeset label.

MARY SCOTT

Oh my god, it was horrifying. It was filled with fairly strong typography—a combination of Neville Brody and other cutting-edge designers, some neoclassical stuff, and student exercises. I was so completely insecure I felt as if I had to get a ball in every pocket. It didn't work at all. At worst, it taught me that in order to sell myself to other designers, I needed to have a consistent worldview. At best, it taught me that I really had no business asking other people what they thought of me.

PATRIC KING

My first portfolio committed many of the sins I warn against: too much work, too many things included just because they were printed. It was my first and last portfolio because I never looked for another job after I got my first one. So it sits slowly deteriorating in my basement.

MICHAEL BIERUT

It was amateurish, sloppy, and poorly conceived. Despite that, a lot of what I do today derives from those projects— from illustrative solutions to hand-drawn type and deconstructed forms. What strikes me as hilarious now is that the work that has been successful for me as a designer startled my old professors back in the clean days of 1992. Looking back on the poor folded husk of leather-bound work, I suppose that the only thing I learned was to stay true to myself.

JOHN FOSTER

Ugh. My first book was so poorly put together, since it was pre-computer. My mechanicals were sloppy and the final pieces were not as cleanly assembled as they should have been. While the work was good enough to get me my first job, I cringe when I think of what was in that book.

GAIL ANDERSON

My first portfolio wasn't nearly to the creative or finish level that graduate portfolios show today. I enjoyed doing the work, so it honestly reflected my passion for graphic design. It didn't show some of the skills that I rely on most today, such as transmedia brand identity development, conceptual thinking, creative direction, or collaboration. Some reviewers back then said it looked retro 1950s, a time that I thought was visually cool. They just thought it looked old... kind of like when I see retro '80s and '90s style references in student portfolios today. I think parts of it are still in my garage, but I'll probably throw it out after going though it again. I'm not nostalgic about these things.

PETRULA VRONTIKIS

Well, I've kind of had a portfolio since junior high, but I do still have the portfolio with which I graduated from grad school. It's filled with color prints that were made from slides. It's of course embarrassing now, but I'm glad I have it. It allowed me to meet some interesting people and ultimately get my first job.

ALLAN CHOCHINOV

It was a mess. I have no idea where it lurks today. I have constructed numerous portfolios since, each one slightly better than the last. If you are lucky, you will have grown so much in ten years time that looking back at your student portfolio induces fatigue.

PETER BUCHANAN-SMITH

A special thank you to the professionals who have reviewed hundreds of portfolios, interviewed hundreds of designers, and taken the time to answer our questions for our shared benefit.

JUSTIN AHRENS has led Rule29, for more than 14 years, in the firm commitment to making creative matter®. Through a collaborative approach to both strategy and design, Rule29 has fostered a culture that encourages the pursuit of wonder through story and involvement in many social causes. Ahrens has also been a consistent voice for the design community on balancing life and career: he's the author of *Life Kerning: Creative Ways to Fine Tune Your Perspective on Career and Life*.
RULE29.COM

GAIL ANDERSON is a designer, writer, and educator based in New York, NY. Anderson is a partner, with Joe Newton, at Anderson Newton Design. From 2002 through 2010, Anderson served as Creative Director of Design at SpotCo, an advertising agency that creates artwork for Broadway and institutional theater. From 1987 to early 2002, Anderson worked at *Rolling Stone* magazine, serving as designer, deputy art director, and finally, as the magazine's senior art director. And early in her career, Anderson was a designer at *The Boston Globe Sunday Magazine* and Vintage Books (Random House). Anderson is co-author, with Steven Heller, of the upcoming *The Typographic Universe*, as well as *New Modernist Type, New Ornamental Type, New Vintage Type, Astounding Photoshop Effects, American Typeplay, The Savage Mirror,* and *Graphic Wit.* Anderson is a contributor to *Imprint* and *Uppercase* magazine. Anderson teaches in the School of Visual Arts MFA, undergraduate, and high school design programs, and has served on the advisory boards for Adobe Partners by Design and the Society of Publication Designers. She currently serves on the board for the Type Directors Club, and is a member of the Citizens' Stamp Advisory Committee for the U.S. Postal Service. Anderson is the recipient of the 2008 Lifetime Achievement Medal from the AIGA and the 2009 Richard Gangel art direction award from the Society of Illustrators.
GAILYCURL.COM

MICHAEL BIERUT has been a partner in the New York, NY, office of the international design consultancy Pentagram since 1990. A co-founder of designobserver.com, Bierut is a senior critic at the Yale School of Art, a winner of the AIGA Medal and the National Design Award from the Cooper-Hewitt Museum, and a member of the Art Directors Hall of Fame. His book *79 Short Essays on Design* was published in 2007. The first monograph on his work is due in fall 2015.
PENTAGRAM.COM

PETER BUCHANAN-SMITH is a designer, author, and entrepreneur, based in New York, NY, whose career has included art direction of the *New York Times*, creative direction for *Paper* magazine, and work for fashion icon Isaac Mizrahi, musical legends David Byrne, Brian Eno, Philip Glass, and the band Wilco. He is the author of several books, including *The Wilco Book,* and he has collaborated on many others, including *Strunk* and White's classic *The Elements of Style* with illustrator Maira Kalman. His first tome, *Speck: A Curious Collection of Uncommon Things,* explores the fascinating lives of ordinary people and commonplace objects. This connection between people and objects is also at the heart of Buchanan-Smith's most recent venture, Best Made Co., a purveyor of finely crafted tools and an entrée into the symbolic world they conjure. He speaks around the world about style, design, and visual culture, and teaches graphic design at the School of Visual Arts in New York.
BUCHANANSMITH.COM

ALLAN CHOCHINOV is a partner of Core77, a design network serving a global community of designers and design enthusiasts based in New York, NY. Chochinov also serves as Chair of the new MFA in Products of Design graduate program at the School of Visual Arts in New York. Prior, his work in product design focused on the medical, surgical, and diagnostic fields, as well as on consumer products and workplace systems. He has been named on numerous design and utility patents, and lectures widely on design and contemporary culture.
CORE77.COM

HILLMAN CURTIS was the founder of hillmancurtis in New York, NY, a film and web design firm he established in 1998. He designed highly visible websites for clients such as Yahoo and Adobe, and did commercial film work for Sprint and BMW. He wrote three books on design and film and directed the popular "Artist Series" documentaries. As a former art director of Macromedia in the mid-1990s, Curtis saw the evolution of digital and online portfolios firsthand. Sadly, Curtis passed away in 2012 after a fierce battle with cancer.
HILLMANCURTIS.COM

MARC ENGLISH is the man behind Marc English Design outside Austin, TX, which he founded in Boston, MA, in 1993. He has produced identity and publication design, as well as packaging. He is the former president of the AIGA Boston Chapter, and founder (and former president) of the Austin chapter. A dedicated teacher and lecturer, English rarely hesitates spending his hours sharing his experiences and dispensing much-needed advice.
MARCENGLISHDESIGN.COM

JOHN FOSTER is a world renowned designer, author, and speaker on design issues. His work has been published in numerous books and every major industry magazine, hangs in galleries across the globe and is part of the permanent collection of the Smithsonian. He is the proud recipient of both a gold and silver medal from the Art Directors Club as well as a Best of Show from the ADDYs. Foster is the author of *Dirty Fingernails: A One-Of-A-Kind Collection of Graphics Uniquely Designed By Hand, For Sale: Over 200 Innovative Solutions in Packaging Design, New Masters of Poster Design, Maximum Page Design*, and *1000 Indie Posters*. Foster had the honor of penning the layout chapter of Debbie Millman's *Principles of Graphic Design*. He also writes a weekly column on music packaging for brightestyoungthings.com
BADPEOPLEGOODTHINGS.COM

CARIN GOLDBERG is the founder of Carin Goldberg Design in New York, NY, which she established in 1982. She has produced hundreds of book jackets and album covers for some of the most prominent publishing houses and record labels in the U.S. As of late, her work has expanded into editorial and publication design. An indefatigable teacher, Goldberg has been priming design students (and their portfolios) at the School of Visual Arts since 1983. Goldberg is the author and designer of *Catalog*.
CARINGOLDBERG.COM

JESSICA HELFAND, a founding editor of Design Observer, is an award-winning graphic designer and writer. A former contributing editor and columnist for *Print, Eye*, and *Communications Arts* magazine, she is a member of Alliance Graphique Internationale and a recent laureate of the Art Directors Hall of Fame. Helfand received both her BA and MFA from Yale University where she has taught since 1994. In 2013, she was awarded the AIGA medal.
WINTERHOUSE.COM

JOSH HIGGINS is the manager for the Communication Design team at Facebook, a multidisciplinary team of art directors, designers, writers, filmmakers, and engineers whose mission is brand development/communication for Facebook. In 2013 Higgins concluded his role as Design Director for President Obama's 2012 campaign. As the Design Director, Higgins built and led the design team for the historic 2012 political campaign in which the web, design, and technology played a pivotal role. The responsibility of Higgins and the team was to design the Obama 2012 campaign both online and offline. A main focus of his was on creating a uniform message and consistent visual language across all mediums. With roots in both advertising and graphic design, Higgins' work has earned him national honors. Higgins dedicates a percentage of his time to social causes—finding creative ways to support them has manifested into successful exhibits and charitable projects, like The Hurricane, So-Cal, and Haiti Poster Projects in addition to lecture series with photographers, designers, and filmmakers with proceeds donated to various charitable organizations.
JOSHHIGGINS.COM

MICHAEL JOHNSON is the founder of johnson banks in London, England, a design firm he established in 1992 that specializes in comprehensive identity programs, editorial design and, oddly enough, postage stamp design. With a solid internship program in place at his office, Johnson has refined his own skills for detecting talent in young designers. He is the author of *Problem Solved: a primer in design and communication*.
JOHNSONBANKS.CO.UK

PATRIC KING is the co-founder of House of Pretty in Chicago, IL, a small design consultancy established in 2003 that develops websites, identity, and typography. He previously worked with Rick Valicenti at 3st. Perpetually inquisitive and challenging, King has a keen eye for portfolios that truly represent not just someone's talent but their personality as well.
HOUSEOFPRETTY.COM

MARK KINGSLEY... received a personal lesson in branding from Ralph Lauren... traveled with the punk band Bad Religion... counts some of the greatest cultural institutions in the U.S. as clients ... designed packages for musicians like John Coltrane, Jewel, Ethel, Yes, Phil Collins, and Pat Metheny... helped Central Park SummerStage become one of the premier events in New York, NY... was an author on SpeakUp, the first significant design blog... was at Ogilvy's Brand Innovation Group (BIG) during its height... worked at Landor as the global creative lead on the Citi account... led the creative team for a credit card now found in millions of wallets across North America... licked a Jasper Johns painting... learned the dark arts of corporate America... had Isabella Rossellini come to his rescue... performed in an avant-garde opera at Lincoln Center... Kingsley is currently a partner at Malcontent, and an instructor at the School of Visual Arts Masters in Branding program.
MALCONTENT.COM

STEVE LISKA is the founder of Liska + Associates in Chicago, IL, a design firm established in 1980 that produces identity, print, packaging, interactive, book, and environmental work for a multitude of clients. With a constant stream of designers in a large team, Liska has reviewed a large share of portfolios.
LISKA.COM

SIMON MANCHIPP'S mum, dad, brother, and wife—even his cat are all designers. There was never any doubt that Manchipp was going to be a designer. Over the past 20 years Manchipp has been involved in creating transformative design solutions for brands both big and small. He started his career as a junior designer at Michael Peters, worked his way up from Designer to Partner at HHCL, and founded NoOne, a branding specialist inside an advertising agency (HHCL). Manchipp studied at Central Saint Martins, Covent Garden, where he received a BA and met David Law, co-founder of SomeOne. Manchipp has just finished three years as visiting Professor at Central Saint Martins' School of Design, and is trustee and Executive Member at D&AD. He also wrote the Central Saint Martin's short course on Typographic Design. While working on the front line of commercial design he's launched, relaunched, and managed brands worldwide including Eurostar, London 2012 Olympic Games, Sellotape, FastJet, Accenture, Procter & Gamble, WorldPay, TUI, and most recently Cancer Research UK.
SOMEONEINLONDON.COM

NOREEN MORIOKA is the co-founder of AdamsMorioka in Los Angeles, CA, a design and strategy firm established in 1994 that has produced work in various mediums for clients like ABC, Gap, Nickelodeon, Sundance, and The Walt Disney Company. At AdamsMorioka she leads the team in client interface and business development, giving her what most call "people skills," which makes her a great interviewer. In 2006, Noreen was named as a Fellow of the American Institute of Graphic Arts. Noreen is past President of the Los Angeles Chapter of AIGA, past chair of the AIGA National President's Council, Fellow of the International Design Conference at Aspen, Chair of the James Beard Foundation Award for Design and Architecture, and currently serves as a board member of the ADC in New York, NY. She is a frequent competition judge and lecturer. In 2014 Morioka and her partner were awarded the AIGA Medal, one of the highest design honors recognized by their profession.
ADAMSMORIOKA.COM

OCD | THE ORIGINAL CHAMPIONS OF DESIGN (Bobby C. Martin Jr., Jennifer Kinon, and Matt Kay) is a branding and design agency in New York, NY, that builds and implements identity systems for clients like the National Basketball Association, the Girl Scouts of the USA, The *New York Times*, and Friends of the High Line.
ORIGINALCHAMPIONSOFDESIGN.COM

PETTER RINGBOM is a Swedish filmmaker and designer who studied at the Cooper Union School of Art in New York, NY, before partnering with the creative agency Flat, where he served as an art director for clients like MoMA, Red Cross, and ESPN. Ringbom has taught at Parsons School of Design and New York University, and served on the board of the New York chapter of the AIGA. His design work has been recognized by the AIGA, Art Directors Club, Society of Publication Designers, The Webby Awards, *Print* Magazine, and *Communication Arts*. Ringbom was a Film Independent Fast Track Fellow for 2013 and currently serves as the creative advisor for design and innovation firm, Openbox.
PETTERRINGBOM.COM

STEFAN SAGMEISTER studied graphic design at the University of Applied Arts Vienna, Austria. He later received a Fulbright scholarship to study at the Pratt Institute in New York, NY. In 1991, he moved to Hong Kong, China, to work with Leo Burnett's Hong Kong Design Group. In 1993, he returned to New York to work with Tibor Kalman's M&Co. design company. Sagmeister proceeded to form the New York-based Sagmeister Inc. in 1993 and has since designed branding, graphics, and packaging for clients as diverse as the Rolling Stones, HBO, the Guggenheim Museum, Time Warner, David Byrne, and Lou Reed. In 2012 he partnered with Jessica Walsh to form Sagmeister & Walsh. Sagmeister teaches in the graduate department of the School of Visual Arts in New York and has been appointed as the Frank Stanton Chair at the Cooper Union School of Art. He is the author of the design monograph *Made You Look* which was published by Booth-Clibborn editions. Solo shows on Sagmeister, Inc.'s work have been mounted in Zurich, Vienna, New York, Berlin, Japan, Osaka, Prague, Cologne, and Seoul.
SAGMEISTERWALSH.COM

MARY SCOTT was, for over 25 years, Vice-President and director of Creative Operations for Maddocks & Company, a multi-disciplinary firm involved in all phases of communication design based in Los Angeles, CA, and New York, NY. The firm's clients range from Procter & Gamble, Microsoft Web TV, Disney, Platinum Equities, Warner Bros, Columbia TriStar Pictures, Cheseborough-Ponds, Philips, Fredericks of Hollywood, Avon, The Limited, and Sony Entertainment. Scott taught at Art Center College of Design in Pasadena for more than ten years and at Otis College of Art & Design in Los Angeles. In September of 1999, Scott was named Chair of Graphic Design at the Academy of Art University in San Francisco, CA, serving as department chair and an instructor, and in 2000, she assumed the role of Chair of Graphic Design for both the graduate and undergraduate schools. From 1998 to 2001, Scott served on the National Board of the AIGA and is a former Los Angeles chapter President. In 2007, Scott was named an AIGA Fellow and in May of 2012, she was given an Honorary Doctorate of Humane Letters by the Academy of Art University. Scott studied Fine Arts and Foreign Languages at Mt. St. Mary's University in Los Angeles, CA, and Environmental Design at the University of California at Los Angeles. She's an avid landscaper, mother of two, and grandmother of three.
ACADEMYART.EDU

ADRIAN SHAUGHNESSY is a graphic designer, writer, publisher, and educator. He has written and art directed numerous books on design, and has been interviewed frequently on television and radio. He lectures extensively around the world. He is a senior tutor in graphic design at the Royal College of Art, London.
UNITEDITIONS.COM

CHRISTOPHER SIMMONS is a Canadian-born, designer, writer, and design advocate based in San Francisco, CA. As principal and creative director of MINE™, Simmons designs and directs brand and communication design projects for clients ranging from Facebook, Microsoft, and Simon & Schuster, to the Nature Conservancy, SFMOMA, and Obama for America. His work has been exhibited internationally at galleries and museums and is also included in the permanent design archives of the Denver Art Museum. The author of four books, Simmons also lectures on design issues, and frequently participates as a judge for major design competitions. Simmons has been interviewed on design issues by National Public Radio, the *New York Times* and CBS Evening News, and has appeared as a guest on 99% Invisible and Design Matters. In 2013 he was named one of "50 most influential designers working today." Simmons served as president of the San Francisco chapter of AIGA from 2004–2006 and was the founder of San Francisco Design Week. On completion of his tenure on AIGA's board, then-mayor Gavin Newsom issued an official proclamation declaring San Francisco to be a city where "design makes a difference." He is currently serving a three-year term on AIGA's national board of directors. He lives in San Francisco with his wife and two boys.
MINESF.COM

JAKOB TROLLBÄCK is the co-founder and creative director of Trollbäck + Company in New York, NY, a motion graphics firm established in 1999 that produces content across broadcast, print, and interactive mediums for clients like HBO, ESPN, and Nickelodeon. Constantly at the forefront of film title design, and animation and on-air packages for television, Trollbäck scouts the best designers in this fledgling industry.
TROLLBACK.COM

PETRULA VRONTIKIS is a leading voice in graphic design. She lectures at conferences, universities, and to professional organizations worldwide about her work, design education, and on the future of the graphic design industry. Vrontikis is the creative director at Vrontikis Design Office, professor of graphic design and professional practice at Art Center College of Design, and co-author of the Lynda.com online training series, *Running a Design Business*. Vrontikis received an AIGA Fellows Award honoring her as essential in raising the understanding of design within the industry and among the business and cultural communities of Los Angeles, CA. Vrontikis is an avid traveler and visual translator. It's not unusual to find her 85 feet underwater, climbing a steep and rocky slope, or twisting her body like a pretzel in a yoga class.
35K.COM

A brief selection of vendors, stores, sources, and supplies. A jump-starting list to get you on your way.

CUSTOM PORTFOLIO CASES AND BOOKS

Audrey Grossman Handmade
BOOKSANDBOXES.NET

Bella Forte
BELLAFORTEBOOKS.COM

Portfolio Box
PORTFOLIOBOX.COM

Klo Portfolios
KLOPORTFOLIOS.COM

Kristin Dunn Bookbinding
KDBOOKS.COM

Nicole Anderson Book Arts
NABOOKARTS.COM

The House of Portfolios
HOUSEOFPORTFOLIOS.COM

ETSY SELLERS

Broken Cloud Press
WWW.ETSY.COM/SHOP/BROKENCLOUDPRESS

Crafts by Kea
ETSY.COM/SHOP/CRAFTSBYKEA

Hartnack and Company
ETSY.COM/SHOP/HARTNACKANDCO

Lorgie
ETSY.COM/SHOP/LORGIE

Portfolio Box
ETSY.COM/SHOP/PORTFOLIOBOX

Sleek Portfolios
ETSY.COM/SHOP/SLEEKPORTFOLIOS

Studio eQ
ETSY.COM/SHOP/STUDIOEQ

The Bysen Bag
BIT.LY/ETSY_BYSENBAG

Three Points
ETSY.COM/SHOP/THREEPOINTS

READY-MADE PORTFOLIOS, CASES AND BAGS

Booksmart Studio
BOOKSMARTSTUDIO.COM

Book Works
BOOKWORKS.ORG.UK

Brewer-Cantelmo
BREWER-CANTELMO.COM

Lost Luggage
LOST-LUGGAGE.COM

Moab Chinle
MOABPAPER.COM/CHINLE-PHOTO-PRESENTATION

Monochrom
MONOCHROM.COM

Paolo Cardelli
PAOLOCARDELLI.COM

PaperHaus
PAPERHAUS.COM

Pina Zangaro
PINAZANGARO.COM

University Products
ARCHIVALSUPPLIERS.COM

Zetta Florence
ZETTAFLORENCE.COM.AU

FOR HUNTERS

eBay
EBAY.COM

Etsy
ETSY.COM

ONLINE PORTFOLIO HOSTING

All You
ALLYOU.NET

Behance
BEHANCE.NET

Carbonmade
CARBONMADE.COM

Coroflot
COROFLOT.COM

Crevado
CREVADO.COM

FolioHD
FOLIOHD.COM

FolioSnap
FOLIOSNAP.COM

Format
FORMAT.COM

Krop
KROP.COM

Portfoliobox
PORTFOLIOBOX.NET

Portfoliopen
PORTFOLIOPEN.COM

Shown'd
SHOWND.COM

Squarespace
SQUARESPACE.COM

Weebly
WEEBLY.COM

Wix
WIX.COM

COMPS AND PROTOTYPES

A2A Graphics
A2A.COM

Comp24
COMP24.COM

Concept Link LTD
CONCEPT-LINK.COM

COMMERCIAL, SHORT-RUN OR ONE-OFF PRINTERS

Adorama
ADORAMAPIX.COM/PHOTOBOOKS.ASPX

Apple
APPLE.COM/ILIFE/IPHOTO/PRINT-PRODUCTS.HTML

Blurb
BLURB.COM

CafePress
CAFEPRESS.COM

FedEx Office
FEDEX.COM/US/OFFICE

Lulu
LULU.COM

MagCloud
MAGCLOUD.COM

Mixbook
MIXBOOK.COM

Newspaper Club
NEWSPAPERCLUB.COM

Viovio
VIOVIO.COM

OFFICE PRINTERS

Canon
USA.CANON.COM

Epson
EPSON.COM

HP
HP.COM

Xerox
OFFICE.XEROX.COM

PHOTOGRAPHY EQUIPMENT

Adorama
ADORAMA.COM

B&H Photo
BHPHOTOVIDEO.COM

ART AND CRAFT SUPPLIES

A.I. Friedman
AIFRIEDMAN.COM

Dick Blick
DICKBLICK.COM

Kate's Paperie
KATESPAPERIE.COM

Michaels
MICHAELS.COM

PAPER

Domtar
DOMTAR.COM

Epson
EPSON.COM

French Paper
FRENCHPAPER.COM

Moab
MOABPAPER.COM

Mohawk
MOHAWKCONNECTS.COM

Neenah
NEENAHPAPER.COM

Paper Source
PAPERSOURCE.COM

Red River Paper
REDRIVERCATALOG.COM

Strathmore
STRATHMOREARTIST.COM

OFFICE SUPPLIES

Office Depot
OFFICEDEPOT.COM

Office Max
OFFICEMAX.COM

Staples
STAPLES.COM

Target
TARGET.COM

FABRIC AND BOOKBINDING SUPPLIES

Gane Brothers & Lane
GANEBROTHERS.COM

Hancock Fabrics
HANCOCKFABRICS.COM

Hollander's
HOLLANDERS.COM

Jo-Ann Fabrics
JOANN.COM

Talas
TALASONLINE.COM

INDEX